Santa Monica Public Library

I SMP 00 0998218 1

D0601723

 Santa
Monica
Public

4-WEEK

SANTA MONICA PUBLIC LIBRARY

- - 7 - 1990

GEORGE INNESS

SANTA MONICA PUBLIC LIBRARY

Organized by Michael Quick

Nicolai Cikovsky, Jr. Michael Quick

GEORGE INNESS

Los Angeles County Museum of Art

Exhibition Itinerary

The Metropolitan Museum of Art
April 1–June 9, 1985

The Cleveland Museum of Art
August 21–October 6, 1985

The Minneapolis Institute of Arts
November 10, 1985–January 12, 1986

Los Angeles County Museum of Art
February 20–May 11, 1986

National Gallery of Art
June 22–September 7, 1986

Published by the
Los Angeles County Museum of Art,
5905 Wilshire Boulevard,
Los Angeles, California 90036

The hardcover edition is published by
Harper & Row, Publishers, Inc.,
10 East 53rd Street, New York, New York.
Published simultaneously in Canada by
Fitzhenry & Whiteside Limited, Toronto.

Illustrations copyright ©1985 Los Angeles County
Museum of Art, unless otherwise indicated.
Catalogue first published in 1985 by the
Los Angeles County Museum of Art.
All rights reserved. No part of the contents of this
book may be reproduced without the written
permission of the publishers.

Cover: *October,* 1886 (cat. no. 46) (detail)

Library of Congress Cataloging in Publication Data
Inness, George, 1825–1894.
 George Inness.
 Catalogue of an exhibition organized by the
Los Angeles County Museum of Art, and held
at the Metropolitan Museum of Art, New York,
April 1–June 9, 1985, and at other museums.
 Bibliography: p.
 1. Inness, George, 1825–1894—Exhibitions.
I. Cikovsky, Nicolai. II. Quick, Michael.
III. Los Angeles County Museum of Art.
IV. Metropolitan Museum of Art (New York, N.Y.)
V. Title.
ND237.I5A4 1985 759.13 84-28836
ISBN 0-06-430710-7 (Harper & Row)
ISBN 0-87587-124-0 (LACMA : pbk.)

Lenders to the Exhibition

Addison Gallery of American Art, Phillips Academy, Andover, Massachusetts

Albright-Knox Art Gallery, Buffalo

The Art Institute of Chicago

The Brooklyn Museum, New York

The Butler Institute of American Art, Youngstown, Ohio

Canajoharie Library and Art Gallery, New York

Cincinnati Art Museum

The Cleveland Museum of Art

Mr. Thomas Colville

The Corcoran Gallery of Art, Washington, D.C.

Dallas Museum of Art

Delaware Art Museum, Wilmington

George Walter Vincent Smith Art Museum, Springfield, Massachusetts

The Haggin Museum, Stockton, California

Mr. and Mrs. George D. Hart

The High Museum of Art, Atlanta

Indianapolis Museum of Art

Jordan-Volpe Gallery, Inc., New York

Los Angeles County Museum of Art

Mr. Joseph Mattison, Jr.

Mr. and Mrs. Frederick R. Mayer

Meredith Long & Co., Houston

The Metropolitan Museum of Art, New York

Montclair Art Museum, New Jersey

Mount Holyoke College Art Museum, South Hadley, Massachusetts

Museum of Art, Carnegie Institute, Pittsburgh

Museum of Art, Washington State University, Pullman

Museum of Fine Arts, Boston

National Gallery of Art, Washington, D.C.

National Museum of American Art, Smithsonian Institution, Washington, D.C.

The Nelson-Atkins Museum of Art, Kansas City, Missouri

The New Britain Museum of American Art, Connecticut

Paine Art Center and Arboretum, Oshkosh, Wisconsin

Portland Art Museum, Oregon

Reynolda House Museum of American Art, Winston-Salem, North Carolina

The Saint Louis Art Museum

The Santa Barbara Museum of Art, California

Mr. and Mrs. Charles Shoemaker

Mr. and Mrs. Walter Knight Sturges

The Toledo Museum of Art, Ohio

Wadsworth Atheneum, Hartford, Connecticut

The Wellesley College Museum, Massachusetts

Williams College Museum of Art, Williamstown, Massachusetts

Worcester Art Museum, Massachusetts

Several anonymous lenders

Foreword

It is with great pleasure that we join in presenting *George Inness.* This exhibition of sixty-three oil paintings by George Inness (1825–94) displays the full range of his mature artistic output from the 1850s to the last year of his life. The exhibition, which will visit five major metropolitan areas, will be the most widely seen exhibition of Inness paintings ever presented.

Inness was one of nineteenth-century America's great painters. From the early 1880s until well into the twentieth century, he was lauded as a genius. It was only during the third quarter of the twentieth century that his reputation languished. Even to the extent that he remained known or was rediscovered, Inness was largely misrepresented. As a young painter, he was a contemporary of many Hudson River School artists, but he was not one of them. His aims and methods were distinctly different from theirs. Where they were concerned with an accurate depiction of nature, he set out to convey through his landscapes subjective ideas and emotions. The underlying modernity of his art is only now being given proper attention. His lifelong concern with aesthetic questions, with form and the practice of painting, makes it clear that his artistic sensibility was essentially modern.

Inness was interested in nature shaped to human needs, not in scenic splendors, which had long been the mainstay of American landscape art. His own phrase "the civilized landscape" perfectly describes his attitude. In some paintings nature is more dominant and tempestuous, but generally he shows us the land as cultivated by man. He shows it to us in images of subtle tones and evocative of quiet emotions. In the late paintings the

8

images tend to be more visionary as Inness came to perfect an artistic form that was better able to express his own deep spiritual feelings. The whole development of his art was concerned with capturing the spirit of what he saw, and he worked this out by perfecting the form and technique of his paintings. The paintings were formed by artistic intelligence and for artistic purposes. Their subject matter is readily accessible, but it is Inness's structural order that makes them so appealing to our modern expectations of art.

We would like to express our gratitude to Michael Quick, curator of American Art, Los Angeles County Museum of Art, who organized this exhibition in collaboration with Nicolai Cikovsky, Jr., curator of American Art, National Gallery of Art. Nicolai Cikovsky, Jr. and Michael Quick also deserve special thanks for their contributions to the catalogue. We are indebted to the many institutional and individual lenders without whose support this exhibition would not be possible.

The exhibition has been made possible by a grant from the National Endowment for the Arts and by a generous grant from Mr. and Mrs. Meredith J. Long. The Henry Luce Foundation, Inc. through the Luce Fund for Scholarship in American Art has generously supported publication of the catalogue.

Philippe de Montebello, Director
The Metropolitan Museum of Art

Evan H. Turner, Director
The Cleveland Museum of Art

Samuel Sachs II, Director
The Minneapolis Institute of Arts

Earl A. Powell III, Director
Los Angeles County Museum of Art

J. Carter Brown, Director
National Gallery of Art

Acknowledgments

As curator in charge of the exhibition, I have had the pleasure of working closely with one of the most able and distinguished figures in the field of American art history, Nicolai Cikovsky, Jr., the leading authority on the work of Inness, who has contributed an insightful new essay and sensitive catalogue entries. It has been my privilege to collaborate with him in writing a few of the entries and in augmenting others with a second point of view. I am grateful for the valuable advice he offered at different times in the process of selecting works for the exhibition.

The purpose of the exhibition is to present to the public a representative selection of Inness's finest works. In order to arrive at a fresh selection that goes beyond the familiar works, it was necessary to travel throughout the country to examine as many paintings as possible for the color, delicate effects, and fine condition that are impossible to judge from black-and-white photographs. Individual owners and museum staff members too numerous to list graciously assisted me in my quest. I wish I could thank each one for his helpfulness and hospitality. In the process of discovering the best among these little-known paintings, I benefited from the advice of many persons, but principally that of the art dealers who, in handling Inness's work over the years, have developed an extensive knowledge of and affection for the artist, especially Robert C. Vose, Jr., Meredith Long, and Thomas Colville. Mr. Vose kindly opened his firm's files to me, thereby also allowing me the benefit of his father's comments on individual works.

Although the present selection has been distilled from the examination of many more possibilities, I think it only fair to the artist to express my belief that numerous other works of equal quality remain to be rediscovered from among the long list of unlocatable works in LeRoy Ireland's catalogue raisonné. Other excellent paintings eluded even his lifetime of searching. The present exhibition includes several first-rate paintings that have only recently come to light. There are certainly other lost paintings that would do equal credit to the artist.

My warmest thanks go to the lenders, who have so graciously shared their treasures with us for such an extensive exhibition tour. For their research and organizational assistance, I would like to thank Nancy D. W. Moure, former assistant curator of American Art, and Ilene Susan Fort, who presently serves in that capacity. Sheila White, departmental secretary, efficiently prepared manuscripts and loan correspondence. Mrs. Samuel Sapin volunteered to assist with photography orders. Press Officer Pamela Jenkinson Leavitt and her staff ably initiated and coordinated the publicity. The catalogue was edited by Edward Weisberger and designed by Lilli Cristin. Numerous members of the museum staff helped in important capacities, earning my sincere gratitude. I would like to thank all of them for their contributions.

Michael Quick
Curator of American Art
Los Angeles County Museum of Art

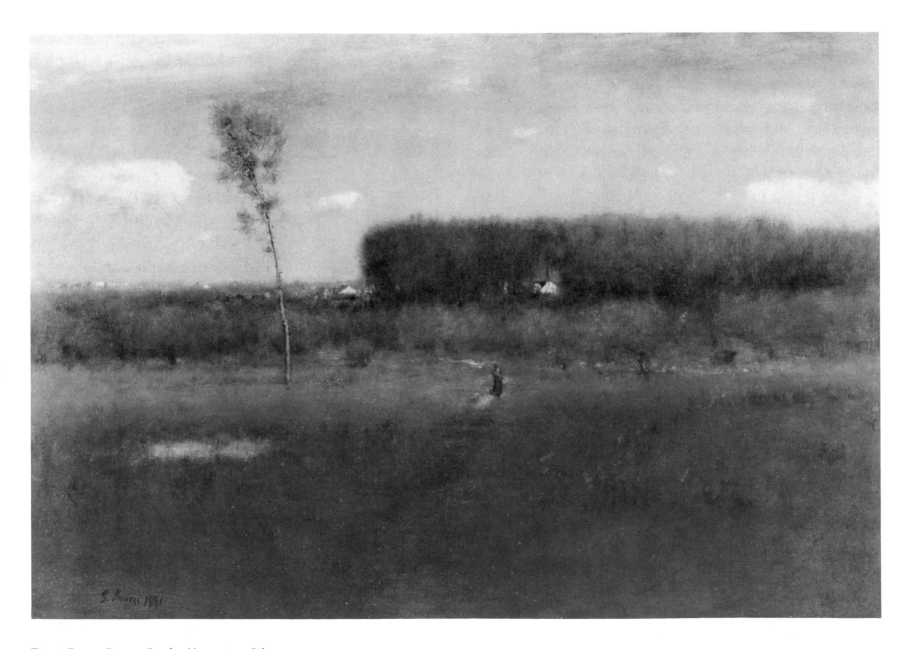

Fig. 1. George Inness. *October Noon,* 1891. Oil on canvas.
29 ½ x 44 in. (79.9 x 111.8 cm). Ireland 1359. Fogg Art
Museum, Cambridge, Massachusetts. Grenville L. Win-
throp Bequest.

The Civilized Landscape *by Nicolai Cikovsky, Jr.*

"More of a painting than a picture"

What first struck me about George Inness was his modernity. A late landscape by Inness (fig. 1) hung in a back stairway of the Fogg Art Museum at Harvard when I was an undergraduate in the 1950s. I came to have a close, almost clandestine relationship with it. What impressed me most about the painting, I remember, was its nearly arbitrary coloration and suggestive form (very like Rothko, I might say now), its reduction of natural objects to pictorial shapes and their reconstitution into a virtually abstract design. This was all the more provocative and begged all the more for explanation because I had never heard of the artist who painted it.

When I learned more about him and his art, I discovered that George Inness was not unknown. On the contrary, he was the subject of a substantial body of literature, which reflected a once very considerable fame. I also found that this painting, while it was an unusually beautiful and striking instance of the modernity of his style, was by no means singular, especially among his late paintings (cat. nos. 52–63), which all to some degree shared its traits.

The standard literature on Inness said nice things about him. It said nothing, however, about his modernity. But when I began to read Inness's contemporary critics, I found that they did speak of his modernism, even though they almost never called it that. Whatever their shortcomings of perception and judgment, they experienced Inness's art with unmatched closeness and continuity and in the full texture of its art historical setting. They saw in his art and collectively delineated in their criticism an artistic sensibility essentially modern in its evident regard for the integrity and expressive power of artistic form and in its disdain for descriptive resemblance.

Inness was a complicated, thoughtful artist. He welcomed influences, and his art underwent dramatic perturbations. Successively, sometimes almost simultaneously, it took different forms. What underlies its changeableness and, as a will to renovation, partly explains it, is modernity. It was expressed in his earliest works mostly as intention and in his later works more openly as appearance. It was expressed by discernibly modern subject matter, what Inness called "civilized landscape,"[1] and simply by an attraction to newness. Whether as instinct, sensibility, idea, or conviction, modernity is the unifying principle of Inness's artistic enterprise.

Inness was born in 1825 near the town of Newburgh, New York, in the mid-Hudson River valley. As an infant he was taken to New York City. There and in its vicinity he was raised and would live and work for most of his professional life.

Two years younger than Jasper Cropsey and Sanford Gifford, one year older than Frederic Church, Inness was the contemporary of a group of American landscape painters closely joined by shared styles and ideals and by a common ancestry in the artistic achievement of Thomas Cole. They were America's most admired artists in the decade or so that preceded the Civil War; for instance, no price as great as that paid in 1859 for Church's *Heart of the Andes* had ever been paid for a contemporary American landscape painting. Such artists as Cropsey, Gifford, and Church traveled widely to England, Europe, the Near East,

South America, the Arctic, and the American West. But they were so closely associated with the Hudson River valley, especially the Catskill Mountains, and so fully captured its sense of place that they came to be called the Hudson River School.

Most American landscape artists associated themselves with the Hudson River valley. But Inness left the valley for New York City. As an infant he was, of course, not responsible for that move. Nevertheless, the event is symbolic. It illustrates the essential character and tendency of Inness's artistic life. Wherever his contemporaries were going, he was going the other way. He had an almost categorical disregard for the common practices and received beliefs of his time. When others faithfully (both closely and with almost religious devotion) depicted nature, Inness imitated art—Cropsey found him straying in 1845 and he reported, "I directed his attention to the *study* of nature. I presume he has been guided by it";[2] but he was not. When they painted nature's sublime vastness, Inness painted with poetic intimacy. When they painted tightly, he painted broadly. When they were most intensely American, he went to Italy and France and fell under the spell of foreign art. And so on.

He paid a price for this contrariness, this disobedience of the practices and principles of his contemporaries. When they were being praised and honored, Inness was ignored. When their work defined America's national artistic standards, his was regarded as incomprehensible. The National Academy of Design certified the professional correctness of Cropsey, Gifford, and Church by electing them to full membership in 1851, 1854, and 1849, respectively. Inness did not become a full

academician until 1868. When he finally did so, it reflected a profound shift of taste. Inness had not changed, the times had.

At the end of the 1860s, experiences of the Civil War created conditions more receptive to Inness's art. The tensions of war created an emotional climate sensitive to his expressive style. There was an artistic restlessness and a longing for change. Broader, more varied knowledge of art produced a greater artistic tolerance and deeper artistic culture. As a result, Inness's art began to make sense to more people and seem less strange than it had before. During the following quarter century or so, tolerance turned into understanding, understanding into admiration, admiration into adoration, and adoration, by the time of Inness's death, into apotheosis as America's greatest living landscape artist. During the same period, in the same proportion that Inness's fame grew, that of the Hudson River School artists declined. When Inness died in 1894, his body lay in state in the National Academy of Design, and everybody knew who he was and what he had done. When Frederic Edwin Church died in 1900, he was virtually unknown; anyone born since about 1870, one writer felt, either would not know who he was at all or confuse him with the younger artist, Frederick S. Church.[3] When Inness died, he was in the public eye, and his paintings had for a long time epitomized American artistic understanding and sensibility. Church died in obscurity, and his art had long since lost its currency. Had each died about forty years earlier, their situations would have been exactly reversed.

In 1894 a critic described one of Inness's works as "more of a painting than a picture."[4] That essential premise of modernism had always been Inness's central artistic intuition. Before the

Civil War, when the art of Cropsey, Gifford, and Church—more picture than painting—was most greatly admired, Inness's art was not and could not have been. Only later in the century, in literally more modern times, others came to see, as Inness had foreseen, that artistic form had distinct claims of its own to beauty, meaning, and expression apart from whatever it might depict. Only when that perception was normal and not, as when Inness first expressed it, exceptional did Inness's art become correctly understood and properly admired.

"A young artist of good promise"

When Inness told of his early life many years later, he said he "began without any art surroundings whatever" and that "a month with [Régis François] Gignoux" was "all of the instruction I ever received from any artist."[5] Why Inness wanted it known that he was largely self-taught is not clear. Perhaps he thought it made his mature achievement seem more impressive, or perhaps he thought it was somehow more American. It is true that his artistic education as a whole was very much "off and on," because of "the distress of a fearful nervous disease," epilepsy, that "very much impaired my ability to bear the painstaking in my studies which I would have wished."[6] Nevertheless, Inness knew a great deal about art, both from his art education and from his "art surroundings."

An exposure to art was one of the primal experiences of Inness's childhood. We can make that inference from the description of such an experience, which probably derived its tone and information from Inness himself, in an early biography.

His love of pictures was always a passion with him, and his earliest art friend was an old volume on landscape painting which he found one day among his father's books. This he used to read, re-read and dream about. It . . . talked of the glory of Claude and of others of the masters of landscape art. . . . It was so easy to be a Claude, George thought, and he hugged the old volume to his heart, and he read it once again, and again he dreamed over it.[7]

It is not possible to identify this impressive "old volume." Judging from the description, it was the sort of collection of artistic rules, recipes, and stories, perhaps illustrated with engravings of celebrated paintings, which was commonplace in the eighteenth and early nineteenth centuries. We do not have to be able to name it to know how profoundly it aroused in the young Inness so fervent a passion for landscape art that he dreamed of it and wanted "to be a Claude."

That his household contained books, at least one of them on art, suggests that Inness was raised in an atmosphere of more than ordinary literacy and cultivation; that his brother James became a schoolmaster also suggests it. When it became clear that Inness was determined to be an artist, his father, a prosperous merchant, gave him numerous opportunities for study. Therefore, rather than being self-taught, he learned so much from the lessons and examples of his teachers that it is possible to trace to them some of the most essential and abiding features of his art.

Inness's first teacher was an itinerant artist named John Jesse Barker (active 1815–56), who claimed that he had studied with Thomas Sully. Inness could not have learned much from Barker, whose artistic abilities were unexceptional and whose work

showed none of Sully's almost effortless fluency of style. But at this first stage of Inness's artistic education, Barker's artistic lineage may have been especially impressive. It is possible that through him Inness received some knowledge, if only as formulas and recipes, of Sully's supremely painterly style. The fluency of handling and richness of pigmentation and coloration of Inness's mature artistic language may have been a taste, if not a skill, for which Barker was originally responsible.

The most important influence on Inness's artistic outlook was his brief study with the French-born painter Régis François Gignoux in 1843. The thoroughly trained and gifted Gignoux surely taught Inness more of the craft of painting than Barker did, at any rate as much as Inness could learn in a month. Gignoux had no visible influence on Inness's art, in which there is no reflection of his delicately painted genre scenes and landscapes (fig. 2). It was not what Gignoux actually taught Inness, but what he represented that mattered most. He was a pupil of Paul Delaroche. Delaroche was first trained as a landscape painter influenced particularly by Dutch seventeenth-century landscape art and was later a pupil of Baron Gros, who was a pupil of Jacques-Louis David. Gignoux was thus a direct heir to the great traditions of European and contemporary French painting; as such, he may have been an alluring incarnation of everything that vividly filled Inness's artistic imagination. Inness as a youth "read, re-read, and dream[ed] about . . . the glories of Claude and of others of the masters of landscape art." Gignoux's example, advice, and pedagogical discipline gave substance to Inness's dreams. It was one thing "to want to be a Claude." It was another to know how to go about it. Gignoux showed Inness how.

In the middle 1840s the chief concern of Inness's American contemporaries was to formulate a native landscape art derived from native precedents, particularly those established by Thomas Cole, and based on the direct study of American nature. Studying the old masters, nearly everyone thought, was one of the worst things an American artist could do. It was the surest way to compromise one's nationality and, by replacing the imitation of nature with the inherited conventions of art, corrupt one's vision. Inness's interest in the art of the past was not normal; it was almost perversely contrary to everything his contemporaries believed. From Gignoux's teaching and exemplification of artistic tradition, Inness derived the knowledge and fortitude to undertake professionally an enterprise that diverged radically, as he and his teacher must have realized, from the artistic principles and practices of their age.

When Inness began exhibiting professionally in 1844, he was received by critics as "a young artist of good promise."[8] Little else but his promise pleased them. They found his paintings artificial and untruthful. In a review of Inness's paintings in the 1848 Academy exhibition, one critic told why: "we fear that he is beginning to lose sight of Nature in the 'Old Masters'," to the degree, he believed, that Inness's paintings were imitations, even actual copies, of Claude.[9]

In 1851 Inness made his first visit to Europe. What he knew at this point of the old masters he knew only from descriptions, engravings, or painted copies. From them, assisted perhaps by Gignoux, he learned a great deal. He was able to deduce with remarkable completeness the modes of drawing, patterns of pictorial construction, and even ways of handling paint (fig. 3)

Fig. 2. Régis François Gignoux (United States, 1816–1882). *Winter Scene in New Jersey*, 1847. Oil on canvas. 20 x 24 in. oval (50.8 x 61 cm). Courtesy, Museum of Fine Arts, Boston. Bequest of Martha C. Karolik for the Karolik Collection of American Paintings, 1815–1865.

Fig. 3. George Inness. *Our Old Mill*, 1849. Oil on canvas. 29 ⅞ x 42 ⅛ in. (75.9 x 107 cm). Ireland 57. Courtesy of The Art Institute of Chicago. William Owen and Erna Sawyer Goodman Collection.

that characterized and were the principles of old master style. He had not, however, experienced old master paintings directly or in any significant quantity. Most American painters went to Europe at one time or another, but it was not regarded as a necessary part of their artistic education. On the contrary, going to Europe was considered just as bad, just as perilous for an artist's naturalness and nationality, as imitating the old masters. But it was essential for Inness.

Inness may have thought of going to Europe as early as 1848; at that time, he applied for a passport and gave the following description of himself in his early twenties: "Stature: 5 feet 5½ inches. Forehead: High and wide. Eyes: Brown. Nose: Aquiline. Mouth: Small. Chin: Pointed. Hair: Light. Complexion: Fair. Face: Irregular." So far as we can tell, however, he did not actually go to Europe until the end of February 1851.[10]

Inness went directly to Italy, destined for Rome. "But long before he reached the Eternal City," it was reported later, "the artist stopped on his way there and began to work. At four o'clock one afternoon he arrived at Florence; by ten the next morning he was out with his easel and made his first sketch of the day."[11] He finally reached Rome by the spring of 1852.

Inness may have planned to stay a second year abroad. If so, his plan was abruptly changed by an episode so serious that it apparently resulted in his expulsion from Italy; we know that on May 15, Inness, his wife, and their daughter Elizabeth (born in Florence) arrived back in New York.[12] The episode itself was reported in the most detail by a correspondent to the *Boston Transcript.*

Mr. Innes,* the artist, a small delicate man, was in the Piazza of San Pietro, among the crowd assembled to see the Pope make his appearance on the balcony. The sun was very hot, and when the Pope came out to bless the people there were only a few of the lower classes of French and Italians who took off their hats. I saw some thousands around me, including the French officers and soldiers, who kept their hats on their heads, where, through their tacit permission, I was suffered to keep mine. A French officer standing near Innes ordered him to take his hat off, to which Innes paid no attention. The officer then knocked it off. Innes had a small cane in his hand, with which he rapped the man in the epaulettes over the head; whereupon there was terrible commotion among the soldiers, a dozen of whom rushed to the assistance of their companion in arms, and by force of numbers took the little artist into custody, and carried him off to jail. He was soon after liberated. I understand Mr. Cass [an American diplomat] intends investigating the subject, and demanding an apology.[13]

This account provides a clear description of Inness's appearance and gives an early indication, of which there would be many more later, of the prickly temperament that inhabited his small, frail body.

Inness's 1851–52 trip to Italy did not change his art. He went abroad to study in the original the kinds of paintings he had known only through prints and copies and, by that experience, to confirm, not change, the direction he had been pursuing since the beginning of his professional life. *A Bit of the Roman*

*Inness's name was frequently misspelled by his contemporaries.

Aqueduct (cat. no. 1), which Inness either painted in Italy or as a memory of Italy after his return to America, imitates the modes of pictorial construction and descriptiveness of old master paintings less overtly, less earnestly and mechanically, than Inness had done earlier (fig. 4). It is more inventive and more fully mingles natural observation, particularly of color and atmosphere, with pictorial formulas. However, its debt to old master painting is still perfectly clear in both its compositional massing and descriptive details. His critics continued to notice that debt, which tried their critical standards more sorely than ever. One wrote that his paintings "betray a much profounder regard for 'old masters' than for Nature" and "he is consumed by the old landscapes." He then asked:

> Is an artist to-day to be satisfied with doing pictures which might be taken for [Gaspard] Poussin's? Imitation when most perfect is then most hopeless.... The difficulty with Mr. Innes is, that he has gone all wrong, but there is no proof that he cannot go right if he will...let him not be mastered by the Masters. The end of the artist in studying Raphael, Claude or Titian is not to know them, but Nature.[14]

Another said, Inness's

> pictures have become shallow affectations of that which is at best superficial to Art—the accomplishment, not the substance. What the condition of that mind can be which will resign, not only all nature, but even all that is most valuable in art, to a tone of color, we cannot conceive. The artist's mission is to interpret nature; what, then, is he who contents himself with studio concoctions as blank and wanting in the truths of nature as the canvas they are painted on?[15]

It was not just the resemblance of Inness's paintings to earlier art, that he was "mastered by the Masters" and "consumed by the old landscapes," that troubled them. That was merely the sign or symptom, from their viewpoint, of a more profoundly serious error: Inness's unmistakable tendency to imitate art more closely and fondly than nature, his apparently uncontrollable attraction to the means and methods of art—color, tone, shape, design, inherent properties of pigment—for their own sake instead of their capacity to imitate nature. He was so respectful of the authority of artistic form that he was indeed, as they said, perfectly willing to resign all nature "to a tone of color" and quite content with "studio concoctions."

Inness's critics did not misconstrue his intentions, his "condition of mind." Like any young artist, Inness would have followed his critical reception closely. He knew, therefore, that it was consistently unfavorable, and he knew why. Yet he obviously did nothing to please his critics. He did not take their advice, alter his artistic course, and paint the kinds of pictures that would please them. Inness continued to paint as, by taste, temperament, and belief, it suited him to paint. Even at the outset of his artistic life, his determination was so firm and purpose so clear that no amount of unfavorable criticism could defeat or deflect him.

Inness's critics read his intentions in his style, in which they recognized his attraction to the masters and what they saw as his infidelity to nature. They did not particularly notice his subject matter. But Inness's subjects show his essential artistic conviction even more clearly than his style, so clearly that he might have chosen his subjects for just that purpose.

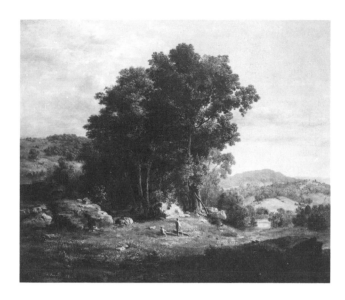

Fig. 4. George Inness. *Landscape,* 1848. Oil on canvas. 29 ½ x 44 ½ in. (74.9 x 113 cm). Ireland 36. The Fine Arts Museums of San Francisco. Mildred Anna Williams Collection.

Fig. 5. George Inness. *The Sunshower,* 1847. Oil on canvas. 29 ¾ x 41 ¾ in. (75.6 x 106 cm). Ireland 22. Collection of The Santa Barbara Museum of Art, California.

Fig. 6. George Inness. *The Wood Chopper,* 1849. Oil on canvas. 19 ⅞ x 23 ⅞ in. (50.5 x 60.6 cm). Ireland 56. The Cleveland Museum of Art. Mr. and Mrs. William H. Marlatt Fund.

By the 1840s, when American critics spoke of nature, they usually meant wilderness nature; when American artists painted nature, they usually painted wilderness nature. In contrast, Inness said many years later that he preferred "civilized landscape" in which "every act of man...marks itself wherever it has been" to landscape "which is savage and untamed."[16] He declared that preference no less plainly in his earliest works by painting subjects that depict acts and emblems of civilization, which exemplify and express the human domination of nature. In *The Sunshower* of 1847 (fig. 5), the foreground is populated by a reaper and shepherdess, symbols of nature tamed and shaped to human purposes by cultivation and husbandry. *The Wood Chopper* of 1849 (fig. 6) depicts an explicit emblem of the subjugation of wilderness nature. In *The Lament* (1846), the stump of a newly felled tree spells the doom of the wilderness's natural inhabitant, the Indian, and is the cause of his lament. In *Surveying* (1846), nature is plotted and organized by human reason for human use and pleasure.

All of these subjects depict episodes or reflect issues in the civilizing settlement of America. There seems to be nothing remarkable about that, all the more as they were painted at the time that the process of settlement was most intense. In 1847, just when Inness was painting civilized landscapes, American landscape artists were publicly summoned to preserve in their pictures the wilderness, which was in fact being rapidly and often wantonly destroyed by the "axe of civilization."[17] By painting images of civilization when most artists were painting wilderness, Inness was purposefully different, as different as he was in imitating the conventions of art when American artists were expected to imitate the truths of nature. He painted such images

not to be contrary but because he could not fail to perceive that the civilized landscape carried meanings so directly relevant to the artistic enterprise, as he understood it, that they might serve as the metaphorical expressions of his undertaking.

When the wilderness was, in fact, being destroyed, to paint wilderness was to paint the past, the natural "relics" of America's "natural infancy,"[18] not the present. Wilderness landscapes were history paintings and mythology. Inness's civilized landscapes were modern paintings, legible signs of his affiliation with the modern present as against the mythologized past. The civilized landscape was nature shaped by the formative intelligence and creative power of mankind. It was the counterpart in reality of Inness's artistic determination to transform nature into art—to impress his artistic will on nature and use its materials for his own aesthetic and expressive ends—just as reapers, shepherdesses, woodcutters, and surveyors used and remade nature for human purposes. His depiction of the railroad in *The Lackawanna Valley* of about 1855 (cat. no. 2) is the definitive pictorial statement of this conviction.

There is another sign of this determination. Inness disdained mere resemblance. When asked where a picture was painted, he replied, "Nowhere in particular; do you suppose I illustrate guide-books? That's a picture."[19] There is in his earliest work one particularly certain case of this disdain. On the reverse of a landscape (fig. 7) that Inness presented to his brother James is a note by James Inness that reads, "The group of trees and rocks in the foreground were taken from the Sharp Mountain in the Borough of Pottsville, Pennsylvania AD 1844."[20] This certifies that part of the painting originated in nature. But the rest of it,

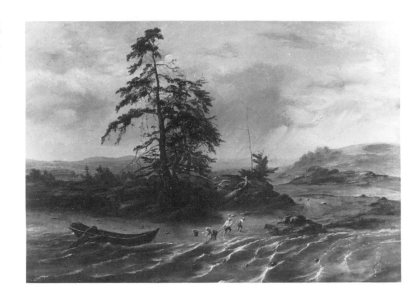

Fig. 7. George Inness. *Landscape with Fishermen,* 1844. Oil on canvas. 25 x 36 in. (63.5 x 91.4 cm). Not in Ireland. Collection of The Santa Barbara Museum of Art, California. Gift of Mrs. Tracy W. Buckingham.

18 we can be just as certain, did not, for no body of water of the kind Inness depicted exists in the vicinity of Sharp Mountain. This may be an extreme case of the kind of inventive license that Inness allowed himself. By its very extremity, it shows how little he felt bound to the configuration of nature and the great liberty he allowed himself in changing it.

Sometime in 1853 Inness made a second visit to Europe, where he spent about a year, mostly in France. We do not know exactly who or what he saw there, what he did, or even how long he stayed. We know from its results, however, that this was the most decisively important experience of his artistic life, one so profoundly impressive that all the paintings he made after this trip, to the end of his life, would in some way show its influence.

In the summer of 1854 Inness visited the Rijksmuseum in Amsterdam.[21] Only a single visit was recorded, so this did not represent concentrated study of Dutch paintings. While no serious landscape painter could ignore the Dutch contribution, Inness's interest in seeing Dutch paintings at this time may have been meant as a visual antidote to the Italianate landscape style of Claude and Gaspard Poussin, which had been the largest and clearest influence on his earlier art. This, in turn, may be one sign of a profound stylistic change that overcame his art during his second visit to Europe.

The greatest cause of this change came not from Dutch art but from modern French landscape painting of the Barbizon School, so called because most of its artists worked in and around the village of Barbizon in the Fontainebleau Forest near Paris. Under the influence of Barbizon art, Inness completely remade the appearance of his art. He replaced the dark tones and tight handling of old master paintings, which had formerly been his models, with the suggestive handling, lighter coloration, simpler compositions, and more informal pictorial constructions that he obviously appropriated from Barbizon landscapes.

From time to time Inness imitated the mood, manner, and motifs of Barbizon art, and his paintings sometimes reflect the style of individual Barbizon artists, such as Rousseau (perhaps the most influential), Dupré, Diaz, Jacque, Troyon, Daubigny, and Corot. Despite episodes of imitation, Inness was never merely a copyist of Barbizon art or artists. His relationship to Barbizon art was more complicated and problematic. Although a change in Inness's art was immediately visible after his critical experience of Barbizon painting (compare cat. nos. 1 and 4), his own paintings in the Barbizon mode were for a long while, until about 1860, hesitant and tentative. He was experimenting with it—testing its possibilities, exploring its range, slowly absorbing and carefully adjusting it to suit his special requirements—in order ultimately to make it fully his own. It was as though he wished to inform himself with, not conform himself to, Barbizon style. "He learned the lesson that the Fontainebleau painters had to teach, not by way of imitation, which was absolutely impossible to him at any time, but by analysis. He was learning to write his own hand."[22]

That, of course, took time. What made the process particularly time-consuming was Inness's evident unwillingness simply to abandon what he had done before in favor of the allure and authority of Barbizon art. Inness's early, pre-Barbizon paintings

are too derivative in form and awkward in manner to be impressive as works of art. Even so, they reveal a sincere and resolute regard for older art and, taken as a group, embody an artistic point of view quite remarkable in its clarity and determination for an artist so young. Those characteristics did not give way easily or immediately to Barbizon influence. A particularly clear instance of this is *The Juniata River* of 1856 (cat. no. 3). Its greater breadth and lighter composition are clear evidence of Inness's experience of Barbizon art. Yet two years after that experience, those traits of Barbizon style are joined to, almost literally laid upon, a pictorial construction that in its symmetrical enframement and planar arrangement of space still derives from the formulas of old master landscape painting.

Inness held to his artistic point of view even more resolutely than he did to certain earlier modes of style. It is possible that Inness found Barbizon art so immensely attractive precisely because it did not require a fundamental revision of belief on his part. On the contrary, it was a way of reforming and renovating his artistic convictions, of giving them more explicit and articulate form and making them new.

As we have seen, Inness understood that art and nature were different things: paintings were not necessarily pictures, and it was the artist's function, even his obligation, by an aesthetic and expressive reorganization, to interpret nature and not merely depict it. In the suggestive breadth, bold handling of paint, and compositional informality of Barbizon style, exact resemblance was less important than expression: the painted object was the record of an artistic presence, and the act of painting was a direct expression of artistic feeling. In Barbizon style Inness discovered artistic means by which nature could be more fully, freely, and visibly remade into art than it had been possible for him to do before.

We have seen, too, that while Inness was painting in a frankly old-masterish style, his subjects had an unmistakable modernity. Inness first experienced Barbizon art when it was, as he certainly knew, the most modern form of landscape painting. All that Inness found useful and congenial in specific features of Barbizon style, therefore, carried the additional value of modernity. To paint in the Barbizon manner was to paint in a modern way, with the result that for the first time Inness's art was modern not only by instinct and intention but in appearance as well.

All of this was too much for Inness's critics. Previously, his art was noticed frequently and, if not always favorably, at least solicitously and with the hope of correction. His Barbizon-inspired paintings were simply baffling; the critics were either silent or, when they broke their silence, wrote as in this account of Inness's "lamentable display" at the 1855 Academy exhibition:

> It is scarcely credible that an artist who is possessed of undoubted talents, and who has produced fine works, should so prostitute his ability as to paint like this. One of these pictures is a mass of green cheese dotted with sheep, (most people imagine these sheep to be cows); in the other, Mr. Innes has striven to give the effect immediately after a summer thunder-storm. He has made a conglomeration of soft tallow and an astonishing rainbow. Mr. Innes, pray leave off such freaks, and paint as we know you *can* paint. Thus to trifle with yourself and the public is more than foolish: it

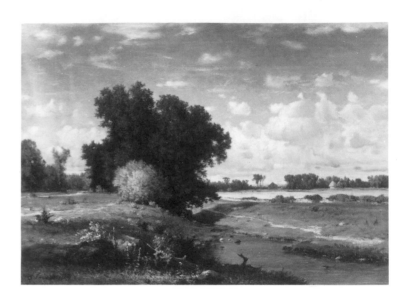

is criminal.[23]

Inness's paintings are now not just thought of as artificial and redolent of past art; they are considered illegible. According to his critics, he is not merely misguided; he has criminally transgressed the limits of public comprehension. The same pungently expressed annoyance with artistic license—the open tampering with the appearance of familiar things—would characterize the criticism of modern art some fifty years later.

"A man of unquestionable genius"

In 1860 Inness moved from New York to live in the village of Medfield, Massachusetts, beginning what would be, for about twenty years, a nomadic existence in this country and Europe. Inness moved to Medfield chiefly for his health, physical, psychological, and artistic. His physical health had always been uncertain, but it was so critical by 1860 that it became a matter of public concern.

> Our admiration for him has been constantly growing, and we do not fear to prognosticate for him—should he live a few years longer—no second place among American landscapists. Should he live! We write the words sadly; for alas! in this, as in so many other cases, the flame of genius burns in too slight a temple. A feeble frame, of the most sensitive nervous organization, compelled to intense and protracted labor by the fiery energy within, cannot be expected to hold out long. We trust that in saying this we do not sin against the sacred privacy of personal history.[24]

This nearly mortal illness was probably another episode in the struggle with poor health that plagued and disrupted all of Inness's life. Its particular seriousness may have been compounded psychologically by the accumulated trials and tribulations that Inness endured for much of the previous decade. Expulsion from Italy, constant economic uncertainty, the intensely stimulating influence of Barbizon art (with the troublesome, even troubling, revisions in his art that it caused) may have tried and broken his "sensitive nervous organization." Inness settled in Medfield mainly for his health. But he may also have done so because of its closeness to Boston, with the hope that his art might find there a more tolerant reception than it had for the past several years in New York.

About 1860, after several years of almost concerted neglect, people began to pay attention to Inness. They followed his whereabouts and were interested in his life, even "the sacred privacy of personal history," more than ever before. As the report of his illness suggests, he had also acquired a distinct public individuality: "sensitive," "nervous," and "intense." It was so clearly developed by 1867 that he epitomized

> perhaps more than any of our painters the popular idea of an artist. His slight form, his marked features, his sensitive mouth, his high cheek-bones, and sharp-cut prominent brow, which encases dark-brown eyes, now restless and now fixed . . . his long black hair, always in disorder, his ardent temperament and sensitive nature, his ignorance of the "savoir-faire" of life—all go to make up the artist.[25]

Before 1860 Inness was only a promising young artist. But in 1860 one writer thought it was "a matter of supreme wonder to us why this artist has not been given his place in the first rank of our landscape painters," and another asked "why popularity has been so long held back to consecrate a talent so remarkable."[26] Inness was now acclaimed as "a man of unquestionable genius."[27]

Fig. 8. George Inness. *Hackensack Meadows, Sunset,* 1859. Oil on canvas. 18 ¼ x 26 in. (46.4 x 66 cm). Ireland 162. Courtesy of The New-York Historical Society, New York City.

People began to admire the novelty and subtle suggestiveness of his art and to understand its motives. They began to see how distinctly different it was in subject, how much formal properties counted in its effect, and that it was more interpretive than descriptive. In 1860 a landscape by Inness was admired because it was not the usual kind, not "one of those striking, picturesque works, where mountains, waterfalls, cliffs, and other romantic objects take the fancy by a *coup d'état,* and may cover up much that is poor or false in the rendering."[28] In the same year, another writer said that Inness was "one of the finest and most poetical interpreters of Nature in her quiet moods among our landscape painters."[29]

All of this was not simply a matter of belated admiration and understanding. In 1860 Inness's art itself suddenly achieved a confidence it had not possessed (with certain significant exceptions) during the previous years of trial and experimentation. *Hackensack Meadows, Sunset* of 1859 (fig. 8), though wonderfully sensitive in coloration and atmospheric effect, is still uncertain and unconvincing in the construction of objects and space. But such paintings of 1860 as *A Passing Shower, Twilight,* and particularly *Clearing Up* (cat. nos. 6–8) are works of suddenly greater authority and conviction—masterful in their command of form, color, and pictorial order—with a seriously substantial beauty that none of his earlier works possessed.

The decade of the 1860s represents a new stage in Inness's development, during which his art achieved both a discernible individuality of style and a new dimension of content. Although the debt to Barbizon painting remained clear, Inness had shaped that decisive influence to his own tastes and feelings. "He follows no master," as one writer said in 1860, "but adopts his own methods of expressing his ideas."[30]

Inness was motivated by expressive responsibilities that he had never before felt so intensely. His "poetic genius [was] tyrannized over by his moods" and he was "overpowered at times by the glory and meaning of nature."[31] Some of this came naturally from maturity, from an emotional life ripened and deepened by age; *Clearing Up* is impressive not only because it is beautiful and technically assured but also because it is so weighted with mature feeling. Much of that feeling came from the emotionally excited, crisis-ridden temper of the war years. Inness was deeply aroused by the Civil War. He was "never more excited than when the news of the firing upon Sumter reached the village [Medfield], for he was not only a fervent American but an Abolitionist from his youth up."[32] Poor health prevented him from enlisting, but he participated in other ways. This incident was reported in 1862:

> George Inness has done the next thing to going, the quota of ten men for the town of Medfield, where he resides, not appearing, he called a meeting, rushed into town, obtained one hundred dollars, used up ten dollars' worth of cobalts, cadmiums and lakes in painting a placard, "Come to the meeting," "Rally," etc.; went to the meeting in time to make an eloquent speech, gave his one hundred dollars to the first man who put down his name; he then pitched into a lot of rich old fellows on the platform, because they did not offer bounties, whereupon they came down with the funds, and the quota was filled.[33]

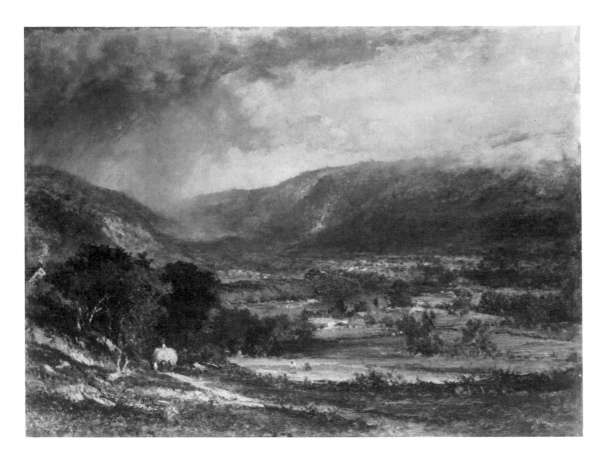

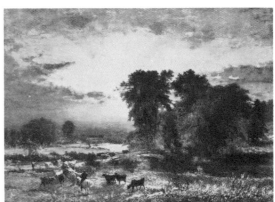

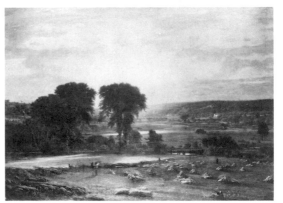

Fig. 9. George Inness. *Delaware Valley,* 1865. Oil on canvas. 22 x 30 in. (55.9 x 76.2 cm). Ireland 313. The Metropolitan Museum of Art, New York. Gift of Several Gentlemen, 1889.

Fig. 10. George Inness. *The Light Triumphant,* c. 1860–62. Oil on canvas. 26 x 36 in. (66 x 91.4 cm). Ireland 218. From George Inness, Jr., *Life, Art, and Letters of George Inness.* (New York, 1917), facing page 36. Present location unknown.

Fig. 11. George Inness. *Peace and Plenty,* 1865. Oil on canvas. 77 ⅝ x 112 ⅜ in. (197.2 x 285.4 cm). Ireland 311. The Metropolitan Museum of Art, New York. Gift of George A. Hearn, 1894.

Fig. 12. George Inness. *The Valley of the Shadow of Death,* 1867. Oil on canvas. 48 ⅝ x 72 ¾ in. (123.5 x 184.8 cm). Ireland 390. Vassar College Art Gallery, Poughkeepsie, New York. Gift of Charles M. Pratt.

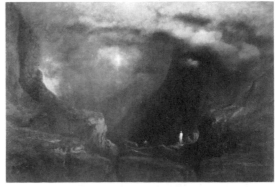

In 1863 Inness contributed to the war effort in another way. He completed a large allegorical landscape, at approximately six by eight feet the largest painting by far that he had ever made. He called it *The Sign of Promise,* and it was shown in special exhibitions in Boston and New York. (The painting itself no longer exists, but a contemporary description closely matches a painting now called *Delaware Valley* [fig. 9], which may either be a smaller version or a study.)[34] That *The Sign of Promise* was a symbolic, spiritually uplifting reference to the war is certain from the contemporary responses to it. One writer saw it as

> a comingling of vaporous clouds and azure sky, murmuring stream and quiet meadow, field and forest, hills and mountains, and over all the rainbow of hope, following the storm, gives glorious promise of peace and joy to come.[35]

Another felt that the painting

> has a moral in its subject and a moral in its treatment. It expresses hopefulness, the promise of good; it implies a divine purpose, in the fertilizing shower, the genial sunshine, the beautiful and fruitful valley, and in the combination of these in a grand union that is surely not unmeaning.[36]

When *The Sign of Promise* was exhibited at Snedicor's Gallery in New York in 1863, it was accompanied by a pamphlet (perhaps by Inness himself, though written in the third person) that announced the painting's exemplification of a kind of expressive landscape new to American art. "The prevailing tendency of American landscape painting," it said, had been for "what is *called* the real . . . that is to say, the local and particular."

> Mr. Inness, on the contrary, has long held the opinion that only the elements of the truly picturesque exist externally

in any local scene . . . and that the highest beauty and truest value of the landscape painting are in the sentiment and feeling which flow from the mind and heart of the artist.[37]

The pamphlet also reprinted and thereby endorsed an interpretation of the painting by the critic James Jackson Jarves. It is more explicit than the pamphlet's own text about what the painting "reveals [of] the aspirations and sentiments of the artist." For Jarves, *The Sign of Promise* was almost a manifesto, "a visible confession," of Inness's "theory, faith and aims."

> It develops the fact from the idea, giving the preference to subjective thought over the objective form of its fundamental *motive.* . . . His picture illustrates phases of mind and feelings. He uses nature's forms simply as language to express thought.[38]

An inclination to use nature rather than imitate it had been one of Inness's central artistic instincts from virtually the beginning of his career. But it was not until the 1860s that he made "a visible confession" of a theory that nature could be manipulated as a language to express the artist's thought and feeling.

The Sign of Promise is not unique among Inness's paintings of the 1860s. Few others were quite as large, but some were just as allegorical, as their titles indicate. Among them are *The Light Triumphant* of about 1860–62 and *Peace and Plenty* of 1865 (figs. 10 and 11). Most elaborate of all was a three-part series, The Triumph of the Cross, based on John Bunyan's *Pilgrim's Progress,* which he painted in 1867. Only one painting, *The Valley of the Shadow of Death* (fig. 12), survives; the others were *The Vision of Faith* and *The New Jerusalem.* Such unmistakably allegorical paintings are just special cases of a broad tendency in

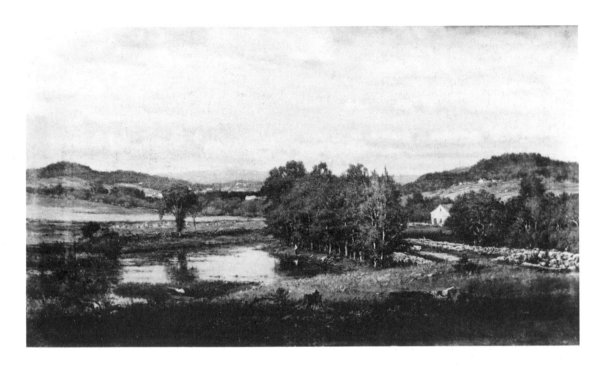

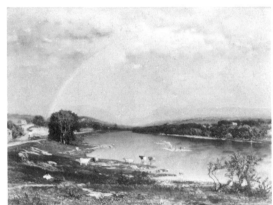

Fig. 13. George Inness. *Shades of Evening,* 1863. Oil on canvas. 15 ¼ x 26 ¼ in. (38.7 x 66.7 cm). Ireland 255. George Walter Vincent Smith Museum, Springfield, Massachusetts.

Fig. 14. George Inness. *Delaware Water Gap,* 1861. Oil on canvas. 36 x 50 ⅛ in. (91.4 x 127.3 cm). Ireland 232. The Metropolitan Museum of Art, New York. Morris K. Jessup Fund, 1932.

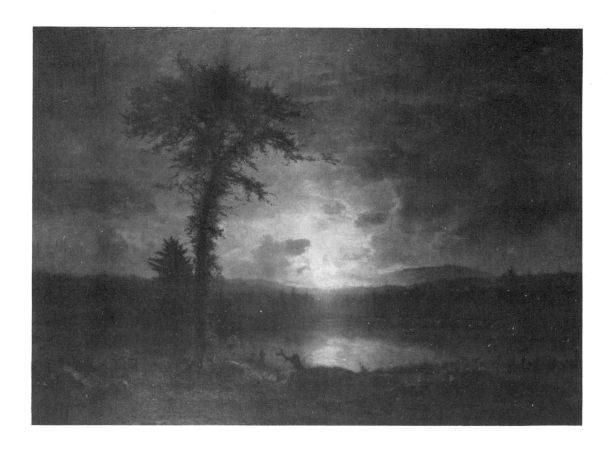

Fig. 15. George Inness. *The Close of Day,* 1863. Oil on canvas. 25 x 35 in. (63.5 x 88.9 cm). Ireland 250. Collection of the J. B. Speed Art Museum, Louisville, Kentucky.

Fig. 16. George Inness. *Cloudy Day,* 1868. Oil on canvas. 14 x 20 in. (35.6 x 50.8 cm). Ireland 429. Smith College Museum of Art, Northampton, Massachusetts. Gift of Mrs. John Stewart Dalrymple '10, May 17, 1960.

Inness's art of the 1860s—a "vague problem which his brush is . . . ever striving to express"[39]—to make symbolic paintings that "illustrate phases of mind and feelings" and use nature as a "language to express thought," as Jarves said. In painting after painting, by "seizing upon the critical moment in some marked phase of nature,"[40] nature is made articulate and immanent with meaning. Moods of calm are emphatically peaceful (cat. nos. 12 and 15, fig. 13). Bleakness is unmistakably harsh and cold (cat. no. 13). Rainbows are clearly portentious (cat. no. 10, fig. 14). And sunsets, the subject he depicted most often, are gloriously radiant (figs. 10 and 15); "so long as golden sunsets melting into darksome nights moved him the most strongly, he would paint little else."[41]

Inness's paintings of the 1860s did not depend for their meaning solely on symbolically articulate conditions of nature, nature in "her solemn and mystic moods."[42] Their meaning came equally from properties of artistic form, particularly a broadly suggestive, vigorously urgent, and expressively charged handling of pigment (figs. 10 and 16). Inness's "contemptuous rejection of the trivialities of detail, and . . . thorough mastery of broad, large effects" made it clear that he was "always painting with a purpose above that of a mere picture-maker."[43] It was the "rough" and "rugged" handling and "nervous force of execution" of his paintings of the 1860s,[44] the "great sprawling marks of the brush every which way all over the canvas,"[45] that enhanced and energized symbolic meaning through directly apprehensible evidence of personal feeling. "Surely, surely this man's hand must have been nervous and trembling with enthusiasm when he painted this work," said a reviewer of The Light Triumphant; "his pictures are wrought out with grand, hasty strokes of the

brush."[46] The expressiveness of his brushwork was now so evident and admired that another critic considered that same painting "a feat of pigments rather than a picture."[47]

Some of Inness's grandest allegorical paintings were inspired by the Civil War. Perhaps The Light Triumphant was; The Sign of Promise and Peace and Plenty surely were. The general symbolic and expressive tendency of Inness's art of the 1860s, however, was not caused by the war but by newly aroused and more clearly focused religious convictions. A religiously inspired belief that nature was, or could by art be made to be, spiritually articulate explains the form and the effect that many of Inness's landscapes of the 1860s assumed: the calligraphically legible condition of enthusiasm in which they were painted and especially the intensely glowing luminosity that was the natural artistic sign of divine immanence.

Religious convictions and experiences had always been a part of Inness's life and did not suddenly originate in the 1860s. He came by them familially and believed in them deeply. Although by his intensity he could give the impression of being a religious zealot, he was never, or not for long, interested in religious ritual. In the last year of his life, he said theology was "the only thing except art that interests me."[48] Theology and metaphysics fascinated him for the intellectual problems they posed and the field for speculation they provided, not as systems of belief. Inness was never, in any usual way, a religious painter. Religion was seldom conventionally expressed or obviously visible in his work. Yet there are few American artists for whom religion mattered as much or was so crucial. Its significance cannot be measured by the ardor or particular form of his belief but by its

essential (underlyingly effective) relationship to the form, content, and, ultimately, quality of his art. Inness first began to work out that relationship in the 1860s under the influence of two impressive personalities: Henry Ward Beecher and William Page.

Beecher, pastor of Plymouth Church, Brooklyn, was the most popular preacher and one of the most esteemed public figures of his time (until his fame was tarnished in the 1870s by charges of adultery with one of his parishioners). He had an active interest in art in the early 1860s, both as a collector and, in a manner of speaking, a theoretician. One of the artists he most admired was Inness. Beecher was "an early and habitual buyer" of his paintings.[49] He believed Inness was "the first of American painters" and "the best American painter of Nature in her moods of real human feeling."[50]

Given Beecher's admiration for Inness, it is likely that they were acquainted, probably most closely in the early 1860s when Beecher was acquiring Inness's work. If it was Beecher who named *The Light Triumphant,* that is one example of the kind of close relationship he had with artists he admired.[51] A clearer and more important example of that relationship is the advice he liked to give to those artists. He told the sculptor John Rogers in 1865 that a true artist "either purposely or unconsciously, employs forms & colors, to express some worthy thought or emotion & so allies art directly with the soul & makes it the tongue of the heart, and not merely the nurse of the senses."[52] Judging from Beecher's other utterances on art, the kind of advice he gave Rogers was typical of his artistic views and was surely the kind he also gave Inness. The nature of his advice—that art is

expressive, not imitative—suggests that Beecher may, to a considerable degree, have been responsible, not only for Inness's religiosity of the 1860s but also for "that fit of symbolic landscape"[53] that was its manifestation in his art. Certainly everything Beecher said in his writings about the divine meaning of nature ("he that reads nature reads God's language")[54] and the artist's responsibility to interpret it ("the artist employs forms, colors and symmetries to convey some sentiment or truth")[55] finds in Inness's art a virtually exact visible correlative. In *The Light Triumphant* and the numerous paintings of its kind that followed, Inness began, as the eloquently persuasive Beecher said the true artist should, to ally "art directly with the soul," to read God's language in nature, and to employ "forms, colors and symmetries to convey some sentiment or truth."

Contact with William Page, another persuasive personality, had an even greater effect, if a less immediately apparent one, on Inness's art and thought. In 1863 or early 1864 Inness left Medfield to settle at an estate called Eagleswood, near Perth Amboy, New Jersey, that had once been a utopian religious community known as the Raritan Bay Union. The Raritan Bay Union had been effectively disbanded by the time Inness and his family arrived at Eagleswood. But one of its founding members and guiding spirits, Marcus Spring, continued to live there, and in him something of its radical idealism survived into the 1860s. Such idealism may have appealed to Inness, who was religious and was said to have been an abolitionist. His later espousal of the theories of Henry George suggests the depth of his commitment to social betterment; John C. Van Dyke, who crossed to Europe with Inness in 1894, said "he was as positive as ever about religious, socialistic, and political convictions."[56]

In an effort to revive a spirit of communal intellectual enterprise, Spring invited a number of artists to live at Eagleswood, among whom the most prominent were Inness and William Page. Inness and Page may have known each other earlier; they lived in the same house in the Via Sant'Apollonia in Florence in 1851. At Eagleswood, in any event, they had a close, intense, and apparently quarrelsome relationship and finally parted on unfriendly terms. Page was, according to a contemporary critic, "a tyrannical and consistent theorist, who subjects all by his logic."[57] There is no question that Inness felt his intellectual and spiritual influence. Under its spell Inness became and would remain for the rest of his life a devoted follower of the teachings of the eighteenth-century Swedish scientist-turned-mystic, Emanuel Swedenborg. Inness's conversion to Swedenborgian beliefs was complete enough by 1867 (the year he left Eagleswood to return to New York) that a biographer could write: "In his religious faith he is a disciple of Swedenborg, and believes that all material objects in form and color have a spiritual significance and correspondence."[58] Whether that belief was immediately or successfully translated into art is another question. There are no certifiably Swedenborgian paintings. Inness's most overtly religious work at this time, The Triumph of the Cross series, was based on Bunyan. It is not at all certain that the spiritual significance that material objects and pictorial form and color undoubtedly possessed in Inness's art of the 1860s had a specifically Swedenborgian meaning, instead of a more generalized spiritual meaning for which Beecher was perhaps more responsible than Swedenborg. If it is true that at Eagleswood Inness "fell into the study of theology which for seven years was his only reading,"[59] then his understanding of

Swedenborg's thought was a complex process that could not have immediately assumed pictorial form or expressed itself as subject matter. That process of translation was a major effort, perhaps *the* major effort of the following decades.

"All the strength of his thought and the subtlety of his pigments"

By 1870 Inness was mature as a man (he was then forty-five) and as an artist. Maturity, however, brought neither settlement nor contentment. For much of the decade Inness continued to move restlessly from place to place, much as he had done before. In 1870 he began a four-year stay in Italy and France, which was followed by two years in Boston and two years in New York. Only in 1878, when he began to live in Montclair, New Jersey, did he at last find domestic stability.

During the 1870s Inness's art was as unsettled as his life. In contrast to earlier periods in which a single issue or intention predominated, he investigated, sometimes almost simultaneously, a variety of problems, both theoretical and stylistic. Discontent and self-criticism, inquisitiveness and curiosity, alertness and thoughtfulness, as well as the "unconquerable nervousness of his disposition,"[60] drove Inness to revise and reshape his art. He also maintained a deliberate openness to influences. "I [have] never completed my art and as I do not care about being a cake I shall remain dough subject to any impression which I am satisfied comes from the region of truth," Inness explained.[61] As a result, as someone wrote in expressing the exasperation of many of his contemporaries, "You do not

Fig. 17. George Inness. *Italian Landscape*, 1872(?). Oil on canvas. 26 ½ x 42 ¾ in. (67.3 x 108.6 cm). Ireland 559. Courtesy, Museum of Fine Arts, Boston. Bequest of Nathaniel T. Kidder.

know quite what to look for in Mr. Inness next."[62] Varied and often unequal as his work of the 1870s was, it nevertheless contained some of the most beautiful and powerfully moving paintings he ever made.

To give some, very arbitrary, order to the variety of Inness's paintings of the 1870s and to give them some schematic clarity, they may be arranged into four groups, which we may call commercial, aesthetic, expressive, and theoretical.

Inness went to Europe for the third time in April 1870. He settled in Rome (from which he had been unceremoniously expelled nearly twenty years earlier), where he was said to have lived in Claude's studio. He made a pilgrimage to Titian's birthplace in Pieve di Cadore. He also surely looked at other art, though we do not know what or how much. But this trip to Europe was fundamentally a business venture in which Williams & Everett, the Boston picture dealers, were to receive his European paintings in return for regular payments to him while he was abroad.

Williams & Everett had an interest not simply in the number but also in the kind of paintings that Inness produced in Italy, which explains the commercialization of Inness's style visible in many of them. A friend of Inness's who noticed in his Italian paintings "an undue attention to detail and ornateness" saw one aspect of Inness's commercial style as a polish and precision of handling different "from the breadth of his earlier manner."[63] This was clearly Inness's attempt to make popular and salable paintings; as he said later, "finish is what the picture-dealers cry for."[64] He

was also compelled, more than his own inclinations had ever led him to be, to make "pictures" depicting the life and popular scenic attractions of Italy. This accounts in large part for his travels to Tivoli, Perugia, Albano, Venice, and the Tyrol. *The Tiber below Perugia* of 1871 (cat. no. 18) is probably the kind of painting—with its more exactly detailed and finished style, colorful subject matter, and scenic scope—that Inness made for the popular market. If so, he did not allow the requirements of commerce totally to compromise his integrity or corrupt his ability, for he could still produce work of the finest quality.

In Italy a couple of years later, Inness made other commanding paintings that, while still redolent of Italian life and scenery, are in their great formal refinement and aesthetic sensibility quite the opposite of popular or picturesque. Of these aesthetic paintings, *The Monk* of 1873 (cat. no. 24) is perhaps the most impressive. Inness had always insisted, in words or by example, on the freedom to remake nature for his own purposes. Never before had he remade it so explicitly or with such sophistication. Never had natural forms been so overtly transformed into pictorial shape. Never had color been so arbitrarily unnatural. Never had pictorial design—parallelism and rectilinearity, compression of parts into a two-dimensional plane, and artfully asymmetrical disposition of compositional elements—been so manifestly aesthetic. And never had this been so manifestly the objective of painting. *The Monk* is not a singular case. In *Italian Landscape* of about 1872 (fig. 17), natural space and substance have been similarly flattened and stratified, and color has been pushed beyond descriptive truth. *In the Roman Campagna* of 1873 (cat. no. 20), despite its convincing illusion of deep atmospheric

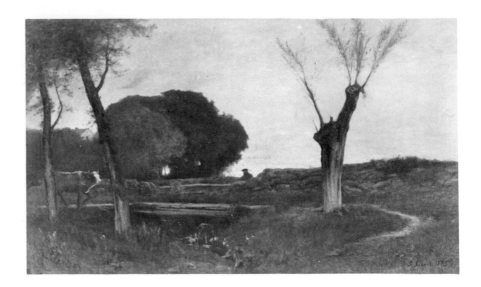

Fig. 18. George Inness. *Evening at Medfield, Massachusetts,* 1875. Oil on canvas. 38 x 63 ⅛ in. (96.5 x 160.3 cm). Ireland 709. The Metropolitan Museum of Art, New York. Gift of George A. Hearn, 1910.

space, is effective chiefly for the play of form—the tensions and balances and visual echoes of shape—that takes place on the two-dimensional picture plane.

Inness returned to America in 1875, where, perhaps to be close to the Boston dealers who at this time seemed to be his most effective agents, he lived in Medfield once again and kept a studio in Boston. A few paintings, like *Evening at Medfield* of 1875 (fig. 18), display the aesthetic formalism of *The Monk* and other of his Italian paintings. In the summer of 1875, which he spent in the White Mountains of New Hampshire painting with great intensity and almost serially, he began to make some of the most magnificently expressive landscapes he had ever done (cat. nos. 27, 28, 34, and 35). In them he does not, as he did for much of the 1860s (compare *Catskill Mountains* of 1870 [cat. no. 17]), find expressive meaning in the articulate conditions of nature, in its sudden bursts of spiritual revelation or "golden sunsets melting into darksome nights." Nor does the handling of paint betray the nervous agitation and emotional excitement of his works of that decade. These expressive paintings of the 1870s are more gravely moving; their colors, deeper and more reserved; their brushwork, more stately; and their forms, larger and simpler. As George P. Lathrop wrote, they are "conceived on a grand scale, and wrought in a massive manner," in contrast to the paintings of the 1860s, with their "roughness and vigor."[65] In them, too, a natural condition and an artistic effect—the activity of the brush and the movement of nature, the pigmentation of art and the colors of natural objects and effects—become one and the same. For the first time, though not for the last, one can see what Inness meant when he said, "My forms are at my finger tips as the alphabet is on the tongue of a schoolboy" or what his disciple Elliott Daingerfield meant when he said of Inness, "He himself was nature."[66]

In the late summer of 1875, it was reported that Inness "is understood to be engaged in writing a work of some kind upon art."[67] He had long had an appetite for philosophical speculation, and it was nourished during the 1860s by Beecher, Page, and the teachings of Swedenborg. But this is the first indication of Inness's serious and, to the extent that he committed it to paper, disciplined interest in art theory. Whatever he wrote has not survived (although, as we shall see, we may have some idea of what he was writing about). A few years later, however, his intellectual activity was embodied in two extensive and substantial public theoretical utterances: "A Painter on Painting" appeared in *Harper's New Monthly Magazine* in 1878 (see Appendix), and "Mr. Inness on Art-Matters" appeared in *The Art Journal* in 1879.

Inness's thoughtfulness in the 1870s is reflected not only in his published remarks but also in his art. Some of the paintings of this period are distinctly theoretical. For example, his use of color in the late 1870s was apparently determined by both artistic and religious beliefs. Color had always been an important formal and expressive part of Inness's art. In the late 1870s, just when Inness was most energetically and publicly thoughtful, his color became more visibly assertive and formally essential (e.g., cat. nos. 30 and 36). The very titles that Inness gave his paintings in the 1878 Academy exhibition—*The After Glow, The Morning Sun, The Rainbow*—declared the new prominence of color in

his work. His contemporaries noted it too. In 1878 they described him, as they had never done quite so categorically before, as "essentially a colorist, a luminarist" and "one of the very few painters we have who can be called colorists."[68] They were not entirely pleased with Inness's color, but their displeasure is as telling as their praise. Feeling that Inness sacrificed structure and form to color, they said his colors lacked self-restraint and his paintings had "a new touch of what looks like bumptiousness. They are violent instead of dignified, loud instead of deep in color."[69] A reviewer of the 1879 Academy exhibition said that Inness "explodes again in one of his landscapes."[70]

Inness himself spoke of the importance of color at this time in connection with a controversy that arose in 1878 over a suggestion by the painter John LaFarge that wood engravers be included among the artists representing the United States at the Paris Exposition in 1879. Inness disputed this equation of painters and wood engravers on several grounds; he argued that "the painter must be a colorist—the most difficult thing in the world. Every painter tries to be one, but how many of us succeed? No artist feels that he perfectly succeeds with his color—with that which is the soul of his painting."[71] Inness's defense of painting, of course, accounts for some of the stress he places on its distinctive attribute of color. That stress also stems from the centrality of color, "the soul of painting," in his own art and at the same time from the problematics of its use, "the most difficult thing in the world." Both, in turn, are reflected in the "bumptious" and explosively unrestrained colorism of his art of the late 1870s.

Some influential artistic experiences of the 1870s may also have stimulated Inness's interest in color. In Italy he renewed his acquaintance with the old masters with a special intimacy and intensity, especially with two who were particularly noted for their color: Claude and Titian. A correspondent reporting from Rome believed that Titian "greatly influenced him, as is plainly shown in the greater depth and richness of his coloring."[72] Inness himself thought he most resembled Titian, who, he believed, "stood at his elbow."[73] In 1874, the year of the first Impressionist exhibition, he was in Paris and may have had intimations of Impressionism. If so, nothing he had to say of Impressionism was ever complimentary; it was a "sham," "a mere passing fad," and he vehemently denied its influence.[74]

Also, perhaps Inness's colorism derived from the British landscape painter J. M. W. Turner. Contemporary critics repeatedly connected them. As early as 1862, a critic found "something Turneresque" in The Light Triumphant, and in 1879 another called Inness "the American Turner."[75] In 1878 the poetry Inness inscribed on the frames of his Academy pictures reminded two critics of Turner's well-known practice of accompanying his paintings with bits of his poem The Fallacies of Hope.[76] But Inness disavowed Turner as strenuously as he had Impressionism. Turner's Slave Ship, he said in 1878, was "the most infernal piece of clap-trap ever painted," and, using terms oddly like those applied to his own paintings at the time, said "it is not even a fine bouquet of color. The color is harsh, disagreeable, and discordant."[77]

It is possible that Inness may have wanted by the severity of his

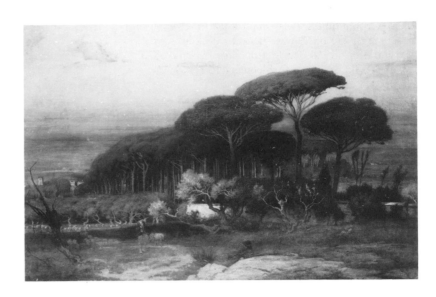

criticism of Impressionism and Turner to disguise his real debt to them. Given his lifelong attentiveness to other art, such influences cannot be discounted. Nevertheless, it is most likely that the conspicuous colorism of his paintings of the 1870s originated in theories, not in stylistic influences. An incident reported in the reminiscences of D. Maitland Armstrong (artist and onetime American consul in Rome, who knew Inness in Italy and America) very strongly suggests this. After saying that Inness was "much occupied with theories and methods of painting, and also of religion," Armstrong went on:

I once met him in the White Mountains [probably in the summer of 1875] and we spent several hours talking together, or rather he talked and I listened, about a theory he had of color intertwined in a most ingenious way with Swedenborgianism, in which he was a devout believer. Toward the latter part of the evening I became quite dizzy, and which was color and which religion I could not tell![78]

This account gives evidence that it was ideas—"theories and methods of painting" and Swedenborgian beliefs—not Titian, Turner, or Impressionism, that caused Inness to think so seriously about and work so openly with color in the late 1870s. It was mainly by color, apparently, that he was trying to translate Swedenborg into art. That was the question Inness explored in his talk with Armstrong and, in all likelihood, in the "work of some kind on art" he was said to be writing in 1875. Precisely how color and Swedenborgianism were at this point linked in Inness's thought and practice, it is unfortunately impossible to say.

Color was not the only conspicuous part of Inness's art of the 1870s. In 1875 a critic said of the large painting *Pine Grove of the*

Villa Barberini, Albano (fig. 19):

It seems to be but an attempt to fathom and reduce to rule the mysterious and infinitely-varying arrangement of the landscape . . .; it appears to be an illustration of the laws of harmony in landscape as resolved and applied by our understanding of things. There is little real nature in it. . . . Pictures, no less than poems, do not admit of construction by rules of logic and mathematics.[79]

The composition consists of a diagonal division of the painting into two nearly equal parts: earth and sky, solid and void, dark and light. The composition is so explicit and artificial that it seems to be determined more by theoretical ideas than by visual experience. Just at the time that Inness was painting *Pine Grove,* he was also explaining to Armstrong, and perhaps writing upon, the relationship between color and Swedenborg. It is therefore entirely possible that pictorial design or construction, plotted by "rules of logic and mathematics"—so emphatic in this case that it must, one feels, imply some larger meaning—may have held a similar theoretical significance for him. That is what the critic Charles De Kay, who could have known it from Inness himself, said a few years later: "Back of the landscape, in whose confection rules founded on logic that can be expressed in the mathematical terms have been strictly followed, lies the whole world of immaterial spirits, of whom Swedenborg was the latest prophet."[80]

"The very god of art"

During roughly the last ten years of Inness's life, critics spoke of his work with the most lavish praise and claimed that he was America's, even the world's, greatest landscape painter. To

Fig. 19. George Inness. *Pine Grove of the Villa Barberini, Albano*, 1876. Oil on canvas. 76 ⅞ x 118 ⅝ in. (195.3 x 301.3 cm). Ireland 786. The Metropolitan Museum of Art, New York. Gift of Lyman G. Bloomingdale, 1898.

some, he was simply the greatest painter. He also began at last, after years of financial hardship and uncertainty, to prosper from his art. This was due at least partly to the efforts of the collector and dealer Thomas B. Clarke, who, beginning probably in 1878, acted as Inness's agent, friend, and adviser; he purchased thirty-nine of Inness's paintings, including many of his greatest and now most famous ones (e.g., cat. nos. 33, 40, 41, and 52). By the 1880s, too, Inness had settled in the home at Montclair, New Jersey (which he first occupied in 1878), where he would live until his death.

Praise, prosperity, and settlement brought some contentment and comfort. They could not allay the poor health that plagued Inness with regularity during his last years, the dyspepsia and rheumatism for which he sought relief in travel to places like California, Nantucket, and Florida (where, at a house and studio at Tarpon Springs, he spent a considerable portion of his last years). Nor could they prevent periodic attacks of severe despondency. After his death it was reported that "while living at Montclair, New Jersey, he frequently gave way to fits of depression and melancholy, much to the alarm of his friends."[81] It was also reported that he even attempted suicide: "The late Mr. William Bradford...told the writer that a comrade found [Inness] once in his studio, slowly bleeding to death from an artery he had opened in his arm on one of those days when life seemed too dark to endure."[82] According to another report, Inness's final trip to Europe, where he died suddenly in 1894, was made to restore the "tranquility of his mind."[83]

If Inness's physical strength, never great, slackened in his later years, his artistic powers remained undiminished. They seemed, indeed, to grow ever greater, as his art acquired an assurance, resolution, and conviction that it had never before possessed so completely. If he was beset by depression and melancholy, his art did not show it. His late paintings have a tranquility of mood and a singleness, though not a sameness, of style that betray neither emotional disturbance nor artistic anxiety. As a group they have the composure of settled purposefulness. They are so far from reflecting any disintegration that their intellectual and formal elements are joined in harmonious and inseparable unity.

In the middle 1880s Inness began making the kinds of paintings upon which his greatest contemporary fame and future reputation rested. They were not new paintings. Everything in them, whether of form or content, he had used or considered earlier. Nothing new happened to Inness at this time. He did not see new things (as he did in France in the 1850s), did not have newly influential acquaintances (like Beecher and Page in the 1860s), and did not bring into his art a new formal element or, as he had with color in the late 1870s, give special emphasis to an already existing one. What did happen in the 1880s was a consolidation of his art's syntax, a synthesis of its chief visible and ideological parts. *Synthesis* is a term that was introduced into the critical discussion of Inness's art for the first time, significantly, in the early 1880s.

This change was internally mapped by thought and motivated by growth, not externally inspired. However, some aspects of Inness's experience during the late 1870s may have facilitated it and quickened its pace. At that time, he apparently had stimulating contact with younger artists. This contact was greater and more direct than someone of his age would otherwise have had

because his son, George Inness, Jr., also a painter, and son-in-law, Jonathan Scott Hartley, a sculptor, were their contemporaries. It may explain the juvenescence critics noticed in Inness's art: "The landscapes of no painter in the [1877 Academy] exhibition, young or old, are so luminous, so full of vitality. The artist has lost none of the force, and what is still more remarkable, none of the curiosity of youth."[84]

Invigoration was not the only benefit Inness received from the younger generation of artists. During the late 1870s, its members, most of them recently returned from foreign study, contemptuously swept aside the older guiding pieties of American art, such as nativism and the belief in the faithfully minute depiction of nature. Some of them believed instead, as it was summarized in 1881, "that art legitimately concerns itself only with the felicitous arrangement of color and line," that it "is decorative in its functions [and] its only prerogative is to please persons who are in sympathy with it by the exposition of lineal and chromatic beauty; and as such it is an end in itself."[85] Few younger artists were quite that extreme. Yet for most of them and those in sympathy with them, the notion of decorative integrity—the self-sufficiency of "lineal and chromatic beauty"—in some fundamental way penetrated and shaped their understanding and critical judgment.

Inness never regarded art as purely decorative or as an end in itself. He did believe, almost instinctively, that artistic form made definite aesthetic and expressive claims, which must in some way be visibly acknowledged. For a long time, almost no one else believed it, which often made Inness's artistic enter-prise a singular and lonely one. In the late 1870s the example of younger painters and their supporters suddenly made his aesthetic belief current, respectable, and a canon of advanced artistic thought. As a result, Inness's art became less out of place than it had once been. More art was like his in motivation, if not in appearance or subject. More people were both equipped and disposed to understand his paintings. Reviewing an exhibition of works by younger artists that also included paintings by such older, advanced artists as Inness, a critic noted that "in old Academy exhibitions these pictures would have looked strange and foreign. Here, they are quite at home, and . . . we can judge them fairly because we can compare them with works of their own kind."[86] That other art had caught up with Inness could only have confirmed the fundamental rightness of his artistic undertaking and given him a composure and assurance that his artistic surroundings had never provided before.

The exhibition of Inness's work held at the American Art Galleries in New York in 1884 may have contributed more concretely to this assurance. It was an unquestionably clear measure of the growing esteem for his art. By far the largest exhibition held during his lifetime, it contained fifty-seven paintings covering almost thirty years of his career. It was accompanied by a substantial catalogue that included up-to-date biographical information supplied by Inness, a selection of writings about him, and passages from the 1878 article "A Painter on Painting." All of this provided an extraordinarily comprehensive picture of Inness's life, thought, and artistic achievement. The exhibition was not a commercial success, but it and its attendant publicity made Inness familiar in a way that he had never been. It may

well have been responsible, as its organizer believed, for Inness's great fame in the last decade of his life. More importantly, it was for Inness himself an occasion, which few artists are given and fewer still could tolerate, to appraise his art after forty years of professional practice. By recapitulating what he had done before, it may have enabled him to see with unusual clarity what he could do better and do further. As an opportunity for self-assessment and as a summary that in effect closed one part of his artistic life, the 1884 exhibition may have been responsible for the change in Inness's art that followed shortly after it.

In 1886 a writer described that change, which just then began to assume its most visible form, as a "combination of philosophical thought and aesthetic discernment," a recognition of "the relations of subjective and objective," and a "fusing [of] all by a sort of religious fervor."[87] The three component parts of Inness's late, synthetic style were, in other words, a theory of art, pictorial form (which that theory described), and religious belief (which form contained and to which it was conformed).

In the 1870s Inness had explored several different artistic possibilities or modes of style. Some paintings were formal or aesthetic, consisting of pictorial designs so explicit—so artificial and literally on the surface—as to be almost abstract (cat. nos. 20 and 24). Others were expressive, consisting of stirring effects of coloration and solemnly charged movements of the brush, which recorded both nature's force and the artist's feelings (cat. nos. 28, 34, and 35). And some paintings were more objectively—occasionally, even picturesquely—descriptive (cat. no. 18). Beginning in the middle 1880s, Inness began to draw these different artistic possibilities together through a synthesis into a

single style, one that simultaneously acknowledged the claims of subjectivity (form and feeling) and objectivity (convincing descriptiveness).

October, painted in 1886 (cat. no. 46), is one of the clearest examples of the synthetic style that Inness developed in the middle 1880s. It is completely believable as nature. It has space and depth, atmosphere and substance, recognizable objects and familiar effects. Much of its beauty is the beauty of a natural condition accurately depicted. But much of its beauty and most of its visual intelligibility is formal, not natural. Inness did not see and then simply transcribe the virtually exact horizontal and vertical symmetries that structure the painting and order its parts; he did not see and transcribe the parallelism, subtly measured intervals, and carefully placed accents that play against and vary that structural order and each other. These structural elements come from aesthetic sensibility, visual thought, and requirements of art, not from observation.

October calls attention to itself as an object of art. The rectilinear system by which it has been ordered, in echoing the frame and implying a structural grid, acknowledges the picture's edges, its physical limits, and thereby its essential identity as an object. That identity is also made apparent because of its tendency to flatness, not the pure flatness of a decorated surface or an abstract design, but flatness as an ever-present reminder of the two-dimensional surface that is the primal condition of all painting.

There is no attempt to hide the fact that *October* is a painting made of pigment shaped by human agency, that, in a word, it

has been *painted*. To whatever degree it is synthetic in terms of structure, we can also always see that a hand and brush, animated by pleasure in the beauty of paint itself and the process of painting, have moved pigment on the surface of the canvas. In the movement of the brush, its pace and conviction, its rhythm and direction, we also sense the artist's feelings about what he is seeing and what he is making. We sense it with more immediacy, perhaps, than any single experience of a work of art usually allows.

Properties of nature, art, and human feeling concur in this painting of 1886 as they had never done before in Inness's art, each preserving its own purity yet with greater unity and wholeness of effect. That is what Inness's contemporaries noticed when, in the 1880s, they began describing his style as synthetic. *October* and other paintings like it are synthetic, not only by being more highly and indivisibly unified in structure but also by being invented or compounded from the immediate materials and conditions of art.

This synthesis (in both of its meanings and manifestations) may have been the result of the self-assurance and technical mastery that came with maturity; Inness was sixty-five in 1885. It may also have been the expression of the deepened and concentrated understanding permeated by a lifetime's experience—the special perception of the essential and disregard for the incidental and superficial—which marks the late style of the relatively few artists whose creative powers remain intact in their late years. Stylistic synthesis, however, was not simply a natural development of age. On the contrary, it was a condition of artistic

perfection that Inness foresaw and described in theory significantly before it made its appearance in practice.

Inness was not a theoretician in the usual understanding of the term. He was entirely too impulsive for sustained systematic thought and too explosive for orderly discourse. But as everyone who knew or knew of him was aware, few American artists were as thoughtful, as intellectually active, and few devoted as much energy to theoretical speculation. Inness wrote copiously (he mentioned writing "piles of manuscript" on a favorite subject),[88] but almost nothing of his theoretical writing has survived. He was also a voluble talker, but most of his talk went unrecorded. Beginning in the late 1870s, his thoughtfulness became a publicly prominent part of his artistic personality, displacing, though never completely replacing, the "ardent temperament and sensitive nature" that had largely characterized his public image in the previous decade. Critics sought him out and recorded his ideas and opinions, and it is chiefly from these interviews, "A Painter on Painting" and "Mr. Inness on Art-Matters," that Inness's theory of art can be distilled.

Unity, Inness said, was "the fundamental principle of all Art."[89] It was neither an aesthetic nor a visual effect, but a "great spiritual principle."[90] The chief peril to its wholeness and force was literal and painstaking descriptiveness, an insensitively mechanical or merely optical act that called undue attention to the things it described and to itself as a feat of technique. As he explained, "The [true] artist reproduces nature not as the brute sees it, but as an idea partaking more or less of the creative source from which it flows."[91] The chief way of reaching and reproducing

that idea, that creative source, was by a broad and spontaneous style: "You must suggest to me reality, you can never show me reality."[92] A painting produced by "spontaneous movement," that obeyed "the [spiritual] law of homogeneity or unity," possessed more true and essential reality than one made by "laborious efforts" at exactitude.[93]

Pictorial perfection was attained neither by inspired painterly acts nor by allusiveness. What counted was not the experiences of the painter, but the experience of the painting, not the painting's ability to hint at things beyond itself, but its own integrity and the compelling convincingness of what it itself contained. According to Inness, a painting clothed an idea "in a form fitted to material comprehension" and accommodated it to the senses.[94] As he put it, almost as a parable of what he conceived the true experience of a painting to be, "When John saw the vision of the Apocalypse, he *saw* it. He did not see emasculation, or weakness, or gaseous representation. He saw *things,* and those things represented an idea."[95] Pictorial unity was neither a simplified design nor a "gaseous" harmony of color and tone, but a concretely plausible and materially comprehensible condition of spiritual feeling: "Whatever is painted truly according to any idea of unity, possesses both the subjective sentiment— the poetry of nature—and the objective fact."[96]

What Inness described in his theory in the late 1870s—the fusion, with equal purity and equal weight, as a single and undifferentiated artistic experience, of subjectivity and objectivity, feeling and fact, suggestion and precision—he had not yet achieved in his art. That condition of artistic perfection, that complex and delicate balance of opposites that could unite (as Inness put it by citing well-known examples of style) "Meisonnier's careful reproduction of details with Corot's inspirational power," seemed to him so impossibly difficult to achieve—so far beyond his own powers, beyond the collective artistic accomplishment of his time, and beyond mere human attainment—that if a painter could realize it he would be "the very god of art."[97]

None of Inness's art before the 1880s exemplified the godlike powers he envisioned in theory. Even in the late 1870s, during what was his most seriously thoughtful period, his art did not look or perform as in theory he said it should. His work of that period is immensely beautiful and deeply moving. At times it seems to reflect directives of thought. It can be highly realistic or almost entirely invented. But it is never all those things at once. Only about the middle of the 1880s did it become so. That is when others, calling it synthesis, began to notice in his paintings what Inness, in his theoretical utterances of the 1870s, called unity. Paintings like *October* began visibly to assume characteristics Inness explored as ideas and described as theory before he was able to enact them as art. In the 1880s he first attained the powers that had seemed distantly godlike to him only a few years before.

The most essential part of his late synthetic style—the part, indeed, it was largely formulated to contain—was religion. After his conversion to Swedenborgianism in the 1860s, Inness's chief artistic purpose was to find artistic expression for his new belief. It was a formidable problem. There were no pictorial or

iconographic conventions of Swedenborgian art for him to draw upon. Swedenborg's writings did not tell how his doctrines might be given form as art. Artists as different as William Page, known as "the American Titian," the neoclassical sculptor Hiram Powers, and the Barbizon-inspired Inness were all Swedenborgians. Apparently, it was not Inness's intention to make specifically Swedenborgian art. Instead, more by infiltration than overt change, he endeavored to make his art, within its own terms, Swedenborgian. One looks in vain, therefore, for explicitly Swedenborgian subjects, symbolism, or iconography.

As Charles De Kay put it, Inness "does not express [his religion], but hides it, in his art."[98] Where did he hide it and how well? Landscape, since the beginning of his career virtually Inness's only subject, was one embodiment of religious meaning. "In the mind of Inness," De Kay wrote, "religion, landscape, and human nature mingle so thoroughly that there is no separating the several ideas."[99] To some extent, Inness regarded landscape pantheistically as "an expression . . . of the Godhead" immanent (or homogeneous) with divinity.[100] He characterized divinity variously as emotion, impression, idea, creative source, and the "subtle essence that exists in all things of the material world,"[101] and he implied that art conveyed it by suggestion and "spontaneous movement." To some extent, too, Inness must have believed in Swedenborgian correspondences; we have seen that as early as 1867 a biographer said that Inness held that "all material objects in form and color have a spiritual significance and correspondence." If so, he never showed any apparent interest in developing a language of symbols that might convey correspondent meanings.

There is reason to think that for Inness religion was not only inseparably joined to the perceived appearance and felt essence of landscape but that it also resided, was hidden, in its form and structure and, therefore, in the formal structure of the landscape paintings that depicted it. Inness told De Kay "how the symbolization of the Divine Trinity is reflected in the mathematical relations of perspective and aerial distance,"[102] that is, told of one way in which religion and natural pictorial structure were intimately linked. As we have seen, at about the same time that Inness described how color "intertwined" with Swedenborgianism, he also made at least one painting (fig. 19) that seemed constructed largely by "rules of logic and mathematics." As this implies, the pictorial form of his late paintings, of which color and construction are the main ingredients, can be understood as the embodiment of religious meaning. No other explanation of the peculiar traits of his late style works quite as well.

The subjects of Inness's late paintings seem perfectly natural and, without insisting on resemblance, reflect the places where they were made, such as Montclair, Florida, the Catskills. But particularly in the paintings he began making after about 1890 until his death in 1894, paintings that comprise as a group his highest level of sustained and concentrated artistic achievement (cat. nos. 52–63), one senses something more than the natural. What these paintings seem to depict is not so much discrete things—trees, field, figures, buildings—shown in particular configurations but something that subsumes or, in potentiality, contains them. It is something—neither matter, vapor, nor tonal key of color but all of them together—in which nominally solid

objects have the property of yielding softness and the nominally atmospheric has palpable and weighty substance. These paintings depict a medium—a common element or condition of things—from which, by the particular color and form that give them their identity, things have coalesced or been precipitated. Inness described unity, in theory, as the most perfect state of art. He achieved it most perfectly in his late paintings by that medium that holds and binds together everything in them. As idea, creative source, or "subtle essence," unity was, as Inness said, "a great spiritual principle." His late paintings, by their formal unity, are therefore the most fully and perfectly religious of his works.

Unity is not experienced as a vision, a "gaseous representation," as Inness put it disdainfully. As in Inness's interpretation of St. John's apocalyptic vision, unity is experienced as *things* actually *seen.* Those things do not appear in Inness's late paintings as illusions of physical reality nor do they merely depict optical effects, which is probably why Inness objected so strongly to being called an Impressionist. They do not operate according to the physical laws of nature: weight is suspended, time is slowed, sound is stilled, substance is softened, atmosphere is unbreathably substantial and thick with color. They do not, at the same time, operate unlawfully or implausibly. If anything, they are regulated by an order purer and more clearly discernible than that of the physical world. What Inness's late paintings contain—what they are as objective fact—is a world, more metaphysical than physical, in which metaphysical laws are expressed and tangibly embodied in art as rules of pictorial form. Metaphysics and aesthetics, religion and art, are one and the same. Pictorial design, color, and construction are the elements of metaphysical order; pictorial form is the means by which that higher order and higher beauty are "fitted to material comprehension." That is how and where Inness hid his religion in his art.

He hid religious meaning in artistic form not to be private or allusive, but because, with his modern sensibility, that was the only way he could make religious art. De Kay understood that. Discussing the relation of Inness's religion to his art, he said that in contrast to an artist like William Holman Hunt who, in *The Shadow of the Cross,* "seeks to return to the simplicity of the Van Eycks in treating religious questions,"[103] Inness treated those questions both by using the modern subject of landscape and the way he painted. "Does he try to express religion? We should say no. It is rather the methods by which he does [his paintings] that are governed in his own mind by religious ideas." And that, as De Kay concluded, is "modern to the last degree."[104]

Purely as sensibility or understanding, Inness's modernity might have taken many other visible aspects than the one it assumed in his late paintings. It appeared as it did largely because of the influence of Swedenborg. By the time he began making his late paintings, Inness had been a serious student of Swedenborg for about twenty years. He naturally studied Swedenborg's writings for doctrine. But what made those writings so compellingly attractive was Swedenborg's description of the afterlife. Swedenborg claimed to have had actual experiences of the other world and its spiritual and angelic inhabitants. As a result, his descriptions of that world have the impressiveness and precision

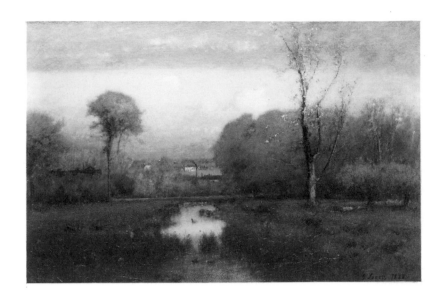

Fig. 20. George Inness. *Autumn Gold,* 1888. Oil on canvas. 30 x 45 in. (76.2 x 114.3 cm). Ireland 1284. Wadsworth Atheneum, Hartford, Connecticut. Henry and Walter Keney Fund.

Fig. 21. George Inness. *After a Spring Shower, Montclair,* 1893. Oil on canvas. 40 1/8 x 54 5/16 in. (101.9 x 138 cm). Ireland 1465. The Toledo Museum of Art, Ohio. Gift of Florence Scott Libbey.

of eyewitness accounts. Unlike the conventional image of heaven, the world he described was not "an indefinite somewhere."[105] Its topography, botany, and zoology were like those in the natural, material world. It was a world in which spirits and angels "like men in the natural world live together in spaces and times" and in which things are visible in light and shade.[106] The difference is that in the spiritual world matter is substance, space is appearance, and neither substance nor appearance is hard or fixed, settled in form or place. And the "splendor and refulgence" of coloration of the spiritual world is incomparably greater than that of the natural world.[107]

This very abbreviated description of Swedenborg's account of the spiritual world indicates how it might have shaped Inness's visual imagination and artistic understanding. To give pictorial form to the world Swedenborg described, one in which mundane experiences and spiritual essence were fused, Inness developed (first in theory and then as art) a mechanism of style capable of synthesizing such polarities and expressing them, plausibly and palpably, as one. Swedenborg's image of the spiritual world as the thoroughly believable and familiar counterpart, in terms of substance and appearance, of the material world has its pictorial counterpart in Inness's late paintings. They, too, are believable and familiar, sometimes so currently familiar that they contain such things as factory chimneys (figs. 20 and 21). At the same time, they have the yielding softness, apparent space, placement, and refulgent coloration (within the limits of pigments) that are, in Swedenborgian terms, the properties of spirit, not of matter.

Inness's late paintings are not simply illustrations of Swedenborg's account of the spiritual world. They are rescued from that, just as they are rescued from being illusions of the natural world, by Inness's modernist candor, the visible admission, as the French painter Maurice Denis put it in 1890, that "a picture—before being a battle horse, a nude woman, or some anecdote—is essentially a plane surface covered with colors assembled in a certain order."[108] The candor of the late paintings is so great—artistic identity so clear, formal authority and sheer beauty so self-sufficient—that it is possible to admire them, as did most of his contemporaries, without knowing or caring about his religion. But regardless of how well and with what deliberation Inness's religion was hidden, it is ultimately its presence—experienced as profundity, complexity, and conviction, as "his sincerity, his faith, his earnestness...which escapes like a perfume from his works,"[109] rather than as specific subject matter—that makes Inness's late paintings different from, by being better than, the myriad contemporary paintings that seem to resemble them. For in the final analysis, religion is expressed as artistic quality.

"Modern among the moderns"

The relationship of Inness's art to the works of other artists and other times had been perfectly clear to his contemporaries. His affiliations with the old masters and the Barbizon painters had been patent evidence of both his formalism and modernism. Almost as a polemic of his artistic purpose, they had been part of the content of his art. By about 1890, as part of his late stylis-

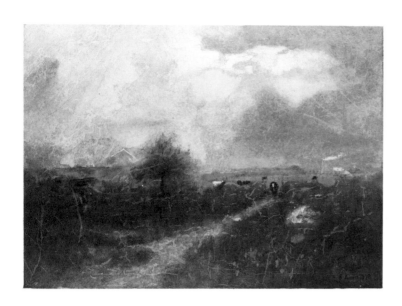

tic synthesis, Inness had absorbed and individualized his sources so completely that his work was visibly more original than derivative. It was said that there was no artist "whose vision has been more entirely unobstructed by continental dogmas" than Inness and that he "certainly represents no school but his own."[110] The relationship of Inness to his sources had shifted from one of dependency (in varying degrees) to one of complete originality.

About 1890, because of the relentless pressure of his modernist impulses, Inness produced not merely an individual variant but a new state of Barbizon style, a "post-Barbizon" style of quite different formal and expressive dimensions. There is no counterpart in Barbizon art itself for Inness paintings of the 1890s. No Barbizon paintings are as explicitly formal, and none is as allusively subtle or intricate in meaning. There is none in which meaning and beauty reside so openly in art rather than in nature and in which the configuration and coloration of nature are made to conform so arbitrarily to the designs (in both purpose and pattern) of art. Maurice Denis's test of modern pictorial integrity, that no matter what a painting depicted or contained it was "a plane surface covered with colors assembled in a certain order," was one that no Barbizon painting could pass. All of Inness's post-Barbizon paintings could pass that test. Perhaps that is what one of Inness's astutest critics was thinking of when in writing on the progress of art in New York in 1893, he wrote that Inness remained "modern among the moderns."[111]

If we are not prepared to see that today, it is precisely because the essential stylistic medium of Inness's modernism, as for other nineteenth-century American artists of similarly modern

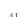

instincts and ambitions (most notably Albert Pinkham Ryder), was Barbizon art. The contemporary counterpart of their modernism in France was Post-Impressionism. We have no difficulty recognizing the latter's modernity because it is conveyed, as the designation implies, in the more historically advanced language of Impressionism. The clearest and most advanced form of modernism in America (until American artists began imitating Picasso and Matisse in the first decade of the twentieth century) used the language of Barbizon style. If there seems to be no phenomenon in America that corresponds in time or accomplishment to French Post-Impressionism, that is because those impulses in America took a different form, that of a post-Barbizon style. Post-Impressionism, after all, was not merely a matter of style—Seurat's pointillist dots, Gauguin's colorful Synthetist decoration, Van Gogh's urgently furrowed brushwork, Cézanne's solid geometry—or of a concern for patterned and visibly painted surface (which is the sign of aestheticism or Whistlerism). Instead, Post-Impressionism consisted essentially of the belief, developed in the course of the nineteenth century but in which no earlier artists had the same determined confidence, that the formal means and physical materials of art—color, shape, volume, space, design, construction, surface texture—could represent beauty and meaning without representing reality. In America, no less than in France, this belief motivated the most advanced accomplishments of painting in the late nineteenth century. Inness understood it just as well and as confidently as any of the French artists did. Within the terms of that modernist principle, he made an art as modern as theirs, and he made it at the same time. It is in that larger sense that he was indeed modern among the moderns.

Notes

[1] "A Painter on Painting," *Harper's New Monthly Magazine* 56 (February 1878): 461.

[2] Cropsey to John P. Ridner, 24 August 1845, Boston Public Library.

[3] David C. Huntington, *The Landscapes of Frederic Edwin Church: Vision of an American Era* (New York, 1966), 112.

[4] "Some Living American Painters. Critical Conversations by Howe and Torrey," *Art Interchange* 32 (April 1894): 102.

[5] Inness to Ripley Hitchcock, 23 March 1884, Montclair Art Museum, Montclair, New Jersey.

[6] Ibid.

[7] "Art Gossip. Departure of George Inness for Europe," *New York Evening Mail,* 31 March 1870.

[8] *The Literary World* 1 (15 May 1847): 304.

[9] *The Literary World* 3 (27 May 1848): 328.

[10] There is no evidence of an 1847 trip that is a fixture of Inness chronologies. Passport applications (for the knowledge of which the author is grateful to the ingenuity and kindness of Merl M. Moore, Jr.) make it clear that the end of February 1851 is when Inness first went abroad.

[11] *New York Evening Mail,* 31 March 1870.

[12] *New York Times,* 15 May 1852.

[13] *Boston Transcript,* 15 June 1852. Merl M. Moore, Jr. supplied this reference.

[14] *New York Tribune,* 1 May 1852.

[15] *The Literary World* 10 (8 May 1852): 332.

[16] "A Painter on Painting," 461.

[17] *The Literary World* 1 (15 May 1847): 348.

[18] Ibid.

[19] Reginald C. Coxe, "George Inness," *Scribner's Monthly* 44 (October 1908): 511.

[20] See author's entry for *The Sun Shower* and *Morning, Catskill Valley* in *The Preston Morton Collection of American Art* (Santa Barbara Museum of Art, 1981), 114–16.

[21] The author is grateful to H. Nichols B. Clark for kindly telling him of the appearance of Inness's name in the visitor's register of the Rijksmuseum on 19 July 1854.

[22] Montgomery Schuyler, "George Inness: The Man and His Work," *Forum* 18 (November 1894): 305.

[23] *The Knickerbocker Magazine* 45 (May 1855): 533.

[24] Mrs. Conant, "George Innis," *The Independent,* 27 December 1860.

[25] "American Artists: George Inness," *Harper's Weekly* 11 (13 July 1867): 433.

[26] *New York World,* 26 September 1860; *New York Evening Post,* 25 May 1860.

[27] *New York Tribune,* 29 September 1860.

[28] Conant, "George Innis."

[29] *New York Tribune,* 29 September 1860.

[30] Ibid.

[31] George P. Lathrop, "Art," *Atlantic Monthly* 31 (January 1873): 115; *New York Commercial Advertiser,* 22 May 1862.

[32] Schuyler, "George Inness," 307.

[33] *New York Evening Post,* 19 August 1862.

[34] Doreen Burke noticed (and will soon publish) the resemblance of *Delaware Valley* to a description of *The Sign of Promise* that appeared in the *New York Evening Post,* 3 March 1863; an "original study" was shown in June 1863 (*New York Evening Post,* 2 June 1863).

[35] *New York Evening Post,* 20 November 1863.

[36] *New York Evening Post,* 3 March 1863.

[37] *The Sign of Promise* (New York, 1863), unpaged.

[38] Ibid.

[39] Lathrop, "Art," 115.

[40] *New York Evening Post,* 8 August 1865.

[41] Lathrop, "Art," 115.

[42] *Frank Leslie's Illustrated Newspaper,* 21 December 1867.

[43] *New York World,* 26 April 1862; *New York Evening Post,* 30 March 1866.

[44] "Art Gossip," *Cosmopolitan Art Journal* 4 (December 1860): 183; *New York Commercial Advertiser,* 22 May 1862; *New York Evening Post,* 30 March 1866.

[45] H., "When is an Artist True to Himself?," *Boston Transcript,* 19 February 1862.

[46] *New York Commercial Advertiser,* 22 May 1862.

[47] "The Lounger. The National Academy—No. II," *Harper's Weekly* 6 (10 May 1862): 290.

[48] "His Art His Religion," *New York Herald,* 12 August 1894.

[49] Montgomery Schuyler, Inness obituary, *Harper's Weekly* 38 (11 August 1894): 787.

[50] Ibid.; Henry Ward Beecher, "Introductory Letter," in Charles Dudley Warner, *My Summer in a Garden* (Boston, 1870), 3.

[51] George Inness, Jr., *Life, Art, and Letters of George Inness* (New York, 1917), 245.

[52] David H. Wallace, *John Rogers, The People's Sculptor* (Middletown, Conn., 1967), 135.

[53] Lathrop, "Art," 115.

54 Henry Ward Beecher, *Eyes and Ears* (Boston, 1862), 35.

55 Ibid., 226–27.

56 John C. Van Dyke, *American Painting and Its Traditions* (New York, 1919), 39–40.

57 *New York Evening Post*, 12 May 1865.

58 "American Artists: George Inness," *Harper's Weekly* 11 (13 July 1867): 433.

59 George W. Sheldon, *American Painters* (New York, 1879), 30.

60 "American Painters—George Inness," *The Art Journal*, n.s., 2 (1876): 84.

61 Inness to Hitchcock.

62 Lathrop, "Art," 115.

63 Stanwood Cobb, "Reminiscences of George Inness by Darius Cobb," *Art Quarterly* 26 (Summer 1963): 236.

64 "A Painter on Painting," 461.

65 Lathrop, "Art," 114–15.

66 George Calvert, "George Inness: Painter and Personality," *Bulletin of the Art Association of Indianapolis, Indiana. The John Herron Art Institute* 12 (November 1926): 49; Elliott Daingerfield, "George Inness," *The Century* 95 (1917): 71.

67 *Boston Transcript*, 7 September 1875.

68 *The Independent*, 25 April 1878; *New York Times*, 10 April 1878.

69 *New York Times*, 10 April 1878.

70 *New York Tribune*, 1 April 1879.

71 *New York Evening Post*, 21 March 1878.

72 H.D.S., "American Artists at Rome," *Boston Transcript*, 28 January 1874.

73 Elliott Daingerfield, Introduction in Inness, Jr., *George Inness*, xx.

74 *New York Herald*, 22 August 1894.

75 *New York World*, 26 April 1862; *New York Tribune*, 7 December 1879.

76 *New York Times*, 10 April 1878; *The Nation* 26 (30 May 1878): 364.

77 "A Painter on Painting," 459.

78 D. Maitland Armstrong, *Day Before Yesterday. Reminiscences of a Varied Life* (New York, 1920), 199.

79 *Boston Advertiser*, 14 September 1875.

80 Charles De Kay (Henry Eckford, pseud.), "George Inness," *The Century* 24 (May 1882): 63.

81 *New York Tribune*, 20 August 1894.

82 *The Independent*, 30 August 1894.

83 *New York Times*, 19 August 1894.

84 *The Century* 14 (June 1877): 264.

85 *New York Evening Post*, 2 April 1881.

86 *New York Tribune*, 30 March 1878.

87 *Boston Transcript*, 22 April 1886.

88 *New York Herald*, 12 August 1894.

89 "Mr. Inness on Art-Matters," *The Art Journal*, n.s., 5 (1879): 376.

90 Ibid.

91 George W. Sheldon, "George Inness," *Harper's Weekly* 26 (22 April 1882): 244.

92 "Mr. Inness on Art-Matters," 374.

93 "A Painter on Painting," 461.

94 Inness, Jr., *George Inness*, 64.

95 "Mr. Inness on Art-Matters," 377.

96 Inness to Hitchcock.

97 "A Painter on Painting," 458.

98 De Kay, "George Inness," 63.

99 Ibid.

100 Ibid.

101 "Mr. Inness on Art-Matters," 376.

102 De Kay, "George Inness," 63.

103 Ibid.

104 Ibid.

105 Emanuel Swedenborg, *The True Christian Religion, Containing the Universal Theology of the New Church*, 2 vols. (New York, 1952), par. 29.

106 Ibid.

107 Emanuel Swedenborg, *Arcana Coelestia*, 12 vols. (New York, 1905–10), par. 4530.

108 Maurice Denis, "Definition of Neo-Traditionalism," translated in *From the Classicists to the Impressionists: A Documentary History of Art and Architecture in the Nineteenth Century*, Elizabeth Holt, ed. (New York, 1966), 509.

109 George W. Sheldon, "Characteristics of George Inness," *The Century* 27 (February 1895): 533.

110 *New York Commercial Advertiser*, 14 March 1890; *New York Tribune*, 10 January 1890.

111 George P. Lathrop, "The Progress of Art in New York," *Harper's Monthly* 86 (1893): 86.

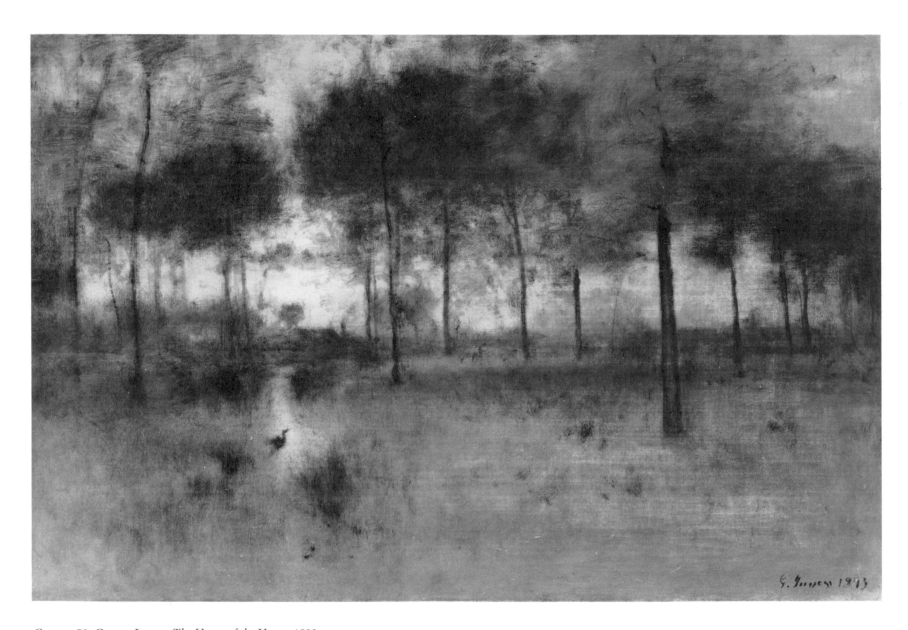

Cat. no. 59. George Inness. *The Home of the Heron*, 1893.

The Late Style in Context *by Michael Quick*

During the last ten years of his life, George Inness worked in a new and markedly different style. Because it is a style characterized by bold design, simplicity, and new freedom in paint handling, it can be seen as the logical culmination of a lifetime of thoughtful work by a great artist. One is tempted to liken it to the glorious late styles of Titian, Rembrandt, Rubens, and Turner. Years of experience gave Inness, as it gave these artists, both the ability to concentrate on essentials and the complete technical mastery that underlay artistic freedom. All surpassed themselves with late works that were the most beautiful and most moving they produced.

It is especially easy to see Inness's late style as entirely personal and idiosyncratic because he was a loner most of his career. He had fit no niche before. He had lived most of his professional life in the country, in relative isolation from artists' groups. Because he had been that much his own man all along, it is reasonable to think that in his final period of creativity he would have achieved complete independence.

I would like to propose, however, that Inness's late style, while very much his own, fits into the American art trends of the 1890s more closely than his style had at almost any time before. One reason for this situation was simply that by 1880 the rapidly advancing American art world had caught up to some of the advanced theoretical positions that had shaped Inness's art earlier. By the time of Inness's major retrospective exhibition in 1884, critics were looking at his paintings in the same spirit in which Inness had created them. Another explanation may have been the contact with a younger generation of artists that Inness received through his son, the artist George Inness, Jr.: "The

younger men were returning from abroad. New ideas and new men had sprung up around him, and there were plenty of fellow-artists for Pop to worry and delight."[1] Among them were young landscape artists who rose to prominence during Inness's final years and always remained in his shadow, such as Dwight Tryon, J. Francis Murphy, and Henry Ward Ranger.

Comparing Inness's late works with the work of other artists of the 1880s and 1890s is, therefore, more useful than an equivalent comparison at almost any other point in Inness's career. First of all, it provides information about attitudes toward art during the period, which can offer additional means of access to Inness's paintings. Learning how the period understood certain types of subject matter, for instance, can indicate levels of meaning not obvious today. Second, comparison with progressive American landscape painters of the period points up shared elements of style, indicating that Inness's late style is not simply idiosyncratic. It is clear that certain features of style were so much in the air that they represent influences upon Inness, rather than either his independent developments, on the one hand, or his influence upon the emerging generation, on the other hand.

It is certainly yet another measure of Inness's greatness that, even at an advanced age, sure of his craft and artistic point of view, he was still alert to stylistic developments around him and ready to explore the artistic issues they expressed. All through his career, he had drawn upon current styles and themes from among an apparently wide range of sources that have yet to be fully identified. He was a restlessly experimental artist whose work is infinitely varied; often one brief stylistic phase con-

trasted sharply with the next. Among American artists, perhaps only John LaFarge showed such diversity.

Even during the 1850s and 1860s, Inness had worked in a tenuous relationship with contemporary art and artists. His highly detailed, brightly lighted landscapes of the middle 1850s, with their bluish shadows (e.g., *The Juniata River* [cat. no. 3]), appear to reflect the English Pre-Raphaelite movement, which also influenced the work of many Hudson River School artists in the late 1850s and the 1860s. And Inness's sunsets of the early 1860s (cat. no. 8) are a subject he shared with many of these American artists. However, in both these cases of parallels between his work and that of Hudson River School artists, Inness's paintings are fundamentally different in character: their brushwork is more energetic, their dimness more mysterious. During this early period, Inness utilized various aspects of the reigning realist style, but he always did so in an expressive manner essentially foreign to its basic nature. During his late period, in contrast, his variations on contemporary styles were more compatible with the general style and taste of that era and, therefore, better understood.

Inness met with little commercial success until late in life. Even full membership in the National Academy of Design was withheld from him until 1868, long after most of his generation had received theirs. Because he was painting differently from the reigning landscape school during the 1850s and 1860s, his peers and his public concluded that he was painting poorly. They had a clear idea of what a successful painting should look like, a paradigm that Inness's work did not fit.

Even today, Inness continues to suffer in general esteem because he did not choose to paint as his contemporaries did. The 1960s saw the rediscovery of the Hudson River School by scholars, followed quickly, in the late 1960s and early 1970s, by museums and collectors. The attendant research, analysis, and focused collections have clarified the taste and practice of the Hudson River School period to a high degree. Any interested person can now learn the qualities that define a good Hudson River School landscape, such as tight brushwork, clarity, and a high degree of realism. He can train his taste to follow that of a century ago. Unfortunately, in doing so, he might learn to consider Inness an inferior artist, possibly even to dislike his work.

To understand the taste against which Inness continues to be disadvantageously judged, Frederic E. Church's *Niagara Falls* of 1857 (fig. 22), one of the greatest paintings of the time, might be taken to epitomize the art of the Hudson River School period. This large painting was an attempt to bring to city audiences the spectacle of the great natural wonder. For paying crowds in London, New York, and many other American cities, it captured the majesty and awesome power of nature. The painting was a sensation. Its realism was so complete and so pervasive that viewers felt that they had seen the real thing; they claimed that they almost felt the cold mist and heard the thunder of the falls. The artistic miracle was twofold: Church had captured and recreated the immensity and dramatic power of the falls, while also recording apparently every detail that the eye could see in the original. In turn, the very precision of detail enhanced both the vividness and the sense of immense scale of the whole.

Fig. 22. Frederic Edwin Church (United States, 1826–1900). *Niagara Falls,* 1857. Oil on canvas. In the collection of The Corcoran Gallery of Art, Washington, D.C. Museum Purchase.

Fig. 23. Aaron Draper Shattuck (United States, 1832–1928). *Leaf Study with Yellow Swallow Tail,* c. 1859. Oil on canvas. 18 x 13 in. (45.7 x 33 cm), arched top. Collection of Jo Ann and Julian Ganz, Jr.

Closer inspection determined that it was not only specific detail but also scientifically accurate detail. Assuming the role of naturalist, Church had studied the hydrodynamics of the eddies in the foreground with precision, a precision probably inspired by John Ruskin's praise of J. M. W. Turner's similar precision in certain early marines.

Ruskin was the most influential critic of the Anglo-American world during the 1850s and 1860s, a powerful force encouraging and sharpening the Victorian period's taste for a photographic realism. At times in tones of religious fervor, he urged artists to approach nature with the pious humility of the painters of the late Gothic period, such as Jan van Eyck, whose Ghent Altarpiece contains minute studies of common weeds and grasses. American participants in what became known as the Pre-Raphaelite movement, such as Aaron Draper Shattuck (fig. 23), filled the foregrounds of their paintings with a tangle of finely painted blades, leaves, and flowers. Such details can sometimes dominate a landscape or even constitute its chief subject.

Another way of looking at this development is that Ruskin justified the Victorian period's fascination with the new vision of reality it encountered in photography. It expected its painters to record a similarly unedited slice of reality. The landscape artist's role, in the 1860s, was to pack into his canvas as complete an illusion as he could. He was offering the purchaser a persuasive facsimile, accurate and fully detailed.

This view of the artist as craftsman and miniaturist, his personal reactions subservient to a fastidious fidelity, was one that Inness

utterly rejected. He specifically repudiated and "fought Pre-Raphaelitism,"[2] finding himself, during the 1880s, among a growing consensus that turned away from and then against the style. One would search his mature works in vain for the kind of detailed painting then generally characterized as niggling. Inness's own renditions of Niagara (fig. 24) depict the cataract in terms of shimmering veils of iridescent color. Some of his views of the waterfall are among his most abstract and delicately nuanced paintings. The major landmarks are barely suggested, let alone detailed, as in Church's great painting. Clearly, Inness's aim is different; his approach and technique differ accordingly.

The landscape aesthetic of the late nineteenth century neither required nor encompassed only the delicate and ethereal. William Morris Hunt in 1878 had responded to the experience of Niagara Falls with paintings (fig. 25) every bit as thunderously powerful as Church's masterpiece. His strong value contrasts, rich color, and active paint textures convey an unforgettable impression of natural force married to beauty. What essential quality do these quite different landscapes by Inness and Hunt share? What essential attitude unites the late nineteenth century's extremes of expression in landscape painting and the spectrum of approaches in between?

The essential, unifying element is the inescapably central role of the artist as interpreter. When asked the objective of art, Inness replied:

> Simply to reproduce in other minds the impression which a scene has made upon him [the artist]. A work of art does not appeal to the intellect. It does not appeal to the moral sense. Its aim is not to instruct, not to edify, but to awaken

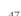

48

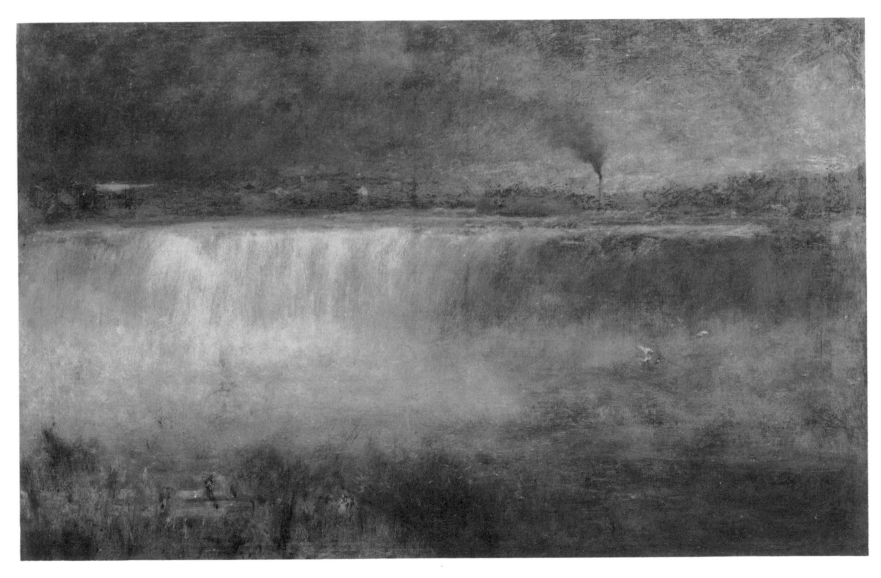

Fig. 24. George Inness. *Niagara,* 1889. Oil on canvas. 30 x
45 in. (76.2 x 114.3 cm). Ireland 1296. National Museum of
American Art, Smithsonian Institution, Washington, D.C.
Gift of William T. Evans.

Fig. 25. William Morris Hunt (United States, 1824–1879). *American Falls,* 1878. Oil on canvas. 30 x 41 ¼ in. (76.2 x 104.8 cm). In the collection of The Corcoran Gallery of Art, Washington, D.C. Gift of Cecil D. Kaufman.

an emotion. This emotion may be one of love, of pity, of veneration, of hate, of pleasure, or of pain; it must be a single emotion, if the work has unity, as every such work should have, and the true beauty of the work consists in the beauty of the sentiment or emotion which it inspires. Its real greatness consists in the quality and the force of this emotion.[3]

The artist's subjective experience of nature and his ability to communicate the emotions that nature evokes are now the whole point of landscape painting. No longer a diligent drudge of a craftsman doomed to lose, against the photograph, the contest of producing an, in any case, inferior facsimile of reality, the artist was now expected to be a poet who felt the mysterious beauty that an objectively recording camera could never see. Many changes in subject matter and approach naturally followed from this fundamental reorientation.

The group of French landscape artists known as the Barbizon School was probably the most important single influence toward this reorientation in American landscape painting, and some of the Barbizon School's specific characteristics also came to be reflected in classes of subject matter and types of technique used by the Americans. The French artists were immensely popular and eagerly collected during the period. Critics discussed their works at length and held them up as models of perfection. It should not seem surprising, then, that Americans sometimes imitated specific Barbizon works or artists. Some paintings of Inness (cat. no. 15) certainly recall others by Théodore Rousseau (fig. 26); the example of Corot strongly flavors the mature work of Henry Ward Ranger. Because the Barbizon School was such a direct influence, the term *Barbizon* has come to be used loosely to characterize the American painters as a group. Yet, as conspicuous as the influence is, it is important to realize that the Americans adopted only certain aspects of the French school. The term *American Barbizon,* therefore, conveys as much confusion as information. (The little-used term *intimist,* by drawing attention to the poetic objectives of the artists, describes the essential nature of the American paintings with less confusion.)

In assessing the larger influence of the Barbizon School, it is essential to understand just what it meant to Americans in the late nineteenth century—as opposed to what it meant to the French fifty years earlier, when it was new. The two meanings could not be more dissimilar. The Barbizon School had arisen, in the 1830s and 1840s, as a realist movement in opposition to French academic landscape painting, which drew upon the long French tradition of classicism established in the seventeenth century by Claude Lorrain and Nicolas Poussin and given new life by the Neoclassical movement in the late eighteenth and early nineteenth centuries. It was a school of synthetic landscape painting, that is, one that arranged perfect elements into an ideal, balanced composition reminiscent of the old masters. In opposition to this highly formal and traditional treatment, the Barbizon artists offered an earthier, more immediate response to nature. Their compositions ignored classical structure. They often painted conspicuously humble motifs. They felt that the inspiration for landscape painting should come from the experience of nature, rather than from the classical tradition. In fact, the themes and appearance of Barbizon painting were closer to Dutch seventeenth-century landscape painting and its descendants, both in their unpretentious subjects and in their informal compositions.

In turning away from the French classical tradition, the Barbizon artists made two important assumptions. The first was that humble subjects were worthy of full-scale artistic treatment. In the case of the Barbizon artists, these might be modest country images such as village lanes and unpicturesque moors. In a larger context, this attitude can be related to the Pre-Raphaelite artists' willingness to find subjects in the least pretentious corner of the natural world. The Pre-Raphaelites were willing to surrender their choice of subject to the general attempt to be realistic, assuming that realism, in itself, would justify anything it replicated. But another assumption, which was to be of fundamental importance in the decades to come, separated the two schools: the Barbizon artists took very seriously their authority to choose the subject. In place of the hallowed consensus of long classical tradition, they claimed for themselves (and for all artists) the ability to recognize in nature what was beautiful and fit for artistic treatment. This attitude, placing the artist's vision at the center of the artistic process, was opposed to both classical tradition and also the Pre-Raphaelite surrender to egoless photographic realism. This central role of the artist as judge, interpreter, and transmitter of the beauties of nature was to be the most important legacy of the Barbizon movement to Inness and American art at the close of the century. By that time, the authority of the artist to recognize beauty gave license for an almost completely subjective and poetic approach. The stylistic revolution had come full circle. Many American landscapes were no longer realistic, except in the most personal sense. They were romantic in spirit and synthetic in composition.

In reading the aestheticians and commentators of the late nineteenth century, one discovers that the critical values of the 1850s had been turned upside down. Everything that earlier had been valued came to be held in contempt. The Hudson River School paintings produced in accordance with that earlier taste now were objects of ridicule. In fact, it was during this period that the originally contemptuous epithet *Hudson River School* was first used. Even Inness did not escape from this stylistic reversal unscathed. Apologies had to be made for his earliest works, even though they did not fully fit the Hudson River School style. They were explained away as juvenile exercises essential to his mature freedom. Biographers of Alexander Wyant, Inness's contemporary, were likewise embarrassed by that artist's highly realistic early works, which they tried to excuse as the result of what they considered his pernicious training at the art academy in Düsseldorf, Germany.

The ambitious showpieces of Church and Albert Bierstadt were easy targets for the scorn aimed at the Hudson River School and suffered the greatest drop in esteem. Although Barbizon School landscapes could often be dramatic in their depiction of weather or heroic oaks, they tended to depict modest subjects that directly reflected one man's intimate experience with nature. They were not panoramas of famous scenery. To the connoisseurs who understood the Barbizon School landscapes, the wilderness spectacles of the outmoded Hudson River School seemed empty and pointless. They seemed to be merely obvious view painting, superficial attempts to impress the unsophisticated with illusions of immense scale and vast distances. Henry James reflected this growing disillusionment with large, theatrical appearing panoramas when he wrote in an exhibition review: "They take up much space on the walls; but they have taken little (and even that we grudge them) in our recollections."[4]

Fig. 26. Théodore Rousseau (France, 1812–1867). *Landscape,* c. 1845–50. Oil on wood panel. 16 ¼ x 24 ⅞ in. (41.3 x 63.2 cm). The Toledo Museum of Art, Ohio. Gift of Arthur J. Secor.

Fig. 27. Alexander H. Wyant (United States, 1836–1892). *Any Man's Land,* c. 1887–92. Oil on canvas. 18 ½ x 30 ½ in. (47 x 77.5 cm). Los Angeles County Museum of Art. Museum Purchase with funds provided by Mr. and Mrs. Willard G. Clark, Mr. James B. Pick and Coe Kerr Gallery.

The Hudson River School painters, like Church and Bierstadt, had brought back to New York showrooms vivid recreations of famous natural spectacles: Niagara Falls, Yosemite, the Andes. Inness and other artists of the late nineteenth century, in contrast, painted aspects of the common landscape. Their patrons were not interested in the exotic. On the contrary, they expected artists to show them the familiar in a new light. The patron of the late nineteenth century did not value his artists for their experiences as hikers and mountain climbers. Snowcapped peaks and vast plains were not part of his world and held little interest for him. Instead, he expected the artist to be a seer of the ordinary, one who could show him his own world as a truer, more vivid reality.

It was the role of the artist to see beauty. His gifted and trained eye was sensitive to the exquisite combinations of color, light, and texture that the layman walks by, unheeding. Walking along a country road, the artist sees light falling through the high branches of a glade, upon the thin white birch saplings within. Perhaps on another day he notices the way a puff of mist stretches in a band across the nearly leafless branches of a solitary tree, realizing how sharply this image can suggest the damp chill of a gray December morning. The artist discovers these humble, but beautiful motifs and interprets them in his paintings.

The true artist would then exercise the greatest discipline, in order to bring his subject to its fullest expression without trivializing it. He would certainly avoid introducing and developing extraneous, anecdotal detail. On the contrary, he would choose the aspect of the scene that seemed to him most significant and direct all elements to support that point of view. Whether his interpretation was to be of the most rarefied subtlety, delicately nuanced, or whether he sought to capture a dramatic and impressive mood of nature, in all cases his work must be completely unified.

This emphasis upon unity followed from the fundamental assumption that the artist was creating an artistic and emotional experience, rather than simply transcribing a view. The artist responds to the experience of nature, then uses the language of nature to communicate a much larger and richer feeling that all can understand. Nature is the source of inspiration and the vocabulary of expression but not, strictly speaking, the subject of the painting. Landscape is the representation of an emotion, of a human quality, that finds its analogue in the experience of nature, but that might just as well be communicated through musical harmonies and rhythms. The bristling detail of the Pre-Raphaelite painters, essential to a photographic portrait of a spot, would have been a jangling distraction within a painting that translates a feeling.

In practice, the degree of elaboration varied considerably. After about 1880, Alexander Wyant developed a broadly brushed, softer style that subordinated all else to a single effect of weather or a striking aspect of terrain (fig. 27). A significant group of his paintings of the period, in contrast, include much of the kind of specific, if unlabored, detail that would fascinate a naturalist. Even Inness, in his great, late painting *The Clouded Sun* (cat. no. 52), provided sufficient detail to develop the central impression of eery stillness. But during Inness's last ten to fifteen years, the larger trend clearly was toward a softer, more generalized style.

Although the softly focused effects of Inness's late style certainly corresponded to the vision of spiritual reality propounded by his Swedenborgian faith, that style's rejection of materialistic clarity also conformed to the artistic vision shared by many artists during those years. A soft focus was a recognized way of subordinating parts to the whole effect, achieving the essential quality: unity.

This softness of handling should never be confused with poor mastery of technique, however, since skillful paint handling was a matter of great interest to these artists and their patrons. Like the principle of unity, it was a consequence of the reorientation of interest from the material world and toward the artist as creator and poet. Brushwork was the artist's signature and also a particularly direct means of expression.

In the art academies of Europe during the 1870s, Americans had learned the joy of manipulating paint. They had been taught to utilize the transparency of glazes and the opacity of scumbles, to mingle colors on the canvas by painting wet-into-wet, and to develop vigorous impastos for texture and emphasis. They learned to paint with both economy and vigor. The surfaces of their paintings were rich with variations drawn from their large technical vocabularies. Proud of their abilities, they had learned to consider the gracefulness of their technique nearly as important as the subject it portrayed. By the 1890s, such mastery was taken for granted as the basic equipment of a painter. Collectors delighted in the lush sensuousness of the paint surfaces. In contrast, critics found the tight, nearly invisible brushwork of the Hudson River School, which we admire, to be dry and boring.

For artists and art lovers who had awakened to the beauty of the paint medium, the richness and the conspicuous skill of Inness's handling in his mature work was a source of unending delight. In his sketches, a touch of his sure brush is enough to suggest any shape or texture. In his finished paintings, that unerring and effortless movement works, within an often complex layering of paint, to even greater effect.

Learning to look closely at paint surfaces and to admire an artist's virtuosity, as the connoisseurs of the late nineteenth century did, opens to us another dimension of enjoyment in the work of Inness and his contemporaries. The subject matter of their landscapes likewise fits a forgotten set of expectations. One must once again try to understand what the period looked for as subject matter in landscapes. A large part of the difficulty is that art lovers of that time turned away from what they considered to be the conventional and too obviously picturesque views, with reflections and sweeps of distance, that had been such an important part of Hudson River School painting. The subject matter that they admired was found in the most unassuming corners of nature.

Inness's landscapes, particularly his late ones, look fundamentally different than Hudson River School paintings, in part, because they are what Inness called "civilized landscapes." Following, directly and indirectly, the example of the Barbizon artists, nearly all American artists, between 1880 and 1920, painted this kind of subject matter, which seems so unpicturesque to many today. One looks, from the shelter of a grove, across pastures toward a distant village. The gentle slopes are broken by

the fences and hedgerows of a well-established rural settlement. Peace and harmony reign in an area that has settled into the rhythm of the pastoral seasons and economy.

During the 1880s and 1890s, the countryside that most Americans knew did look like this, in contrast to our day, when much of it has been obliterated by urban sprawl. Today we talk about the vanishing wilderness, but the disappearance of our most beautiful older rural regions would seem to be an even greater danger. In contrast, the increasingly urban society of the late nineteenth century could still return to the charms of village life by a brief railroad or carriage ride.

In France, this return to rural origins had been the great underlying theme of not only the Barbizon School but also much of the art that derived from it and paralleled it. For the French artists, the essence of their experience was return, rather than the exploration of wilderness by the Hudson River School artists. They returned to ancient villages surrounded by fields. Somewhat like the Dutch artists of the seventeenth century, they organized walls, hedgerows, steeples, and streams into the elements of varied landscapes in which the evidence of man's organizing stamp lent interest to uneventful terrain.

In a Barbizon School landscape, it seems as though nature is seen by someone who uses it and knows it well. One feels that the landscape is painted from familiar experience. It is comfortable and real. The landscape is conceived on a human scale; the land it portrays is one shaped by man's needs.

Likewise, when Inness looked at rural scenes, he read the signs of man's history there:

> Some persons suppose that landscape has no power of communicating human sentiment. But this is a great mistake. The civilized landscape peculiarly can; and therefore I love it more and think it more worthy of reproduction than that which is savage and untamed. It is more significant. Every act of man, every thing of labor, effort, suffering, want, anxiety, necessity, love, marks itself wherever it has been.[5]

Inness's civilized landscapes describe places with a history. Their appeal, among many other things, is patriotic. These established farms and villages are deeply rooted in our national identity. In the responses of the period's commentators, one hears echoes of a nationalistic sentiment that recognizes both the great age of the geological formations and the more recent archaeology of abandoned stone walls. In artists such as Dwight Tryon and Henry Ward Ranger, one senses the land as an ancient living organism, silent, powerful, and enduring. Part of the skill of these artists was to retain a strong sense of a land that is recognizably ours: for instance, Ranger with the stone walls of abandoned fields or Tryon with the granite outcroppings and the rock-strewn patch. These identifying marks are signs of age upon a land that outlasts all.

These themes, which were developed so much further after Inness's death and even enter into Impressionist painting, were a relatively minor current in Inness's work. They are found more often in the work of Wyant. Inness seldom expressed these

themes as fully as in his *Sunset in the Woods* (cat. no. 54), with its powerful feeling of intimacy with the earth, enhanced by his closing off of the sky and his focus on the majestic old tree and great rock in the hushed stillness of the shadows. Other tree portraits by him, such as *Early Autumn, Montclair* of 1891 (cat. no. 53), also communicate this sense of knarled primeval age, the trees almost totems with an animistic wisdom and personal force. Next to these, Asher B. Durand's forest giants look youthful and delicate (fig. 28).

Even in works in which this sense of a specific terrain may not be especially pronounced, one nevertheless often experiences an intimacy with a seemingly sentient nature through the transforming effect of light upon landscape. Recognizing these moods of nature from one's experience can produce a deeply satisfying nostalgia that tinges the aesthetic experience. While in other hands this appeal can lapse into a shapeless sentimentality, the accuracy of Inness's lighting sharpens the emotional appeal almost to the point of objectivity. In fact, the very key to success in many of the late paintings is Inness's ability to capture the precise appearance and feeling of a particular lighting condition at a certain time of day. His favorites are the soft, warm, Claudian light of late afternoon or sunset, or the rise of the full moon with the light of the setting sun fully illuminating the scene, as in the richly evocative *Sundown* of 1894 (cat. no. 63). These are charged moments of sumptuous color that transform the farmyard reality.

Inness is master of many atmospheric conditions and kinds of light; they are the sources of many kinds of poetry for him, from the startling overcast effect of *Gray, Lowery Day* to the silvery chill of *Misty Morning, Montclair* to the jubilation of *Spirit of Autumn* (cat. nos. 33, 61, and 55). One must try to share these strong feelings, or one can miss a great deal of the beauty and significance of the paintings.

To judge from contemporary writing about individual paintings by Inness and other American and French landscape painters, the appropriate response to these poetic landscapes was thought to be a kind of enchanted reverie. Such a sympathetic response is epitomized in George Inness, Jr.'s description of his father's painting, *The Greenwood* (fig. 29):

> Though it is a superb composition, there is no pictorial prettiness in it. It is simply nature, outdoor nature pure and simple, a scene that few but Inness would select. There is nothing in this canvas to attract the buyer. I heard a dealer speak of it as a hard seller. Yes, a hard seller to the man whose art sense consists in picture-painting. "The Greenwood" is not picture-painting. It is nature, and grand, true nature. The very plainness of the subject makes its grandeur, and the breadth and simplicity of its treatment convey its wonder. You emerge from a wood. Everything is green—green grass, green trees, green everything, except a patch of sky that appears under the trees at the left of the picture. This patch of sky is crisp and cool and makes you quicken your step, as it puts life and vigor into your lungs. And looking about, you feel it's all outdoors and all your own, shared only with the girl who strolls through the wood to fetch the cows home from the pasture in the strip of light beyond. But she will pass and leave it all to you again.[6]

Even more exquisite is the spiritual satisfaction that Charles H.

Fig. 28. Asher B. Durand (United States, 1796–1886). *The Beeches,* 1845. Oil on canvas. 60 ⅜ x 48 ⅛ in. (153.4 x 122.2 cm). The Metropolitan Museum of Art, New York. Bequest of Maria De Witt Jesup, 1915.

Fig. 29. George Inness. *The Greenwood,* 1893. Oil on canvas. 32 x 42 in. (81.3 x 106.7 cm). Ireland 1490. Private Collection.

Fig. 30. John Francis Murphy (United States, 1853–1921). *The Russet Season,* 1915. Oil on canvas. 24 x 36 ¼ in. (61 x 92.1 cm). Collection of Mr. and Mrs. Willard Clark.

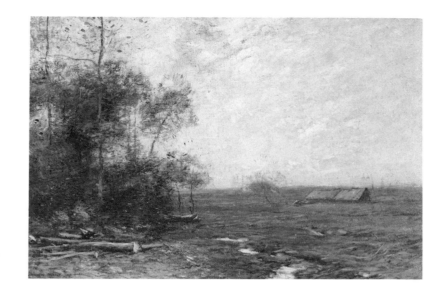

Caffin found in the work of Dwight Tryon:

Similarly in Tryon's Night pictures there is more than the sentiment of night. It is rather the spirit of night that has informed them. The local silence seems for a moment to be charged with the inarticulate echo of Eternity's vast silence; the loneliness tenanted by the companionship of vast distances. Again it is something more rarefied than sentiment that his many Early Morning and Twilight pictures exhale; the breath of a spirituality that has entered into them from an infinite Outside.[7]

It is easier to understand how the nocturnes or the delicate, rosy dawns of Tryon have in them the quality of suggestion that readily inspires such reverie, than it is to anticipate the similar response that Eliot Clark felt for the barren, wintry fields of J. Francis Murphy (fig. 30):

On a canvas in the proportion of two by three the horizon breaks well below the center, giving the sense of heavenly expanse; the border of trees on the left forms a graceful contour, made more effective by the slender upright tree and the decided horizontal contrast of fallen logs, emphatically punctuated by the woodman's axe. A meadow brook leads from the foreground in a curve echoing the line of trees and directing the eye to the distance; an old barn breaks the horizon on the right, the angular gable of which adds a telling form revealing by contrast the suggested expanse of distance. Thus we note that Murphy balances the softened form by the decisive contrast and although the effect is delicate it is never sentimentally sweet or vapid. This illustrates the fundamental trait of Murphy's character, that happy marriage of masculine virility with passive feminine charm. We have, too, that splendid sense of relativity, the solidity of earth gives ethereal quality to the sky; the softened edge of foliage adds vitality to the tree trunk that sustains it; the gradually receding plane gives added significance to the dome of heaven; the curved line is balanced by the angular; the emphatic accent keeps the softened form from being over vaporous. Representing the typical aspect of familiar landscape the composition is nevertheless arranged with most exacting and understanding care, the varied forms are definitely related to a carefully organized unity. In the unimportant examples one may tire of the repeated and calculated devices of picture making, in the inspired canvases like the Russet Season one feels their inevitable necessity.[8]

If these quotations seem overwrought, it is well to remember that they have been taken from longer works, closely reasoned and developed, to which these excerpts provide a climax. Nevertheless, outstanding paintings were thought to be capable of arousing such intense feelings. The tone of such late nineteenth-century criticism suggests how we should look at the paintings today: we should freely follow our subjective associations with the subject matter and allow ourselves to experience the powerful feelings evoked by each painting's formal properties. If the period was willing to accept an artist's impressions and feelings (more than nature itself) as the subject of landscapes, then it followed that the success of a painting would be measured by the intensity of the emotional response the painting evoked in the viewer. These landscapes must be felt to be understood.

As Clark went on to observe in his sensitive interpretation of Murphy:

> A picture is so much paint and material matter merely, until it is quickened by the comprehension. Brought into being by the idea of its creator, it is reanimated only when that idea finds a sympathetic response. The true significance, therefore, of an artist's work is the living reaction of the beholder. As in so many mirrors, the idea becomes reflected and lives again. There can be no didactic or single judgement, no arbitrary measure or standard. It is manifestly unfair and irrelevant to measure the intention of one artist by the different conception of another. The final import of Murphy's achievement exists, therefore, in the individual minds of those who have beheld his pictures. Living for those who find a significance therein, dead for those to whom it is dead.[9]

Just as Inness's late landscapes are fundamentally different from Hudson River School landscapes, the viewer's expectations and participation must likewise differ. A painting that attempts a photographic realism can be read in the same way as a photograph: the initial response is a substantially complete one, and the details can be examined with an objective kind of scrutiny and satisfaction. In contrast, a landscape that transmits a subjective reaction reveals itself to the viewer in other ways: the first impression of the painting is only preliminary to a deeper response that develops over time with the contemplation and shared feeling of the viewer. Even for one highly experienced with this type of painting and prepared to welcome its resonances, the true beauty of a late Inness becomes known only with repeated study. Perhaps that is why some of these paintings seem so empty to those who have learned to expect the obvious.

The viewer should seek to achieve something like the feeling of the artist when he conceived and wrought the work. One must allow the associative qualities of the subject matter—the homestead, twilight, a bridge—to serve as a starting point for a complex of feelings primarily evoked by the abstract qualities of the painting—such as composition, color, contrasts, and brushwork. Such abstract qualities became more and more important to Inness in the work of his final period. During his Italian period of the early 1870s, when he was recording, partly for tourists, known landmarks and motifs, he had executed beautiful drawings and watercolors as studies, as well as oil sketches that correspond closely with finished paintings. After that period, Inness less and less sketched the motif in the field and then reproduced it in his studio. The paintings of his last fifteen years, for the most part, were conceived and composed in the studio. They continued to be based on experience and, in that respect, remained thoroughly consistent and truthful. But increasingly toward the end, the paintings were fundamentally compositions of Inness's own creation. The works of the last ten years were largely synthetic landscapes, in which abstract considerations were paramount. *The Homestead* (cat. no. 32) of about 1877, for instance, a large exhibition picture on which Inness apparently lavished considerable effort, already betrays the characteristics of an assembled landscape with a strong sense of classical order. In *The Home of the Heron* of 1893 (cat. no. 59), a painting from near the end of the artist's life, the arbitrary arrangement derives totally from abstract concerns.

Inness delighted in discussing or, more often, holding forth on theoretical aspects of painting, and in 1875 he was writing a book about art. Stories abound about his painting landscapes to demonstrate a theoretical principle, lecturing all the while. Pic-

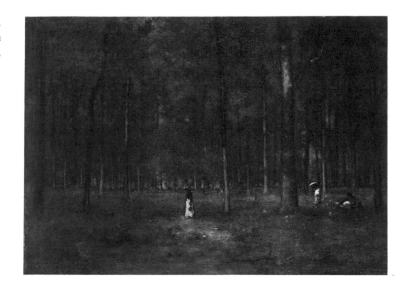

Fig. 31. George Inness. *Georgia Pines,* 1890. Oil on wood. 18 x 24 in. (45.7 x 61 cm). Ireland 1325. National Museum of American Art, Smithsonian Institution, Washington, D.C. Gift of William T. Evans.

tures like his *Georgia Pines* of 1890 (fig. 31), balancing countless thin verticals against a firm horizontal, have this quality of a theoretical exercise in design. Perhaps this is part of the painting's strong appeal to today's taste. It is one of numerous paintings that seem to concentrate on a single principle of design, gaining thereby a purer simplicity. The surprising thing, actually, in view of Inness's attraction to absolute principles, is the remarkable range of motifs and treatments in his work. His design principles must have been basic enough to apply to all situations that Inness's love of variety and impetuous invention could devise.

As they have come down to us, some of Inness's art theories seem to have been idiosyncratic. One elaborate theory related colors in paintings to the articles of the Swedenborgian religion. As a result, some commentators tended to dismiss most of Inness's theoretical discussions as ravings. Whether they were sound or unsound, however, Inness's habit of developing and applying these theories certainly would have developed his sense of abstract design in his paintings. His practice with aesthetic discussions also would have prepared him, even when already an old man, to recognize and apply the design ideas of the young men around him in the 1880s. The stimulation they provided must have propelled Inness's natural development, while also apparently shaping certain characteristics of the late style.

The context of American art in which Inness's late style developed was one of increasing consciousness of abstract concerns. An awareness of the canvas as a flat, decorated surface—rather than a window through which to look at a three-dimensional reality—developed, during the early 1880s, among progressive New York artists. By the 1890s, it was an irresistible current affecting the work of virtually every American artist. Even the archrealist Thomas Eakins by 1892 introduced peripheral elements to flatten the ambiguous space of *The Concert Singer* and by 1900 painted *The Thinker* as a paper-thin silhouette. Few artists were untouched by this pervasive stylistic trend. The supposedly isolated and independent Winslow Homer developed *The Fox Hunt* of 1893 as a highly conscious surface design, joining sophisticated patterning to an unforgettably powerful subject in a masterful way that makes the painting perhaps the artist's finest achievement.

Awareness of surface design naturally plays a role in all of the finest works of art, even the most conspicuously illusionistic and three-dimensional. But in Inness's late work, the 1880s' and 1890s' preoccupation with this principle can be recognized by both its insistence and its special characteristics: a consciousness of structure, a use of a unifying color, and a tendency toward patterning, using an opposition of light and dark masses. Inness's work employs these characteristics at roughly the same time as that of his younger contemporaries.

The universality of these concerns and their timeliness in Inness's work becomes more readily discernible if one looks beyond the realm of landscape to the field of figure painting, which during the period was a more active and progressive school, one in closer touch with European currents. It is perhaps significant that the first emphatic manifestation of picture structure in Inness's work occurs in his monumental figure subjects during a brief period of activity in that genre during the early 1880s.

Fig. 32. Francis Davis Millet (United States, 1846–1912). *A Hand Maiden (The Water Carrier)*, 1886. Oil on canvas. 27 ⅛ x 16 ⅝ in. (68.9 x 42.2 cm). Collection of Mr. and Mrs. Haig Tashjian.

Fig. 33. William Merritt Chase (United States, 1849–1916). *A Friendly Call,* 1895. Oil on canvas. 30 ⅛ x 48 ¼ in. (76.5 x 122.6 cm). National Gallery of Art, Washington, D.C. Chester Dale Collection, 1943.

Fig. 34. J. Alden Weir (United States, 1852–1919). *Children Burying a Dead Bird,* 1878. Oil on canvas. 18 ⅛ x 22 ⅛ in. (46 x 56.2 cm). Private Collection.

The pictorial structure employed by numerous American artists during the 1880s was developed chiefly in terms of geometric order along an implied surface grid. It no doubt had its principal roots in the rage for English decorative styles that swept American artistic circles beginning in 1882. Inspired by the work of Whistler and the English artists of what is known as the Aesthetic Movement, American figure painters began to construct paintings in ways that emphasized a geometric surface design. Backgrounds tended to be parallel to the picture plane, confining shallow spaces. Banding elements often crossed compositions from side to side, locking elements in place. Horizontal and vertical elements were introduced to specify aligned and interlocking planar geometry. Clear examples of such structure are Francis D. Millet's *The Water Carrier* of 1886 and William Merritt Chase's *A Friendly Call* of 1895 (figs. 32 and 33). In such English and American works, regular geometrical forms found in interiors, such as picture frames, paneling, and window mullions, were often used to indicate the surface grid.

Although the English appear to have been the chief influence toward a consciousness of pictorial geometry among American artists, it is worth noting that J. Alden Weir had already painted *Children Burying a Bird* (fig. 34), using such principles in 1878, while in France and partly under the influence of Jules Bastien-Lepage. Weir aligned objects and figures' limbs so obviously to coincide with horizontal, vertical, and diagonal orientations that the sense of an underlying grid is hard to avoid. Among German artists, Hans von Marees's work already exhibited these tendencies by the early 1870s. The consciousness of geometric structure and surface design was one of the most important movements in art during the last quarter of the nineteenth cen-

tury, prominent in the works of the Post-Impressionists, such as Georges Seurat, and climaxing after the turn of the century in the work of many artists, including Paul Cézanne and the Cubists.

The period's sense of geometric structure is clearly discerned in works by Inness such as *The Orchard, Milton, N.Y.* of 1889 (fig. 35) and *The Old Barn* of about 1888 (cat. no. 49), with their numerous strictly aligned and interlocking horizontals and verticals. Henry Ward Ranger was also able to extract this strong sense of a grid from some of his wood interiors (fig. 36). In general, however, such elaborate applications of this sensibility were easier for figure painters to achieve. Inness and most other landscapists had few horizontals to work with in a distant view, so they applied this consciousness mainly in terms of strong horizontal banding and rhythmic, balanced placement of verticals.

It takes very few of these aligned elements at precise intervals to establish a firm sense of structure, as was demonstrated in the archetypal work of the Aesthetic Movement, Whistler's *Arrangement in Grey and Black, No. 1: The Painter's Mother* of 1867–72 (fig. 37), with its limited number of right angles ordering large unmodeled areas. Its spirit of simplicity and disciplined sensitivity is echoed in many late works of Inness such as *The Brush Burners* of about 1894 (fig. 38), in which the subject is highly simplified and the elements are few. In this case, the earth and horizon are nearly flat and the two trees nearly straight as poles. The placement of the three elements (and the balancing vertical of the small figure), in relation to one another and the edges of the painting, has the precision and perfect bal-

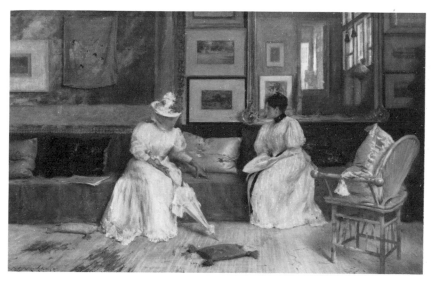

ance of a Mondrian. During the 1890s and even some years before, the organization and balance of horizontal and vertical elements was one of Inness's primary interests, one he explored in infinitely varied combinations of more or less explicitly abstract feeling.

Progressive landscape painting in this country moved very rapidly toward abstraction, during the early 1890s, along paths at times so closely parallel to those of Inness that they may have been one and the same. One might compare Inness's *Evening Landscape* of 1890 with Tryon's similarly composed *Autumntide* of the previous year (figs. 39 and 40). Both use a large principal tree as a fulcrum, balanced on either side by lighter trees at varying distances from the pivotal mass. Tryon's *Twilight—Early Spring* of 1893 (fig. 41) spells out this design issue in its simplest manifestation, using the kind of pencillike saplings that made such clear vertical markers for Inness during these years. It might be compared with Inness's *The Home of the Heron* of the same year.

It takes nothing away from Inness to point out that he was not alone, a solitary old man tinkering with curious theories. On the contrary, it is even more to his credit that he shared these interests with the brightest young talents, experimental artists whose careers were to rest upon these principles, which were recognized universally soon after Inness's death. At the end of his life he rode in the vanguard, lending his prestige and considerable contributions to the eventual success of an important new movement.

This is not to say that Inness left behind him a school of similar

painters. The major direction of American landscape of the Aesthetic Movement was toward an extreme delicacy and refinement. Inness could also achieve this ethereal sophistication in a work such as *Home at Montclair* (fig. 42), but more often he used principles of surface design to impart to his paintings a monumental structure of majestic stability and solidity, a structure that establishes their basic feeling of strength and completeness. A great painting like *Sundown* derives its impact not only from its dramatic light effect but also from its emphatic verticals, locking into the picture's top edge and long horizon. An equally strong sense of order undergirds the more complex *Sunset* of 1893 (fig. 43), contributing much more of the painting's feeling of harmony and peace than does its more obviously symbolic lamb. Bold, precise use of forceful structure imparts to Inness's late works the classical character often associated with a great master's final style. Their nobility is the rare and priceless quality that most sets them apart from other American landscapes.

The other conspicuous formal idea widely disseminated among American artists through the influence of Whistler and the Aesthetic Movement was the use of a unifying color that dominated a composition. The exhibition of Whistler's *Symphony in White, No. 1: The White Girl* (1862) in New York in 1881 precipitated an avalanche of white portraits during the following several years. Portraits and figure pieces in other dominant hues were exhibited by many American artists during the 1880s and through the end of the century. An example by a well-established artist is William Merritt Chase's *Portrait of Lady in Pink* of about 1888–89 (fig. 44). The concept naturally also applied to landscape. In fact, it offered landscapists yet another means to

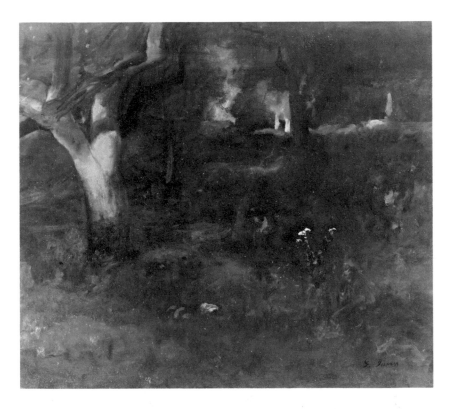

Fig. 35. George Inness. *The Orchard, Milton, N.Y.*, 1889. Oil on canvas. 30 x 35 in. (76.2 x 88.9 cm). Ireland 1306. Collection of Cornelia and Meredith Long.

Fig. 36. Henry Ward Ranger (United States, 1858–1916). *Autumn Woodlands*, 1902. Oil on canvas. 28 x 36 in. (71.1 x 91.4 cm). Lyme Historical Society, Connecticut. Gift of Israel E. Liverant.

Fig. 37. James Abbott McNeill Whistler (United States, 1834–1903). *Arrangement in Grey and Black, No. 1: The Painter's Mother*, 1867–72. Oil on canvas. 56 ¾ x 64 in. (144.3 x 162.5 cm). Musée du Louvre, Paris.

Fig. 38. George Inness. *The Brush Burners,* 1894. Oil on canvas. 24 x 36 in. (61 x 91.4 cm). Ireland 1531. University of Notre Dame, The Art Gallery, Indiana. Gift of Mr. Walstein C. Findlay.

Fig. 39. George Inness. *Evening Landscape,* 1890. Oil on canvas. 20 x 30 in. (50.8 x 76.2 cm). Ireland 1327. Courtesy of The Art Institute of Chicago. Edward B. Butler Collection.

Fig. 40. Dwight William Tryon (United States, 1849–1925). *Autumntide,* 1889. Oil on wood panel. 16 1/16 x 24 in. (40.8 x 61 cm). Private Collection.

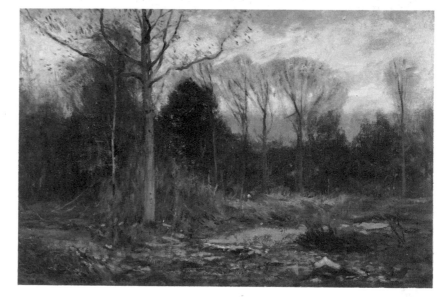

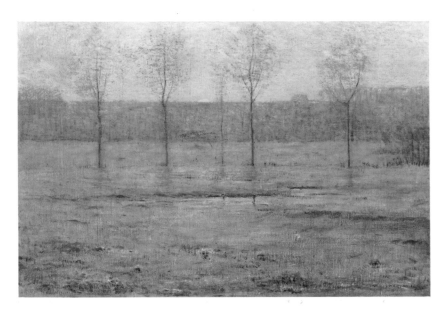

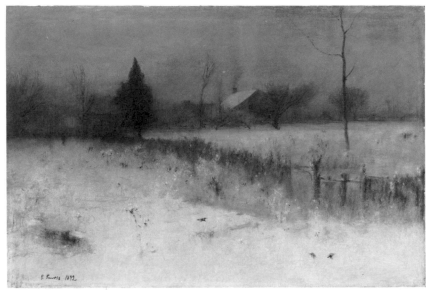

Fig. 41. Dwight William Tryon (United States, 1849–1925). *Twilight—Early Spring,* 1893. Oil on canvas. 22 x 33 ¼ in. (55.9 x 84.5 cm). Courtesy of the Freer Gallery of Art, Smithsonian Institution, Washington, D.C.

Fig. 42. George Inness. *Home at Montclair,* 1892. Oil on canvas. 30 ⅛ x 45 in. (76.5 x 114.3 cm). Ireland 1419. Sterling and Francine Clark Art Institute, Williamstown, Massachusetts.

Fig. 43. George Inness. *Sunset,* 1893. Oil on canvas. 32 x 42 in. (81.3 x 106.7 cm). Ireland 1494. Joseph and Barbara Schwarz Collection.

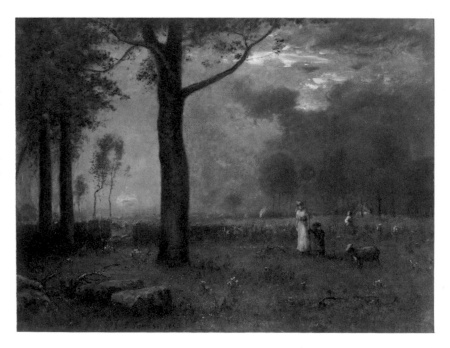

Fig. 44. William Merritt Chase (United States, 1849–1916). *Portrait of Lady in Pink,* c. 1888–89. Oil on canvas. 70 x 40 in. (177.8 x 101.6 cm). Museum of Art, Rhode Island School of Design, Providence. Gift of Isaac C. Bates.

Fig. 45. Charles Davis (United States, 1856–1933). *Evening,* 1886. Oil on canvas. 38 ⅛ x 57 ⅞ in. (96.8 x 147 cm). Private Collection.

obtain the unity they so highly prized. Charles H. Davis's *Evening* (fig. 45) of 1886, painted in France, already utilized the concept fully, and there is no reason to suppose that it was the first such painting by his generation of Americans. John H. Twachtman's French paintings from 1884 and 1885 also exploit this principle in landscape.

In most finished paintings, Inness related his unifying hue to the time of day or a special atmospheric condition, as in *Misty Morning, Montclair.* There is a naturalistic justification for a pervading color in his works, something that other landscapists of the so-called Tonalist movement more and more felt to be superfluous toward the turn of the century. Their overall color and its intensity were often quite arbitrary. Inness's landscapes logically appear bathed in a single tint in such special lighting situations as twilight, dawn, moonlit nocturnes, or the dim light of a fog. His favorite use of this unifying color was for sunsets, a longstanding theme in his work. Some of his sunsets from the middle of the 1860s display as much delicacy in the elaboration of a single hue as he was ever again to obtain. Nevertheless, Inness's markedly increasing preference during the 1890s for situations of extreme lighting coincides with the rise of the Tonalist movement in landscape.

A major exception to Inness's generally naturalistic use of unifying color is found in the large group of unfinished paintings that he was apparently satisfied to leave in the stage of underpainting. Most were abandoned before much local color and possibly any opaque color were added to the thin brown underpainting. Their uniform tonality corresponds to a general lack of defini-

tion and clarity in these unfinished works, with their shapes blocked out and then rubbed and scratched into the transparent underpainting.

In his finished paintings, it is more typical of Inness's approach to use color opposites or chords of colors to describe forms and express lighting. One thinks of his late afternoon skies of interwoven pink, blue, and orange. The many-layered glazing and scumbling of his later painting techniques enabled him to shape forms by the use of several colors. A painting like Chase's *Portrait of Lady in Pink,* drenched in an assertive color, encouraged Inness to paint Tonalist landscapes of a unified color scheme but, at the same time, also enabled Inness to use more color in all his paintings, whether Tonalist or not. The color in Inness's paintings becomes richer and more gorgeous steadily from about 1883 (cat. no. 41) through the last of his finished works. In many, the forms have more color than they can be expected to carry. In the end, the color is used, as much as anything, for expressive purposes.

Another quality in Inness's work that increased in the last ten years of his life, in concert with younger painters, was the active role of light. It was yet another consequence of their consciousness of the design of the picture surface, an increasing awareness of the overall pattern of light and dark. In landscape, the lighter sky would have seemed similar to the so-called negative space surrounding and interpenetrating solid forms in a figure piece. In a thoroughgoing surface design, modifications are made to lend as much grace as possible to the negative spaces, and a similar accommodation is given to the lighted voids sur-

rounding and mingling with the trees and other solid forms of the landscape. This process is nicely carried out, for instance, in *The Home of the Heron* of 1893, resulting in an attractive shape to both the light areas and the dark masses. They are also skillfully interwoven to retain the sense of the flatness of the picture surface.

In giving this much care to achieving a coherent, compact shape to the pattern of lights, it is hard to avoid enhancing the impression that the lights are active in their own right, pressing out along their edges and impinging on the dark shapes. In paintings like *A Silvery Morning* of 1886 and *Early Moonrise in Florida* of 1893 (figs. 46 and 47), one cannot avoid the sense that the lights have molded and partially dissolved the darks. The artist's essential approach to working out light and dark shapes in opposition to one another is readily seen in his very sophisticated design, *The Farmhouse* (fig. 48).

During the twenty-five years after Inness's death, the active role of light was to develop further into one of the main qualities of American landscape. In the powerful expressionist landscapes of Ralph Blakelock, the quivering atmosphere of Ranger, and the Impressionist epiphanies of John Costigan (figs. 49, 36, and 50), light takes on something akin to spiritual force.

The active role of light is an element that imparts special force to many of Inness's late works. Their classic status derives, no doubt, from the firm structure that underlies their sense of stability and repose. At the same time, an energetic light and rich color contribute expressive power. *The Home of the Heron,*

the Inness icon for so many years, epitomizes this perfect marriage of formal qualities.

These major design issues that occupied the American avant-garde during the early 1880s were to shape the course of American art during the next three decades. The formal ideas that Inness had seized upon to forge into his majestic final style were to be worked out in countless variations during the ten to fifteen years following his death until they dominated the general perception of landscape. Because Inness's work incorporated these formal qualities, his paintings looked better and better to commentators and collectors as the years went by. As the avant-garde progressed toward great abstraction and poetic delicacy, Inness's work seemed ever more vigorous and rich. By about 1905 most critics thought his work was the perfect culmination of American landscape art, and Inness seemed to them a genius. The critic and aesthetician Arthur Hoeber expressed a widely held appraisal when he hailed Inness as "not only the greatest landscape painter that America has produced, but . . . one of the greatest artists of the modern world, fit to rank with the best of all nations."[10]

How remote seems the critical attitude that produced that statement. Between it and current estimations of Inness lies the rediscovery of how to look at American landscape of the 1880s and 1890s.

The phases of American art first to be rediscovered by scholars and collectors, during the past twenty years, were naturally the most readily accessible ones: the Hudson River School and

Fig. 47. George Inness. *Early Moonrise in Florida,* 1893. Oil on canvas. 24 x 36 in. (61 x 91.4 cm). Ireland 1450. Memorial Art Gallery of The University of Rochester, New York. George Eastman Collection of The University of Rochester.

Fig. 48. George Inness. *The Farmhouse,* c. 1894. Oil on canvas. 25 ¼ x 30 ¼ in. (64.1 x 76.8 cm). Ireland 1513. Jordan-Volpe Gallery, Inc., New York.

Fig. 46. George Inness. *A Silvery Morning,* 1886. Oil on canvas. 45 ½ x 35 ½ in. (115.6 x 90.2 cm). Ireland 1211. Courtesy of The Art Institute of Chicago. Edward B. Butler Collection.

Fig. 49. Ralph Albert Blakelock (United States, 1847–1919). *The Poetry of Moonlight,* c. 1880–90. 30 x 25 ¼ in. (76.2 x 64.1 cm). Collection of the Heckscher Museum, Huntington, New York.

Fig. 50. John Costigan (United States, 1888–1972). *Landscape with Figures,* 1923. Oil on canvas. 44 x 50 in. (111.8 x 127 cm). Los Angeles County Museum of Art. The Mr. and Mrs. William Preston Harrison Collection.

American Impressionism. Now the time has come to reveal the concepts and approaches of the late Inness and other intimist artists, and that will present a much greater challenge. Those who interpret this art will need to be alert to design questions that do not frequently occur in the appreciation of the Hudson River School. Most important, they must also allow themselves to feel the spirit of a painting. They must not fail to interpret and clarify the inner nature of the work. Their challenge will be to awaken the public's response to the exquisite poetry of a dawn by Tryon or the thunderous power of Blakelock at his best. They will lead the public in feeling the emotions stirred by the sensuous color of LaFarge and the richly inventive technique of Wyant.

The rediscovery of Inness, the greatest of these poetic painters, will come first and illuminate the art of his fellows. Knowing the masterpieces of Inness will change expectations of American landscape, by showing how powerful and rich the thoughtful experience of great landscape can be. If one makes the effort to approach these late paintings as they were meant to be seen, to pause long enough to study their beauty and feel the emotions they share, then it becomes clear that they number among the greatest treasures of the American landscape tradition. For that matter, they may be counted among the masterpieces of American art in any genre and of the landscape art of any nationality.

Notes

[1] George Inness, Jr., *Life, Art, and Letters of George Inness* (New York, 1917), 207.

[2] Inness to Ripley Hitchcock, 23 March 1884, Montclair Art Museum, Montclair, New Jersey, printed in *George Inness of Montclair* (Montclair Art Museum, 1964), unpaged.

[3] "A Painter on Painting," *Harper's New Monthly Magazine* 56 (February 1878): 458.

[4] Henry James, "On Some Pictures Lately Exhibited," *The Galaxy* 20 (July 1875): 89–97, reprinted in *American Art, 1700–1960: Sources and Documents,* John W. McCoubrey, ed. (Englewood, N.J., 1965).

[5] "A Painter on Painting," 461.

[6] Inness, Jr., *George Inness,* 238.

[7] Charles H. Caffin, *The Art of Dwight W. Tryon: An Appreciation* (New York, 1909), 35.

[8] Eliot Clark, *J. Francis Murphy* (New York, 1926), 40–41.

[9] Ibid., 55.

[10] Arthur Hoeber, "By Way of Preface," *An Exhibition of 18 Pictures by the American Master of Landscape Painting, the Late George Inness, N.A.* (Chicago: Henry Reinhardt's Galleries, March 1911), unpaged.

Catalogue

1 A Bit of the Roman Aqueduct c. 1852

Oil on canvas
39 x 53 ¼ in. (99.1 x 135.3 cm)
*Ireland 82**
The High Museum of Art, Atlanta
Purchase with funds from the Members Guild and through
exchange

This painting—its title referring not to the stone bridge in the middle but to the arched structure in the far distance—is one of five that Inness exhibited in 1853 at the National Academy of Design and was presumably painted the year before; it is not otherwise dated.

The 1853 Academy exhibition was the first time that Inness exhibited paintings with Italian subjects—paintings that were inspired by his 1851–52 Italian trip, some of which were painted in Italy. One critic said of them as a whole that "by a careful comparison with the pictures painted before he went abroad, it must be admitted he has made very decided improvement. This is not always the case with our 'travelled artists.' " But he also noted, echoing what Inness's critics had spoken of with disapproval virtually since Inness first exhibited, "They are too much like the 'old masters' for a 'young master.' " Another critic spoke of them as "elaborate compositions," which, as everyone knew then, was the same criticism.[1]

This painting is indebted to earlier art and particularly, in its pictorial construction and soft, warm tonality, to Claude Lorrain. He was the young Inness's first artistic model, to be an artist and to be a Claude were for him the same thing. Claude was also the artist who had for more than a century defined the terms for depicting Italian landscape. Before going to Italy, Inness had been thoroughly familiar with Claudian style, although in a somewhat denatured form (fig. 4). In this painting it is as though the formulas and effects of Claudian style were tested against their natural source by being applied to Italian landscape itself.

Only three of the five paintings Inness exhibited in 1853 are now known: *A Bit of the Roman Aqueduct, View of Genzano* (fig. 1a, once owned by Inness's patron Ogden Haggerty, who financed his Italian trip), and *Land Storm* (fig. 1b). The other two were an *Italian Com-*

Fig. 1a. George Inness. *View of Genzano,* c. 1850–52. Oil on canvas. 38 ¼ x 32 ½ in. (97.2 x 82.6 cm). Ireland 70. Courtesy of Sotheby Parke Bernet Inc., New York.

* Ireland numbers refer to entries in LeRoy Ireland, *The Works of George Inness: An Illustrated Catalogue Raisonné* (Austin: University of Texas Press, 1965).

Fig. 1b. George Inness. *Land Storm,* c. 1852. Oil on canvas. 29 x 36 ½ in. (73.7 x 92.7 cm). Ireland 94. Private Collection.

position (also owned by Haggerty) and an American subject, *Nook in Catskill Clove*. The three surviving paintings are each very different. *A Bit of the Roman Aqueduct* is Claudian, *View of Genzano* is more picturesque, and *Land Storm* is in the wild, dramatic style—nearly as influential in its very different way as Claude's—of Salvator Rosa. Each represents a principal mode of landscape style. The years immediately after his return from Italy were desperate ones for Inness—in November 1852 he wrote that "three shillings is all that I possess in the world and know not where to get more"[2]—so perhaps he was trying to sell paintings by deliberately appealing to a wide variety of tastes in landscape. Or perhaps the differences between the paintings reflected the range of his artistic experiences in Europe and his attempt—the result as much of uncertainty as design—to digest them through imitation. —*N.C.*

[1] *The Knickerbocker* 42 (July 1853): 95–96; *The Literary World* 12 (30 April 1853): 358.

[2] Inness to Samuel Gray Ward, 21 November 1852, Samuel Gray Ward papers, Houghton Library, Harvard University.

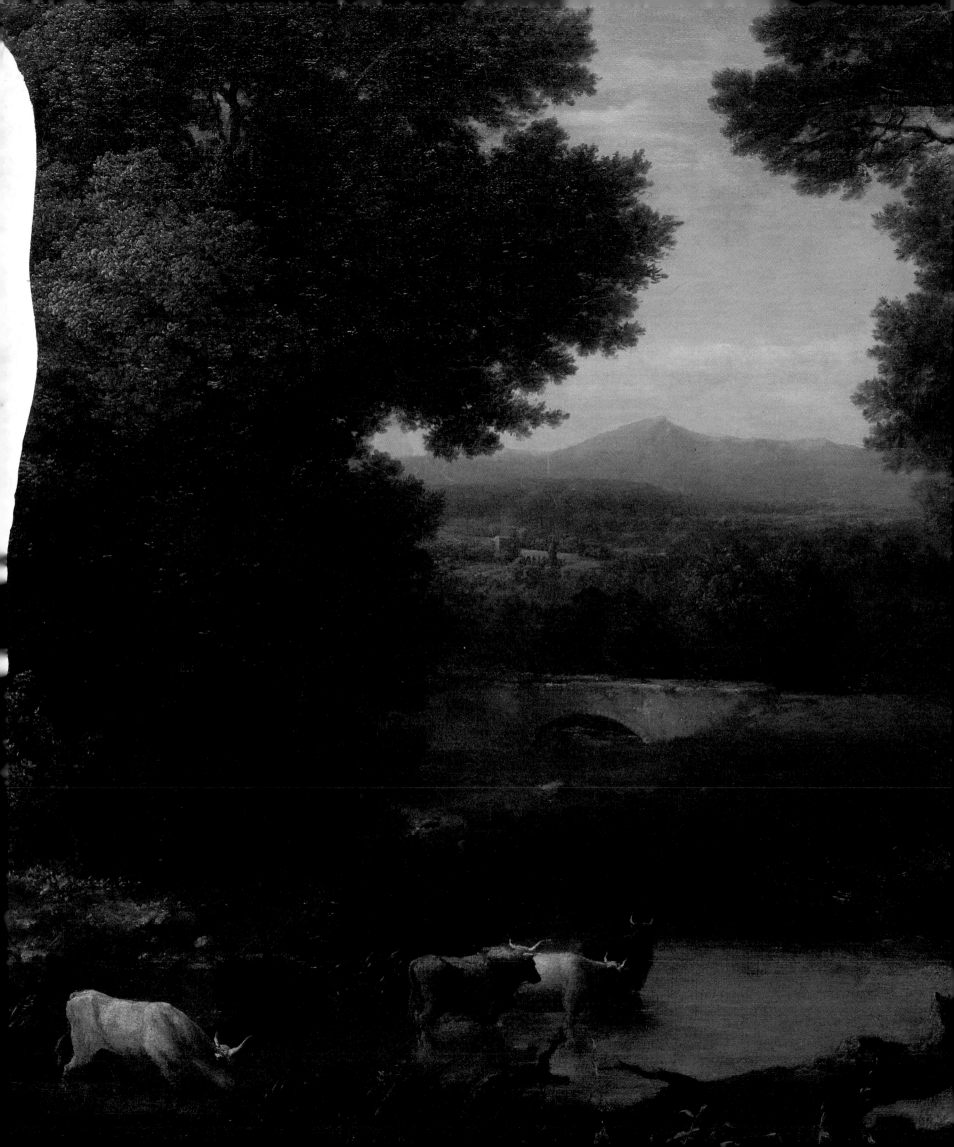

2 The Lackawanna Valley c. 1855

Oil on canvas
33 ⁷/₈ x 50 ¼ in. (86 x 127.6 cm)
Ireland 110
National Gallery of Art, Washington, D.C.
Gift of Mrs. Huttleston Rogers, 1945.

74 From humble beginnings and subsequent neglect, this painting has survived to become one of Inness's most famous. It owes its fame partly to the story of how Inness, as a needy young artist, painted it as a potboiling commission (for which he received seventy-five dollars) from the first president of the Delaware, Lackawanna & Western Railroad; of how, much to his offended artistic integrity, he was required to add more tracks than actually existed and to paint the company's name on the engine; and of how he later found the painting in a curiosity shop in Mexico City, to which it had come as part of a job lot of office equipment.[1] It also derives its fame from its subject. Depicting an episode in the early industrial development of America, it is—or has become to a later time more sensitive to the consequences of such development—an almost iconic image of that momentous and prophetic meeting of nature and the machine. Most importantly, its fame derives from its artistic quality. This painting is undoubtably not only the finest of Inness's early paintings; it is also one of the finest he ever painted.

There is no question that this painting represents the first roundhouse of the Delaware, Lackawanna & Western Railroad at Scranton, Pennsylvania. A contemporary photograph (fig. 2a) of 1859 confirms that the roundhouse is the painting's subject and that it is accurately depicted (even though it is partly obscured by smoke). The painting has always been dated to 1855, but of that there is some question: neither the painting itself nor the preparatory watercolor for it (fig. 2b) are dated. The roundhouse was not finished until 1856,[2] and the painting is similar in its details, in such gauges of time as the sizes of trees and the stump-filled fields, to the 1859 photograph that the possibility of a date later than 1855 must be seriously considered. (For some ramifications of this possibility, see cat. nos. 3–5.)

Fig. 2a. *Scranton, Pennsylvania,* 1859. Photograph. Library of Congress, Washington, D.C.

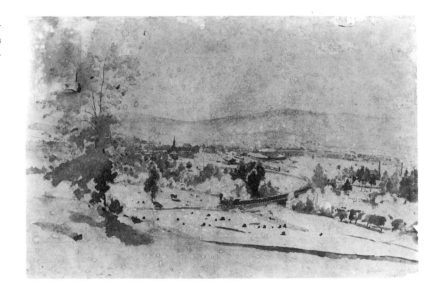

Fig. 2b. George Inness. *Study for "The Lackawanna Valley,"* 1855. Watercolor on paper laid down on board. 12 ¼ x 18 in. (31.1 x 45.7 cm). Not in Ireland. Courtesy of William Doyle Galleries, Inc., New York.

The painting's reputation is a relatively recent one. Never publicly exhibited or discussed during Inness's lifetime, it entered the canon of his major works only after its acquisition by the National Gallery in 1945 and its inclusion the following year in the first modern exhibition of Inness's work, organized by Elizabeth McCausland.[3] Leo Marx's *The Machine in the Garden: Technology and the Pastoral Ideal in America*, published in 1964, located the painting in an intellectual and cultural setting more spacious and subtly textured than it had theretofore possessed. Marx's book has been most responsible for shaping our current understanding of the painting as a central image of technological progress in mid-nineteenth-century America. Inness himself never explained the painting, nor did any of his contemporaries interpret it, so that its meaning—the attitude toward the episode of progressive technological civilization that it depicts—can never be precisely known or satisfactorily explained. But there are grounds for supposing that Inness was not neutral to what it represented. Among his works that preceded *The Lackawanna Valley* are ones whose subjects (see figs. 5 and 6) express his positive alliance with civilization and progress. Later, he openly confessed his preference for "civilized landscape," marked by the acts of man, to wilderness landscape. As Inness was surely aware, nothing exemplified technological progress and modern civilization as clearly, almost emblematically, as the railroad. Other American artists painted railroad subjects.[4] But they were not as candid as Inness about what the railroad did to nature nor were they prepared, as Inness was, to understand the railroad's domination and control of nature as an analogue of art, to take it as a model of artistic purpose and emblem of artistic modernity. Perhaps that is why *The Lackawanna Valley* is such a great and compelling painting.

The Lackawanna Valley is a masterpiece not because of its subject but because it is painted with such sensitivity and authority, such beauty and power. Yet it is significantly greater than most of Inness's other paintings of the period, which were of different subjects, because its special quality of meaning—what its subject meant in itself and what it meant to Inness—determined its special quality as art. —N.C.

[1]Inness himself told part of the story at the end of his life ("His Art His Religion," *New York Herald*, 12 August 1894); his son, George Inness, Jr., embellished it later (*The Life, Art, and Letters of George Inness* [New York, 1917], 108, 111).
For the painting in general, see Nicolai Cikovsky, Jr., "George Inness and the Hudson River School: *The Lackawanna Valley*," *The American Art Journal* 2 (Fall 1970): 36–57.

[2]As reported in the second annual report of the Delaware, Lackawanna & Western Railroad, 1855.

[3]*George Inness: An American Landscape Painter 1825–1894* (Springfield, Massachusetts, 1946).

[4]See *The Railroad in the American Landscape*, exh. cat., The Wellesley College Museum, Wellesley, Massachusetts, 1981.

3 The Juniata River 1856

Oil on canvas
37 x 55 in. (94 x 139.7 cm)
Ireland 119
Haggin Collection, The Haggin Museum, Stockton, California

78 This painting and *The Lackawanna Valley* (cat. no. 2) are the best of Inness's earliest Barbizon-inspired paintings, and, both Pennsylvania subjects, they may have been painted in the same year and, conceivably, even on the same painting campaign. They both embody the same relationship to Barbizon style—the same determination to understand it creatively, not imitate it slavishly or import it indiscriminately. Neither of them can for a moment be mistaken for typical Barbizon paintings. In *The Lackawanna Valley*, coloration, handling, and compositional informality (all of unmistakable Barbizon derivation) are assigned to an intensely American event occurring in a thoroughly American space. In *The Juniata River* they have been applied to or laid upon the conventional pictorial construction of alternating compositional balances and planar spatial recession that Inness learned at the outset of his career from old master paintings or prints. Inness accepted Barbizon influence wholeheartedly, but he admitted it gradually and cautiously into his art, as though still wary of its modernity and still technically uncertain of its use. It was as if he was acclimatizing Barbizon art to American artistic usage or adjusting it to, perhaps testing it against, historical conventions of landscape. He did not make furtive or tentative experiments but incorporated Barbizon influences, as in these two paintings, into ambitious, fully realized, and authoritative paintings that stand among the finest of his works. —N.C.

4 Midsummer Greens 1856

Oil on canvas
24 x 20 in. (61 x 50.8 cm)
Ireland 120
Private Collection

80

Its modest scale and charming intimacy, the almost self-evident appeal of its subject, its succulent coloration and rich pigmentation, all make this painting seem less complex, less challenging, and less novel than the more ambitious *The Lackawanna Valley* and *The Juniata River* (cat. nos. 2 and 3), with which it is exactly contemporary. But that is deceptive. Its debt to Barbizon style, and thus its novelty, is as clear as theirs. And its depiction of nature transformed by human agency to human design for human pleasure—as the tree stump prominently placed in the center of the painting signifies—exemplifies Inness's conception of the purpose of art as clearly as the subject of *The Lackawanna Valley.* —N.C.

Like *The Juniata River*, *Midsummer Greens* partakes of the picturesque tradition in landscape, particularly in its enframing foreground elements and its foreground figures looking into distance. The setting has an ideal, parklike quality—its well-dressed figures picnicking and promenading at a *fête champêtre.* —M.Q.

5 St. Peter's, Rome 1857

Oil on canvas
30 x 40 in. (76.2 x 101.6 cm)
Ireland 142
The New Britain Museum of American Art, Connecticut
Charles F. Smith Fund

82

Inness made his first trip to Italy in 1851–52. This painting, done about five years after Inness had been to Italy, was probably made from studies and sketches, perhaps from a watercolor it very closely resembles (fig. 5a).

It is possible that Inness may have refreshed his memory of the subject not only by his own studies but also by photographs. The use of photographs would account for the painting's very precise depiction of architectural detail, and it might account for its very striking effect of atmospheric distance, achieved by the sharp contrast between the dark and solid foreground and the lighter distance. This effect is not found in Inness's watercolor, in which the transition from foreground to background is more gradual and less emphatically sudden; but it is found in contemporary nineteenth-century photographs (e.g., fig. 5b).

St. Peter's was a popular subject, which is why Inness painted several versions of it and why he received a commission for one of them, perhaps this one, from an art dealer presumably alert to its salability. Like *The Lackawanna Valley* (cat. no. 2), *St. Peter's, Rome*, in other words, may have been a potboiler. Similarly, it was nevertheless a subject that Inness seems to have found particularly rich in meaning.

Fig. 5a. George Inness. *St. Peter's Seen from the Campagna,* c. 1872–74. Watercolor over pencil. 10 x 13 in. (25.4 x 33 cm). Ireland 577. The Detroit Institute of Arts. Founders Society Purchase, Merrill Fund.

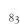

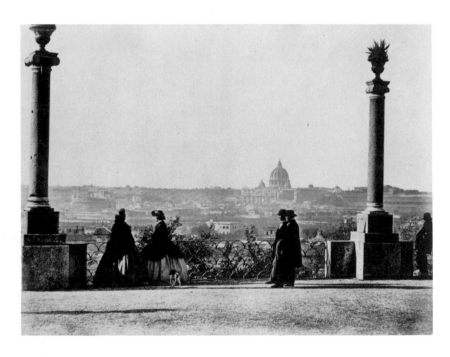

Fig. 5b. Pompeo Molins (Italy, b. 1827–?). *View of Rome from the Pincian Hill,* c. 1862. Photograph. Library of the Academy of Art, Copenhagen. From *Rom in Frühen Photographien, 1846–1878* (Cologne: Museum Ludwig, 1976), pl. 6.

The Lackawanna Valley depicts the characteristically nineteenth-century contest between nature and the machine in peculiarly American terms. It is painted on an American scale, with an American forthrightness, and in a bright, clean, hopeful American light—almost harsh compared to the softer Italian light of *A Bit of the Roman Aqueduct* [cat. no. 1] and this painting. To Inness, who had only recently returned from his second trip to Europe, *The Lackawanna Valley* may have seemed a quintessential image of America. It may have occurred to him at the same time—for it is possible that it was not painted in 1855 but a year or two later (see entry for cat. no. 2)—to reinforce its Americanness by painting a pendant subject that was its equally quintessential European counterpart: *St. Peter's, Rome.* Both paintings are constructed in similar ways, and each has as its most prominent feature a large, domed building. In one case, the building was the most famous piece of religious architecture in the West: St. Peter's basilica. The monumentality of St. Peter's is a symbol of European fixity and changelessness. As seen through the mists of time, it is the embodiment of the Old World past. The roundhouse is its New World counterpart, secular and utilitarian, a shrine of the greatest implement of American progress and enterprise: the railroad. Seen in the clear dawn of a new day, it is the symbol of futurity. —*N.C.*

6 Clearing Up 1860

Oil on canvas
15 ¼ x 25 ⅜ in. (38.7 x 64.5 cm)
Ireland 191
George Walter Vincent Smith Art Museum, Springfield,
Massachusetts

Inness had painted impressively before 1860, but paintings like *The Lackawanna Valley*, *The Juniata River*, *Midsummer Greens*, and *St. Peter's, Rome* (cat. nos. 2–5) were exceptions to an otherwise uncertain and unresolved body of work. In 1860, however, his paintings in general become consistently more authoritative—technically more able and assured, expressively deeper and more resonant—and he began to command attention and exert influence as never before. At the age of thirty-five, having painted professionally for about fifteen years and after two trips to Europe, Inness seemed suddenly to find himself as an artist.

This was chiefly the result of maturity. But in the early summer of 1860 Inness left New York "to plant himself in one of the pleasant villages in the vicinity of Boston [Medfield], where he intends to reside permanently,"[1] and some of his finest paintings of 1860–64 (the years he first lived there), like this one, were painted in Medfield. Perhaps it was the Medfield area itself that inspired him, though it had no particularly striking features. Or perhaps it was the quietness of rural life and the refreshment of nature. The decade of the 1850s, during which he made two trips to Europe, had been both a trying and intensely stimulating one for Inness. On one trip he was expelled from Italy; on the other, to France, he underwent (in a "stupor of intellectual amazement")[2] the profound influence of Barbizon art. In the years that followed he struggled with only occasional success to come to terms with that influence and with the critical disfavor and financial stringency it caused. Much later in life, "when the stress of work became very burdensome; . . . when he would almost break down from sheer effort to conquer difficulties; when nothing would 'finish,' " he would retreat to nature for refreshment and invigoration.[3] Maybe that is what he found at Medfield after the burdensome effort and stress of the previous decade.

Clearing Up is a masterpiece. It is, in the strict sense of the term, the demonstration of his mastery of Barbizon style, his ability to compete in terms of equality with the Barbizon artists by his own methods. It is also simply one of Inness's greatest works and one of the greatest skies, as an effect of nature and as a superb piece of painting, by any American artist. —N.C.

[1] *New York Tribune*, 16 June 1860

[2] Alfred Trumble, *George Inness, N.A.: A Memorial of the Student, the Artist, and the Man* (New York, 1895), 11.

[3] Elliott Daingerfield, "Inness, Genius of American Art," *The Cosmopolitan* 55 (1913): 522.

7 A Passing Shower 1860

Oil on canvas
26 x 40 in. (66 x 101.6 cm)
Ireland 197
Canajoharie Library and Art Gallery, New York

88

This painting, also painted at Medfield, might be the recently com-
pleted painting—entitled *After the Shower*, in which "the sunshine
breaks in upon the middle distance, a rainbow yet lingers in the air, a
lively breeze is driving away the vapory clouds, whose shadows sweep
across the foreground"—that Inness brought to New York in
September 1860. "It is," one writer said, comparing it favorably to
past and present masters of landscape, "as full of color as one of
Diaz's woodland scenes, and as fresh and real as Ruysdael's dewy
scenes," and it prompted him to speak of Inness (as he had never been
spoken of before) as "a man of unquestionable genius," "one of the
finest and most poetical interpreters of Nature," and an artist who
"follows no master, but adopts his own methods of expressing his
ideas."[1] —N.C.

It is remarkable how any artist could, in the same year, paint in styles
as sharply contrasting as those of this painting and *Clearing Up* (cat.
no. 6). The miniaturistic precision of *Clearing Up* bears almost no
relation to the rough paint textures and strong contrasts of *A Passing
Shower*. Ever-recurring wonders in the study of Inness are the abrupt
changes and the briefness of his stylistic phases. The jewel that it is,
Clearing Up belongs to a group of only about five closely related paint-
ings. But *A Passing Shower* stands almost by itself, summing up and
transcending the dramatic current in the works of the previous dec-
ade. During his remaining years in Medfield, Inness then turned his
back on that side of his work and, instead, conjured up images of
pastoral tranquility. —M.Q.

[1]*New York Tribune*, 16 June 1860.

Twilight c. 1860

Oil on canvas
36 x 54 in. (91.4 x 137.2 cm)
Ireland 206
Williams College Museum of Art, Williamstown, Massachusetts
Gift of Cyrus P. Smith '18, in memory of his father, B. Herbert
Smith (Class of 1885)

90 This undated painting may be the one Inness exhibited at the National Academy of Design in 1860, of which a critic wrote:

> To paint water, earth and sky, under their common aspects, so as to satisfy the eye and the sense of harmony within us, is a difficult task; but to take the sky, at twilight, full of black, broken clouds, with the sun below the horizon, throwing back his floods of fire upon them, and kindling them till they burn, while the reflection of all this glory is let down over the land and into the water beneath, with the strength, and at the same time with the softness of nature, must be far more difficult, and could only be successfully achieved by a close observer, and one who has attuned his powers in harmony with nature.[1]

That it was painted in 1860 is suggested also by its resemblance in conception and quality to the signed and dated *Clearing Up* of that year (cat. no. 6).

It is tempting to think that Inness's *Twilight* might have been related to Frederic Edwin Church's great *Twilight in the Wilderness* (fig. 8a), also painted in 1860. Inness probably did not know Church's painting—his Academy painting was exhibited before Church's was exhibited in June—but the resemblances of effect and the possible coincidence of date are nevertheless suggestive. Perhaps Inness saw *Twilight, a Sketch*, Church's study for the painting, exhibited at the Academy the previous year.[2] If so, then Church might in a way have been responsible for the "golden sunsets melting into darksome nights"[3] that would become one of Inness's favorite and most expressively charged subjects later in the 1860s. Although others later in the 1860s were more responsible than Church for instructing Inness in

Fig. 8a. Frederic Edwin Church (United States, 1826–1900). *Twilight in the Wilderness,* 1860. Oil on canvas. 40 x 64 in. (101.6 x 162.6 cm). The Cleveland Museum of Art. Mr. and Mrs. William H. Marlatt Fund.

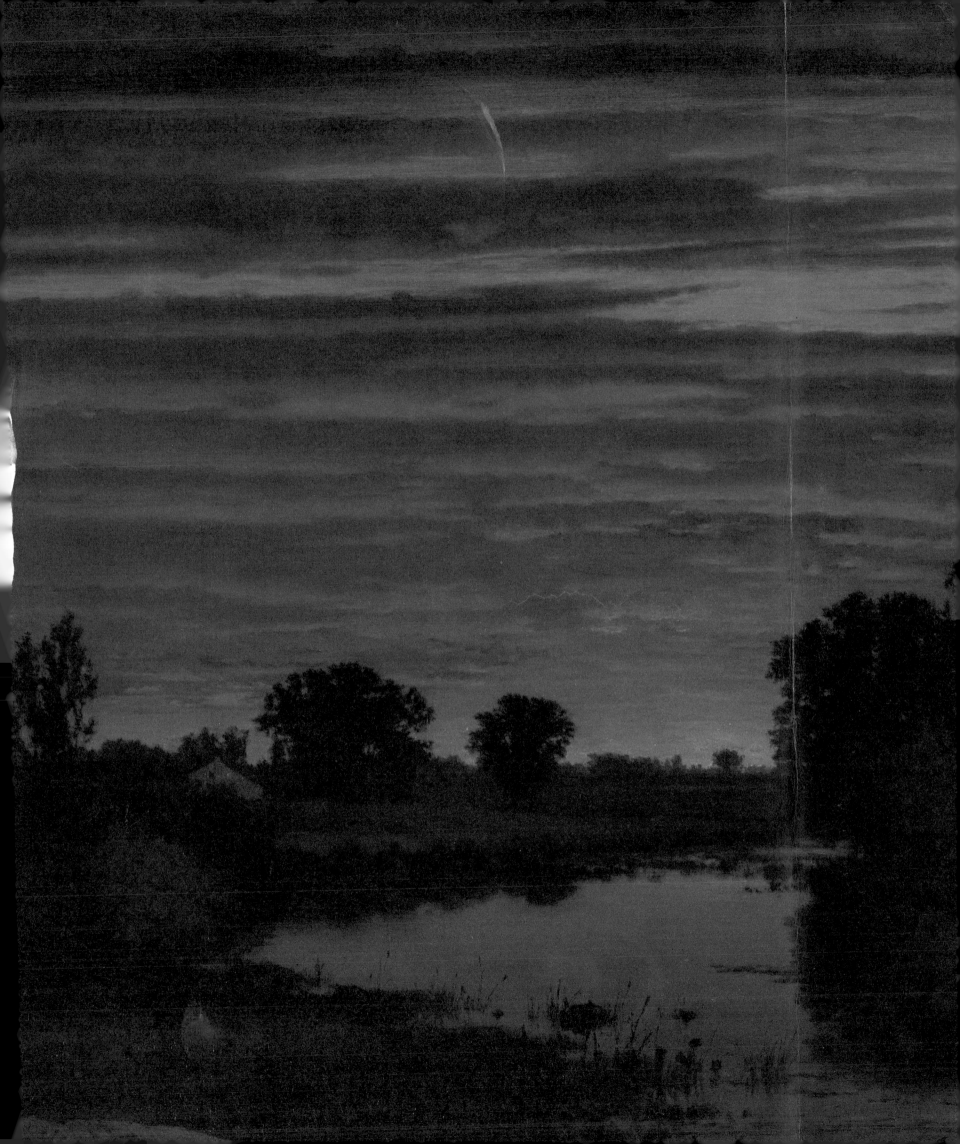

9 Scene on the Hudson 1861

Oil on canvas
16 x 26 in. (40.6 x 66 cm)
Ireland 228
Mr. Joseph Mattison, Jr.

94

This painting—painted when Inness was living in Medfield, Massachusetts, near Boston, and therefore probably not a scene on the Hudson at all—is a standard Inness landscape. A tree or trees (often silhouetted against the sky), a stream, a field, cattle, distant hills, the sky, and sometimes figures and buildings were elements he combined again and again, almost according to formula.

Landscapes of this type were Inness's bread-and-butter paintings in the 1860s. Intimate in feeling, serene in mood, modest in size, they were intended for private appreciation rather than public display, and for patrons who wanted both a typical landscape and a typical Inness.

Careful, subtle, sincere, they are far from being ordinary or perfunctory paintings. The vigorous paint handling and powerful coloration of this painting, and the complex linear movement of the branches and tree trunks in the foreground and middle distance that play against them with musical delicacy and visual wit, make this one of Inness's unusually beautiful and original paintings. —N.C.

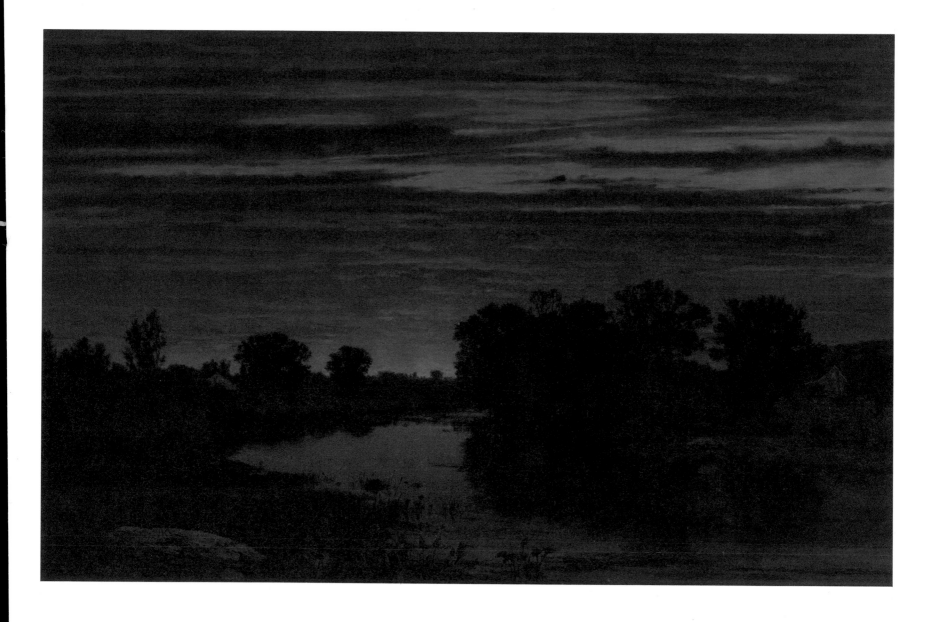

Fig. 8b. George Inness. *The Afterglow*, c. 1863–65. Oil on canvas. 30 x 48 in. (76.2 x 121.9 cm). Ireland 263. Paine Art Center and Arboretum, Oshkosh, Wisconsin.

nature's meanings, it may have been the example of Church's gloriously articulate sky that first showed him the way to give visual utterance to those meanings. —*N.C.*

Twilight shares the exceptional energy that characterizes Inness's chief works of 1860. Like many American artists of the following decade, Inness painted a significant part of his work as sunsets, but he never again achieved the force of this painting. Even in exhibition paintings just as large, such as *The Afterglow* (fig. 8b), his characteristic mood is more muted and delicate, achingly soft. Their delicacy takes the awesome majesty of *Twilight* and renders it intimate and, somehow, slightly melancholy. —*M.Q.*

[1]*New York Evening Post*, 3 May 1860.

[2]The study is now at Olana State Historic Site, Hudson, New York. Franklin Kelly was good enough to call it to the author's attention.

[3]George P. Lathrop, "Art," *Atlantic Monthly* 31 (January 1873): 115.

10 On the Delaware c. 1861–63

Oil on canvas
28 ³/₁₆ x 48 ⅛ in. (71.6 x 122.2 cm)
Ireland 231
The Brooklyn Museum, New York
Special Subscription

Inness painted no other subject as often and over so many years (first in 1857 and last in 1891) as this one, the Delaware Water Gap. He may have painted it so often simply because it was beautiful, because the water gap (where the Delaware River penetrates the Kittatinny Mountains in eastern Pennsylvania) had a certain fame as a picturesque subject, or because he was familiar with it from traveling to visit his brother James in Pottsville, Pennsylvania.

But perhaps he painted it so often because of what it meant. Its combination of natural beauty and the railroad, rafts, and felled tree that exemplify human enterprise made it a pictorial type of definite meaning. Asher B. Durand painted a similar (but in his case invented) image in 1853. There was no doubt what it meant: the painting was entitled *Progress* and the wood engraving after it, published in 1855, was called *Advance of Civilization* (fig. 10a). Inness was candid about his preference for civilized over wild and untamed landscape. *On the Delaware* was in its time a pictorial type virtually emblematic of civilization and progress. Perhaps that is why Inness found its subject so attractive and painted it so often. —*N.C.*

Fig. 10a. Asher B. Durand (United States, 1796–1886). *The Advance of Civilization*. Print by E. Hooper after painting. From *Ballou's Pictorial* 8 (1855): 221.

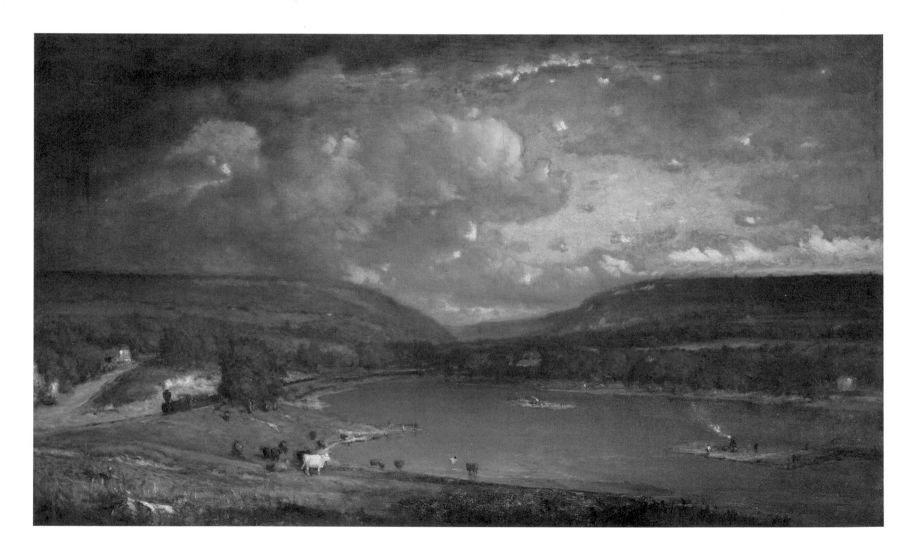

11 Evening Landscape 1862

Oil on canvas
48 ½ x 66 ¼ in. (123.2 x 168.3 cm)
Not in Ireland
Museum of Art, Washington State University, Pullman
Gift of Dr. and Mrs. William E. Boeing

98

Anyone at all familiar with Barbizon paintings will recognize this scene of rustic figures on a tree-lined roadway as as typical Barbizon subject. Inness has domesticated it to Medfield, Massachusetts, but its origin is clear, nonetheless. This painting is very close in conception to another of the same year (fig. 11a), in which, though also an American subject, the flavor of France is stronger and the relationship to French prototypes clearer (fig. 11b)

Inness had, on the whole, assimilated and personalized Barbizon style by the 1860s. But the French influence was still perfectly visible, particularly to those who did not like it: "He paints in what we understand as the French manner," a critic observed in 1861; he "has thus far done little more than graft the style of Rousseau, or French landscape art, on that of American," wrote another in 1863; "somewhat too much of the French style is often complained of as vitiating the legitimate individuality of this artist," Henry Tuckerman said in 1867.[1] Inness, however, was not interested in totally disguising or dissimulating the origin of his style, and the critic who wrote that Inness was "hopelessly affected by the worst characteristics of the style of modern French landscape" unwittingly told why.[2] For Inness's style was not only discernibly French; it was, at the same time, and as importantly, discernibly modern. French Barbizon art, which Inness took as his model, represented the newest and most advanced style in America in the 1860s. Using its language of form at that time signified modernity as clearly as painting in an Impressionist style did about 1890 or a Cubist style about 1910. —N.C.

[1]*New York Commercial Advertiser*, 20 March 1861; "American Genius as Expressed in Art," *The Round Table* 1 (26 December 1863): 21; *The Book of the Artists* (New York, 1867), 527.

[2]*New York Commercial Advertiser*, 4 March 1863.

Fig. 11a. George Inness. *The Road to the Farm,* 1862. Oil on canvas. 27 x 37 in. (68.6 x 94 cm). Ireland 238. Courtesy, Museum of Fine Arts, Boston. Gift of Robert Jordan from the Eben D. Jordan Collection.

Fig. 11b. Jules Dupré (France, 1811–1889). *The Hay Wagon,* 1852. Oil on canvas. 16 x 21 ¼ in. (40.6 x 54 cm). Wadsworth Atheneum, Hartford, Connecticut. Gift of Dr. and Mrs. Charles C. Beach.

12 Landscape c. 1865

Oil on canvas
16 x 24 in. (40.6 x 61 cm)
Ireland 332
Mr. and Mrs. George D. Hart

100

Peace and harmony reign in Inness's Medfield landscapes of the early 1860s. The violence and strong emotions of the distant Civil War seem to find no echo in this vale of contentment, where the season always seems to be late summer or early autumn, the time of harvest and plenty. The closed and sometimes busy compositions of the 1850s now open out into views of broad meadows in gentle terrain. The violent weather, so important in Inness's earlier and later work, seldom stirs the lucid atmosphere. An almost palpable stillness hangs over both the sunny scenes and the hushed sunsets that Inness painted so tenderly during this period.

This painting is one of the simplest and clearest examples of Inness's Medfield imagery—its wide, level meadow dotted with cattle and bordered by trees, in sight of a small town in the nearby foothills. It was to this beloved imagery and this simple composition that Inness was to return, near the end of his life, in *Morning, Catskill Valley (The Red Oaks)* of 1894 (cat. no. 62). In that painting, the long, straight line of the meadow again imparts a strong sense of stability also embodied in the central oaks. *Landscape* is painted in the artist's manner of the early 1860s, with a range of greens applied as highlights of local color on a brown underpainting. It provides a comparison by which to judge the exaggeratedly opulent color of *Morning, Catskill Valley.*

—M.Q.

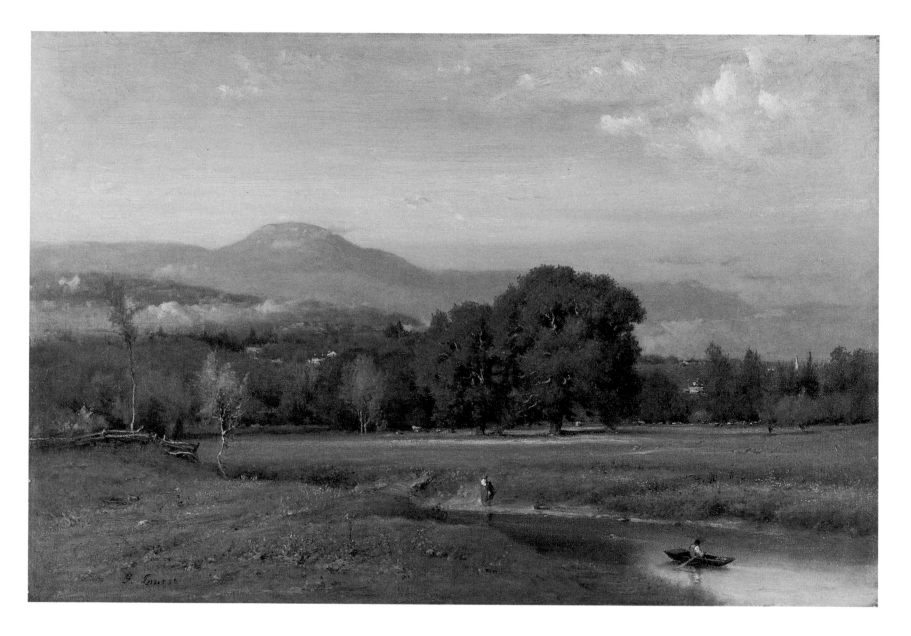

13　Winter, Close of Day　1866

Oil on canvas
22 x 30 ½ in. (55.9 x 77.5 cm)
Ireland 361
The Cleveland Museum of Art
The Charles W. Harkness Gift

102

Inness seldom painted winter subjects, despite the fact that one of his teachers, Régis Gignoux, had specialized in snowy landscapes. He did not find charm in winter, as some American artists and writers did. Bleak and cold, dead and barren, winter was the antithesis of everything Inness found sympathetic and attractive in nature: warmth, color, bountifulness, and hospitality to human use. Perhaps because it was so alien to his almost Mediterranean sensibility, when Inness chose to paint winter he did so with a specially clear perception of its essence, capturing its solemn, fragile, grudging beauty more fully in a single painting than he did the abundant, apparent, and accessible beauty of summer.

Inness painted not one but two winter subjects in 1866, the other is *Christmas Eve* (fig. 13a). What made him paint two such paintings, when he had painted none before and would paint none again for many years, is a mystery. The two paintings are almost exactly the same size, suggesting that they may have been painted for a specific purpose, with a specific meaning in mind, or that they may have been commissioned. But none of those possibilities are verifiable. —N.C.

Defying expectations of white wintery space, both landscapes are filled with color caused by special lighting situations. During the middle of the 1860s, Inness suffused many of his landscapes with the overall color of dying day, but he had to pay for the brilliance of his skies with the gloom of the darkening land. The reflective quality of the frozen land makes *Winter, Close of Day* entirely different in mood and effect. Its paradoxical overall warmth anticipates the artist's treatment of the season in *Winter at Montclair, New Jersey* of 1884 (cat. no. 43). —M.Q.

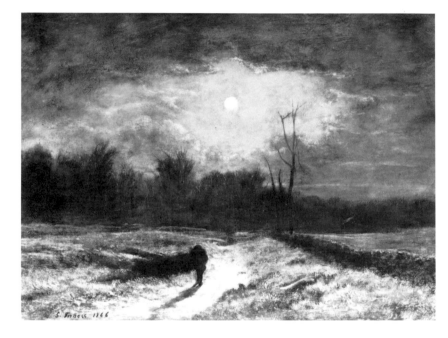

Fig. 13a. George Inness. *Christmas Eve,* 1866. Oil on canvas. 22 x 30 in. (55.9 x 76.2 cm). Ireland 362. Montclair Art Museum, New Jersey. Museum Purchase.

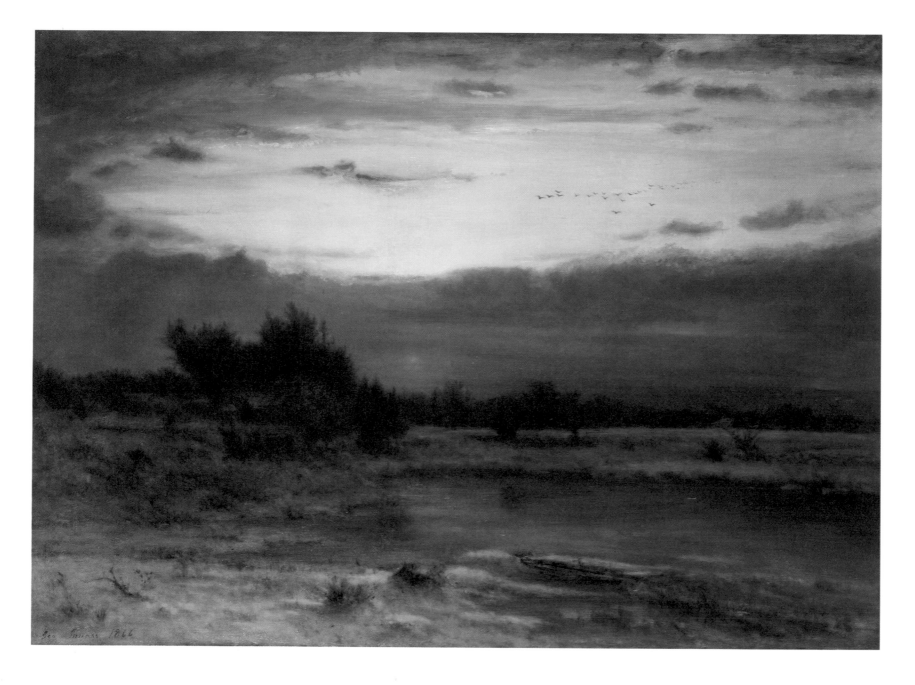

Approaching Storm 1869

Oil on canvas
30 ¼ x 45 ¼ in. (76.8 x 114.9 cm)
Not in Ireland
Mr. and Mrs. Frederick R. Mayer

In the late 1860s, Inness returned to the theme of violent weather that had supplied energy to his visionary compositions of the 1840s and early 1850s and was again to animate his work of the late 1870s. However, *Approaching Storm* still utilizes the imagery of the Medfield period. Its bent trees belong not to wild forests, but to the cultivated and cared-for world, the pastoral ideal, of Medfield. The viewpoint is wider, the scale of natural events larger, but it is still the familiar sheltered valley that the storm threatens.

Several related paintings adopt its wider viewpoint, but this painting is a work unto itself. Its sweep and force are new to the artist's work. The painting suggests, perhaps, how Inness's style would have developed without his subsequent Italian interlude. After that classical period, once again upon these shores, he resumed with the explosive themes of the late 1870s—nature is turned upside down in a frenzy of feeling. In *Approaching Storm* one still feels the controlled grandeur of nature, which the painting's rich coloration renders as more alluring than terrifying. —M.Q.

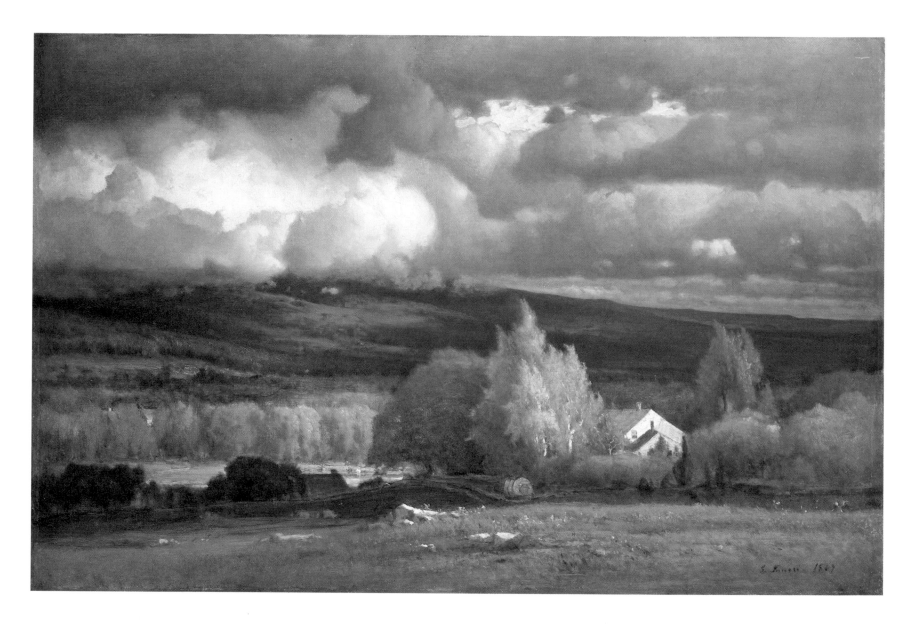

15 Pine Brook, N.J. 1870

Oil on panel
14 ½ x 23 ½ in. (36.8 x 59.7 cm)
Ireland 498
Mr. Thomas Colville

106

Inness painted summer idylls like this many times, especially during
the 1860s. Almost classical in their perfect balance of natural beauty
and human felicity, they were, in the terms of an American subject
matter and a modern language of style, Inness's version of ideal
landscape.

But ideal perfection can be tiresome. Inness varied it sometimes by
unusual effects of color, ones that by hue or strength of contrast have a
slight edge of oddity or eccentricity. He varied it, too, in this painting,
by the noble tree at the right. Old, scarred by life, it is the reminder of
mutability and mortality amidst timeless serenity. Inness liked trees
like this and often gave them prominent places in his paintings. They
have a heroic dignity that he must have admired. But he also must
have admired their expressive movement and formal variety. He
seemed to take a special delight in the complex linear patterns and
rhythms of their branches, and the gestural exchanges and visual re-
sponses they establish with other parts of the painting. —N.C.

The painting takes on a special interest because it bridges his Ameri-
can period of the 1860s and his Italian period of the first part of the
following decade. A note, dated June 5, 1871, attached to the back of
the painting (which is on a heavy panel with two seams) indicates that
Inness sent the painting from Rome. It quotes the artist as writing of
the painting: "An American scene which is so beautiful a subject and,
I believe so fine a picture that I thought I had better send it. The
sketch was taken at Pine Brook[,] New Jersey. The effect is morning
some blue mist in the distance." The quotation confirms that Inness
did sometimes work from sketches during this period, as most of his
contemporaries did. It also makes one wonder, in examining the
painting, which of its elements reflect the artist's experiences in Italy
and the art he saw there. Are there some changes of technique or style
that relate it to the works of his Italian period—perhaps a certain
formality, the warmer light, or the richer color of the greens and the
bluish shadows? —M.Q.

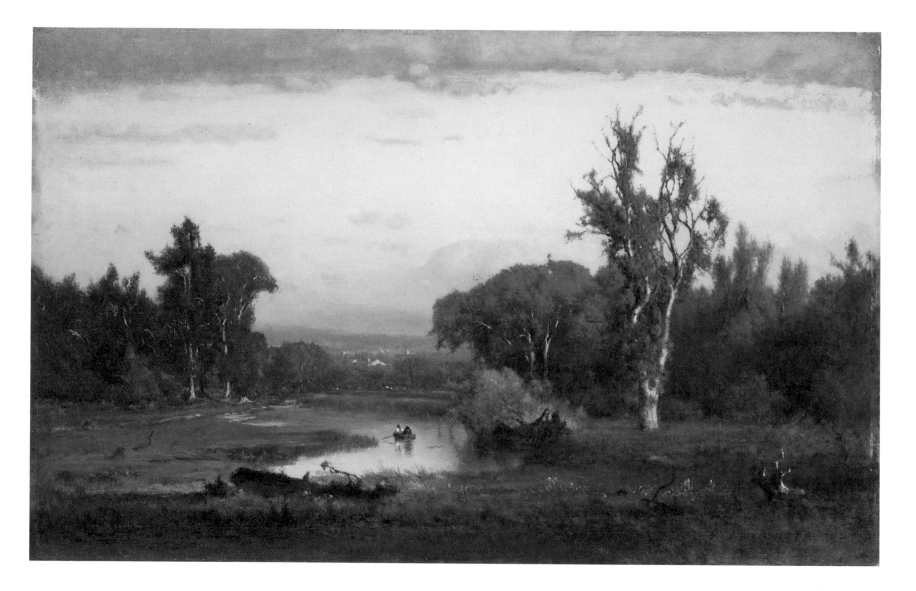

Landscape, Hudson Valley 1870

Oil on canvas
30 x 45 in. (76.2 x 114.3 cm)
Ireland 503
Cincinnati Art Museum
Bequest of Frieda Hauck

This work was painted in the Catskill Mountains. The natural features of the Catskills demanded an expansive form of artistic address, and this grandly spacious painting differed accordingly from Inness's typically more intimate and enclosed compositions. So did *Catskill Mountains* (cat. no. 17), also of 1870.

But the Catskills were also intimately linked with a tradition of art, one which no American artist who painted them could completely escape. The tradition originated in the accomplishment of Thomas Cole (fig. 16a). He made the Catskills a canonical subject for American landscape painters, and his vision of space established conventions for depicting the Catskills that became as binding for American artists as Claude's vision of light was for depicting Italy. Even Inness, who among the artists following Cole most resisted his influence, could not, it seems, avoid Cole's example in depicting the Catskills.

Inness's Catskills, however, are not Cole's. They are not, like Cole's, fresh, wild, and unspoiled. The smoke of chimneys, not mists and vapors, rise from the earth. And Inness's civilized aesthetic, not Cole's wilderness one, rules his image of the Catskills. A glorious light illuminates the sky and, falling with special partiality on each and every human habitation, seems to give divine sanction to this civilized ordering of the world. —*N.C.*

Fig. 16a. Thomas Cole (United States, 1801–1848). *Sunny Morning on the Hudson River.* Oil on panel. 18 ¾ x 25 ¼ in. (47.6 x 64.1 cm). Courtesy, Museum of Fine Arts, Boston. Bequest of Martha C. Karolik for the Karolik Collection of American Paintings, 1815–1864.

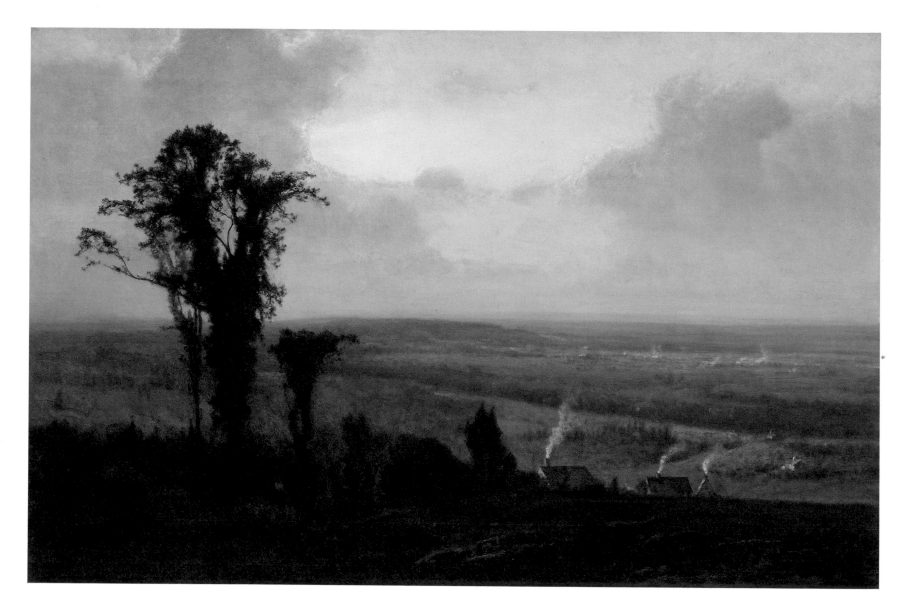

17 Catskill Mountains 1870

Oil on canvas
48 ¼ x 72 ¼ in. (122.6 x 183.5 cm)
Ireland 510
Courtesy of The Art Institute of Chicago
Edward B. Butler Collection

110 In the sense that both *Approaching Storm* (cat. no. 14) and this paint-
ing capture nature in her most transcendent moods, it might be said
that these are religious paintings. In the late 1860s Inness was intro-
duced to and thereafter was a devoted follower of the teachings of the
religious philosopher Emanuel Swedenborg. From Swedenborg
Inness learned, as a biographer reported in 1867, "that all material
objects in form and color have a spiritual significance."[1] In *Approach-
ing Storm*, it is not physical wind or light, but spirit, that seems to
move and animate nature. And it is a spiritual radiance that bursts like
a divine revelation into *Catskill Mountains*. These and other paintings
of the late 1860s are Inness's attempts to express in art his religious
insights into nature's spiritual significance and divine meaning. They
depict those special moments when nature becomes articulate, when
matter is the vehicle of spirit and natural forms are capable of tran-
scendent utterance. —N.C.

[1]"American Artists," *Harper's Weekly* 11 (13 July 1867): 433.

The Tiber below Perugia 1871

Oil on canvas
19 ⁷⁄₁₆ x 30 ¼ in. (49.4 x 76.8 cm)
Ireland 526
The Toledo Museum of Art, Ohio
Gift of Arthur J. Secor

Inness's second trip to Europe, made almost twenty years after his first, was his longest: it began in 1870 and lasted until 1875. He spent almost all of those years in Italy, principally in Rome but, as this painting indicates, travelling elsewhere in search of subject matter. The trip was financed by the Boston art dealers Williams & Everett, with the understanding that they were to receive all of Inness's paintings except those he sold abroad. As a comprehensive, summary description of Italian life, light, and landscape, this painting—one of the earliest he did in Italy and, among those early Italian paintings, the finest—was probably made to satisfy his dealers' expectations for popular, salable subjects. Its composition, similar to that of *Landscape, Hudson Valley* of 1870 (cat. no. 16), may respond to the American taste for panoramic landscapes. Like other of his first Italian paintings, with their ruins, shrines, and costumed peasants, this too, with its ox cart and grape harvest, does its duty to local color. But it is redeemed from being merely scenic by its subtle light and coloration and by the wonderful tree in the right foreground, charged with expressive animation and painted with an evident delight in almost unendingly complex calligraphic elaboration. "In Italy," Inness said later, "I remember frequently noticing the peculiar idea that came to me from seeing odd-looking trees that had been used, or tortured, or twisted—all telling something about humanity."[1] This is surely one of those trees, humanized not in its mimicry of human motion or emotion, but by recording in its tortured and twisted shape the encounters between man and nature that underlay Inness's conception of "civilized landscape" as a record of "every act of man"[2] and the special beauty that can be the result of that civilizing transaction. —N.C.

[1] "A Painter on Painting," *Harper's New Monthly Magazine* 56 (February 1878): 461.
[2] Ibid.

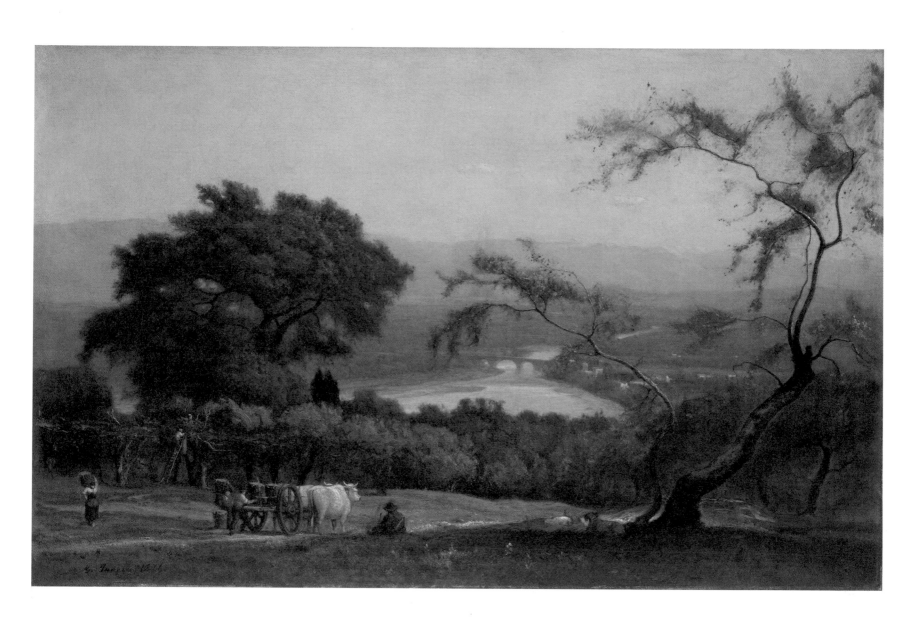

19 Lake Nemi 1872

Oil on canvas
30 x 45 in. (76.2 x 114.3 cm)
Ireland 560
Courtesy, Museum of Fine Arts, Boston
Gift of the Misses Hersey

114

Inness previously visited Lake Nemi on his first trip to Italy in 1851–52, for he painted the town of Genzano (fig. 1a) located nearby, on the hillside beneath the Villa Sforza-Cesarini seen in the distant right in this painting.

Formed by an extinct volcano and set like a precious jewel in the Alban hills south of Rome, the small lake at Nemi had been recognized since antiquity as one of the most beautiful places in Italy. This painting was finished no later than June 1872, because on the 21st of that month Inness shipped it and several other paintings to his dealers in Boston, for whom he painted it. He thought well of it; it was, he reported, "one of my best, as I intended it should be," and, he added, "I am happy to say it was so looked upon by all who saw it in my studio."[1] He had reason to be pleased. With the greatest pictorial economy, he was able to convey the delicate beauty of his subject, to give an almost literally breathtaking illusion of the depth of the crater, accented by the two white birds floating above it. And by balancing the dark and solid portion of the painting at the lower right—not, as required by the conventions of scenic landscape, with an answering mass at the left (which survives only as a thin, parenthetical tree), but with a virtually palpable volume of space—he was able to make a painting of considerable formal daring. —N.C.

[1]Inness to Mr. A. D. Williams, 13 August 1872 (see Ireland 560).

20 In the Roman Campagna 1873

Oil on canvas
26 x 43 in. (66 x 109.2 cm)
Ireland 626
The Saint Louis Art Museum

116 This, like *The Monk* (cat. no. 24), which he painted the same year, is one of Inness's most formally sophisticated paintings. It is properly scenic—depicting a famous place, the Campagna, and a prominent architectural monument, the Lateran—and suitably colorful—joining in the foreground, as an instance of the mingling of the past and the present that Americans found a specially meaningful part of their experience of Italy, a shepherdess and a remnant of ancient architecture. And it creates a convincing illusion of spatial depth and luminously atmospheric distance. But it is the complex interplay of form—the tensions and balances, repetitions and contrasts, of shape and color, occurring as an intricately varied design on the painting's surface—that makes the painting most impressively beautiful.

Inness painted this subject several times. The title of one version, *Sacred Grove near Rome*, points to another of its scenic attributes and also, perhaps, to an aspect of the painting's meaning. For the juxtaposition in precise compositional balance of the sacred grove at the left and the Lateran on the right, and the contrast of pagan and Christian (natural and sacerdotal) religion that it makes, have intimations of ironic commentary. —N.C.

21 Landscape near Perugia c. 1873

Oil on paper on board
12 ½ x 18 in. (31.8 x 45.7 cm)
Ireland 629
Mr. and Mrs. Charles Shoemaker

118

22 The Olives 1873

Oil on canvas
20 1/16 x 30 1/16 in. (51 x 76.4 cm)
Ireland 630
The Toledo Museum of Art, Ohio
Gift of J. D. Robinson in memory of his wife, Mary Elizabeth Robinson

21 Landscape near Perugia
22 The Olives

One of Inness's earliest critics called his paintings "studio concoctions."[1] These two paintings, so different in subject but so nearly the same in compositional arrangement and pictorial structure, are obviously concoctions and inventions, made up in large part from Inness's pictorial alphabet—"Inness used to say that his forms were at the tips of his fingers, just as the alphabet was at the end of the tongue."[2] Two configurations as similar and as orderly as these do not exist externally in nature.

It is not remarkable that Inness invented paintings wholly or in part. Many artists did. Nor is it remarkable that Inness's inventions convincingly resemble natural effects and particular places. Many artists, working from sketches and studies from nature, made entirely plausible compositions. But Inness did not depend on studies and sketches. He did make drawings and watercolors, though relatively few have survived, and almost none have a direct relationship to known paintings. (One exception is the relationship between the watercolor and oil of St. Peter's [cat. no. 5].) He also made few painted studies, and few of them correspond to finished paintings. Some paintings exist in larger and smaller versions, but the smaller version is not necessarily preparation for a larger, later one. *Near Perugia in Spring* (cat. no. 37), for example, is the smaller version of a subject Inness painted two years earlier. In such cases, the smaller version is clearly to be regarded as a variant or replica, not a study from nature. On the other hand, it should be noted that *Landscape near Perugia*, with its somewhat freer technique, was painted on paper, a material traditionally favored for oil sketches in the field.

Unless all of Inness's preliminary sketches and studies have disappeared, which is not likely, the only way to account for the convincingness of Inness's invented pictures—for the way they compel us to believe they *are* pictures—is by his possession of an extraordinary visual memory. It was so exact, so richly stocked, that it provided not only the forms of natural objects and the feeling of natural effects but also the flavor and character of places. He could paint Medfield subjects long after he left Medfield or Italian subjects long after he left Italy, in every way as correct in detail, effect, and flavor as if actually painted in those places. As a result, it is virtually impossible to date Inness's paintings by subject. —*N.C.*

[1] *The Literary World* 10 (8 May 1852).

[2] Elliott Daingerfield, "A Reminiscence of George Inness," *The Monthly Illustrator* 3 (March 1895): 264.

23 The Alban Hills 1873

Oil on canvas
30 x 45 in. (76.2 x 144.3 cm)
Ireland 647
Worcester Art Museum, Massachusetts
Gift from the Lucius J. Knowles Art Fund and Museum Purchase

The Alban Hills, south of Rome, furnished the subject for many of Inness's most important Italian paintings (cat. nos. 19, 24, and 29). It had the advantage of providing both popularly scenic subjects like Lakes Nemi and Albano and refuge, during the summer months, from the threat of malaria (Castel Gandolfo at Lake Albano, for example, was the summer residence of the pope).

With its sweeping space and expanse of sky, *The Alban Hills* is one of the purest landscapes that Inness painted in Italy. It includes shepherds, peasant women, and ruins, to be sure. But as it was put feelingly in the year it was made—speaking of another painting, but in words that apply just as well to *The Alban Hills*—it is not local color but the light and color of the entire landscape "that the artist fixes his mind upon, . . . [he] lingers upon delicate distinctions of color in foliage, and he clothes his vision of Italian sky in tints that seem borrowed from the vesture of the pearl."[1]

The same writer also said generally of Inness's recent art, "you do not know quite what to look for in Mr. Inness next," for "there is a certain experimental air pervading all."[2] He meant that it was technically uncertain. But he could just as well have been describing the often astonishing formal variety of some of Inness's Italian work and the extremes to which Inness was willing to go in exploring certain conditions of form. His paintings of 1873 were in this respect particularly radical and particularly diverse: for example, while *In the Roman Campagna* and *The Monk* (cat. nos. 20 and 24) are carefully plotted compositions carried nearly to the point of abstraction, *The Olives* (cat. no. 22) and *The Alban Hills* are conceived in quite different formal terms, not as shape and structure, drawing and design, but as spatial fields, as single, undifferentiated sensations of color and painterly texture. —N.C.

[1]George P. Lathrop, "Art," *Atlantic Monthly* 31 (January 1873): 115–16.
[2]Ibid.

The Monk 1873

Oil on canvas
38 ½ x 63 in. (97.8 x 160 cm)
Ireland 660
Addison Gallery of American Art, Phillips Academy, Andover,
Massachusetts
Gift of Stephen C. Clark

By collapsing space and flattening objects to shapes, Inness has transformed such scenic and romantic staples of Italy as the white-robed monk and the pines and olives of the Villa Barberini at Albano at twilight (when sold in 1876 the painting was entitled *The Pines and the Olives*)[1] into a virtually abstract two-dimensional design. Its flatness and occult balance suggest the influence of Japanese art, which overcame many Western artists at this time. If that is the source, however, there is oddly no other case in Inness's art in which that influence is as explicit as this one. Inness had for a great while been criticized for making "studio concoctions" and thinking "more of his method than his theme."[2] Yet he never before made a painting as flagrantly formal as this one. Perhaps it was his long-standing potential for doing so, liberated by the more challenging and tolerant artistic climate of Europe, rather than any newly encountered influence, Japanese or otherwise, that explains it. For the same formal inclination is at work in other paintings of the period, like *In the Roman Campagna* (cat. no. 20) painted the same year, with very different visual results. —N.C.

[1]See Ireland 660.

[2]*The Literary World* 10 (8 May 1852); *New York Evening Post*, 30 March 1866.

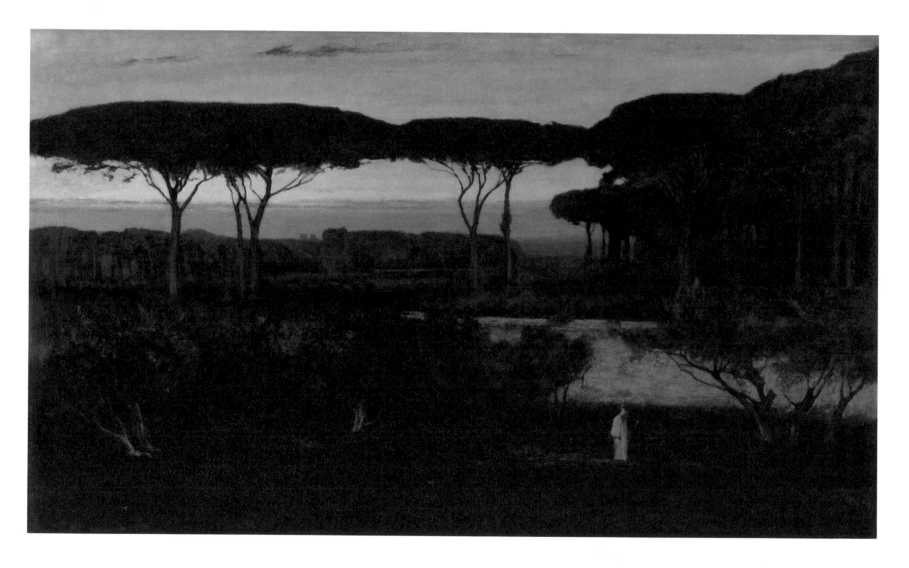

25 Etretat 1875

Oil on canvas
30 x 45 in. (76.2 x 114.3 cm)
Ireland 699
Wadsworth Atheneum, Hartford, Connecticut
The Ella Gallup Sumner and Mary Carlin Sumner Collection

126 Inness left Italy for France in 1874, primarily for the benefit of his son's artistic education (he studied for a time with Léon Bonnat) but also, perhaps, with the intention of exhibiting in the 1874 Salon exhibition, where he did show a single painting, *Environs de Perugia (Italie)*. He was in Paris by June and stayed until February 1875, when he returned to America.[1] In France, Inness did very little painting, and he apparently did all of it at Etretat, on the coast of Normandy. Etretat is best known now through the paintings that Claude Monet made there in the middle 1880s. But for much of the nineteenth century it had been a popular resort "especially affected by artists and literary men . . . attracted by its picturesque and curious situation."[2] One of the large natural arches that were its chief curiosities, the Porte d'Aval, was the subject, depicted from various points of view, of all of Inness's paintings of Etretat. Some of these paintings, like this one, were evidently painted or completed in America: this painting must be the "view of Etretat . . . with a storm in the west, the treatment of which is very powerful" that was seen in his Boston studio in October 1875.[3] *Hillside at Etretat* of 1876 (fig. 25a), the "view of the famous cliff . . . with heavy masses of foliage, light breaking in on one side, and heavy masses of cloud on the other" exhibited in New York in 1876, must also have been painted in America.[4] —N.C.

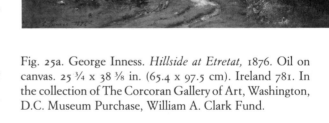

Fig. 25a. George Inness. *Hillside at Etretat,* 1876. Oil on canvas. 25 ¾ x 38 ⅜ in. (65.4 x 97.5 cm). Ireland 781. In the collection of The Corcoran Gallery of Art, Washington, D.C. Museum Purchase, William A. Clark Fund.

[1]Inness to J. C. Dodge, 9 June 1874, National Gallery of Art; he arrived in New York on the *Algeria*, 28 February 1875.

[2]Karl Baedeker, *Northern France* (Leipzig, 1899), 70.

[3]*Boston Transcript*, 12 October 1875.

[4]*Boston Transcript*, 15 November 1876.

26 Kearsarge Village 1875

Oil on canvas
16 x 24 in. (40.6 x 61 cm)
Ireland 751
Courtesy, Museum of Fine Arts, Boston
Gift of Miss Mary Thacher in memory of Mr. and Mrs. Henry C.
Thacher and Miss Martha Thacher

After returning from Europe in 1875, Inness lived once again in Medfield, Massachusetts. But he spent the entire summer of 1875 in the White Mountains of New Hampshire, using as his studio the upper floor of an old schoolhouse in North Conway village.[1]

The White Mountains were regarded in the early nineteenth century as the nearest American equivalent to the Alpine scenery of Europe. They were a powerful attraction for American artists, who were, in turn, largely responsible for the mountains' wider fame. Winslow Homer's *Artists Sketching in the White Mountains* of 1868 (fig. 26a) suggests the density of the region's artistic population. Cole, Durand, Kensett, Cropsey, Bierstadt, and Homer were a few of the artists who worked there.[2] Inness, however, had never painted in the White Mountains before 1875, preferring less grand and emphatic subject matter. When he did paint there, it was not in the usual way. He shifted the burden of expression from natural monuments to natural moments, depicting the sometimes dramatic, sometimes delicate play of color, light, and atmospheric movement, not specific scenes or celebrated sites. In so doing, he reinterpreted and refreshed the White Mountains as a subject of art.[3]

Kearsarge Village was probably painted in the White Mountains in the summer of 1875. It may be the painting that was shown at the Boston Art Club in 1876, described as "a ledge study, with vigorously painted evergreens between the middle distance and foreground, with clouds, some catching the vivid white lights and others in grey masses breaking over the brow of the mountains." It was pronounced "probably the most striking landscape of New Hampshire scenery shown here this season."[4] —N.C.

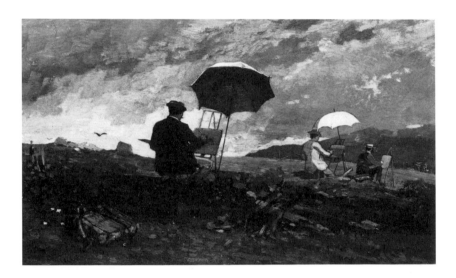

Fig. 26a. Winslow Homer (United States, 1836–1910). *Artists Sketching in the White Mountains,* 1868. Oil on panel. 9 ½ x 15 ⅞ in. (24.1 x 40.3 cm). Portland Museum of Art, Maine. Charles Shipman Payson Collection.

[1] "The Arts," *Appleton's Journal* 14 (18 September 1875): 375.

[2] See *The White Mountains: Places and Perceptions,* exh. cat., University Art Galleries, University of New Hampshire, Durham, 1980.

[3] Donald D. Keyes, "Perceptions of the White Mountains: A General Survey," *The White Mountains: Places and Perceptions,* 56, calls attention to the unconventionality of Inness's White Mountain paintings.

[4] *New York Evening Post,* 26 January 1876.

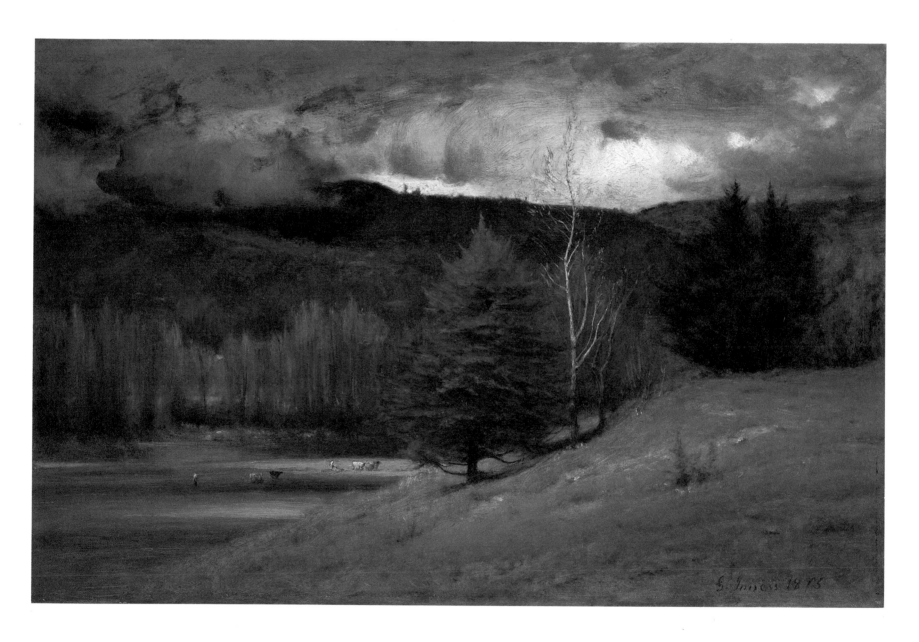

27 Passing Clouds 1876

Oil on canvas
20 x 30 in. (50.8 x 76.2 cm)
Ireland 774
Private Collection

130

This painting is closely related to *Saco Ford: Conway Meadows* (cat. no. 28) but in a different mood. One critic felt that Inness's Conway paintings were "better designated as 'days,' than as this or that particular view."[1] These paintings are two of Inness's White Mountain "days."

Passing Clouds must have been one of the impressions of weather that Inness is known to have rushed back to his studio to dash off in a couple of hours of energetic painting. There is a broad simplicity of technique and vigor of execution that bespeak spontaneous work carried to completion in a single sitting. The brilliant effects of this painting are a showcase for Inness's mastery of technique. —M.Q.

[1]"The Arts," *Appleton's Journal* 14 (18 September 1875): 376.

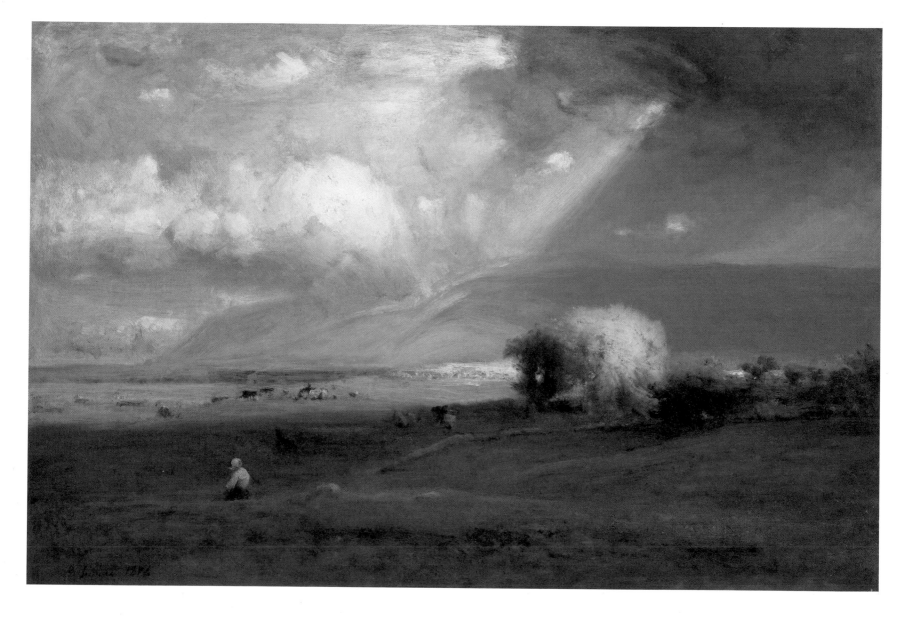

28 Saco Ford: Conway Meadows 1876

Oil on canvas
38 x 63 ¼ in. (96.5 x 160.7 cm)
Ireland 775
Mount Holyoke College Art Museum, South Hadley,
Massachusetts
Gift of Miss Ellen W. Ayer

132

According to one of his friends, Inness precipitously left Boston for the White Mountains during the summer of 1875, when he happened upon a fellow artist who was going there.[1] He ended up staying four months at the Kearsage House in North Conway, New Hampshire.

Inness's choice of North Conway as a summer sketching ground appears to have been impulsive, but this decision to paint in an area famous for its scenery fits into the direction of his work during the preceding five years. He had spent those years working in Italy and France, where he painted subjects that supplied an American market for recognizable views. Like the famous natural arch in *Etretat* (cat. no. 25), the view across the Saco River to Moat Mountain and the Ledges was a famous picturesque sight. It was previously painted by numerous artists, among them John F. Kensett and Albert Bierstadt.

But a painting such as *Saco Ford: Conway Meadows* is far more than merely an example of view painting. The breadth of Inness's execution obscures the detailed landmarks in order to contribute to the painting's surging energy. Instead of the lucid atmosphere and sunny skies of conventional views, Inness has given us an image of nature in all her majesty.

This painting may be the one entitled *The Ford of the Saco* exhibited in Boston in September 1876. It is, however, close in subject to a painting of Mote Mountain described a year before, in which there were "great masses of cloud and the vapors that precede the mountain-storms, which, descending the upper ridges of the mountain, settle down toward the valley below, and wrap its huge shoulders in obscurity and gloom. Frequently by day the farms and orchards that cover its base are bathed in bright sunshine, while the upper regions of the mountain are hidden by dense and dark thunder-clouds, which roll about it in round masses dun as smoke."[2] —M.Q.

[1] J. A. S. Monks, "A Near View of Inness," *The Art Interchange* 34 (June 1895): 149.

[2] "The Arts," *Appleton's Journal* 14 (18 September 1875): 376.

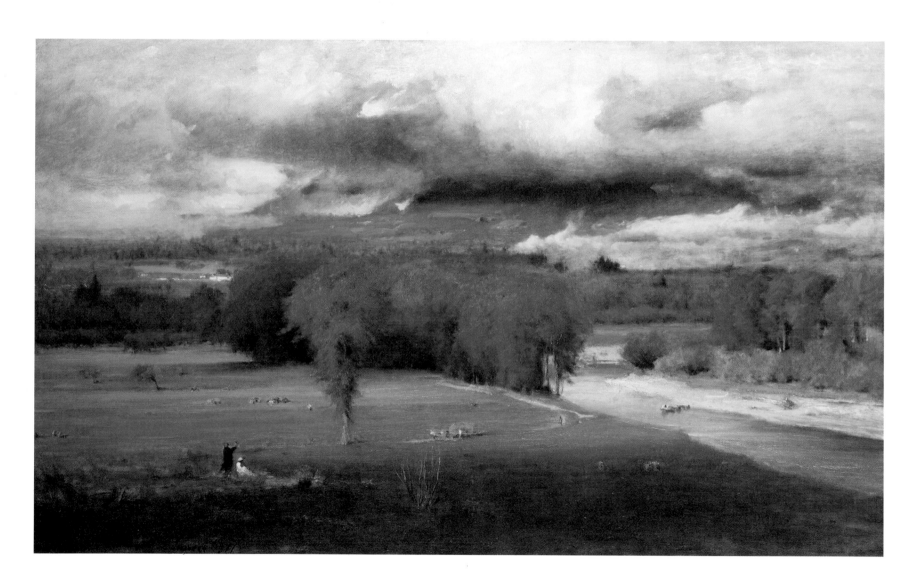

29 Castel Gandolfo 1876

Oil on canvas
20 x 30 in. (50.8 x 76.2 cm)
Ireland 792
Portland Art Museum, Oregon
Helen Thurston Ayer Fund

134 This painting is in every detail related to, but in style and quality totally unlike, a larger version of the subject entitled *Lake Albano, Sunset* (fig. 29a). The larger painting is darkly toned, thickly and almost clumsily painted, and depicts the motif at sunset; whereas this version is high keyed, crisply accented, and deftly painted and depicts the scene in a delicate morning light. Inness described the subject to the purchaser of the larger painting as "a view of Lake Albano taken from near the Franciscan Convent which is situated on the east side of the lake and the garden walls of which you see on the right. On the opposite shore is Castel Gandolpho [sic] or as it is generally called by Italians, Castello."[1] Castel Gandolfo was the summer residence of the pope.

The usual reading of this painting's date is 1876, which would mean that it was painted in America after Inness's return from Italy. It is entirely possible, since Inness did paint a number of Italian subjects after his return. But the last digit of the date may read 4, not 6, which would mean, of course, that it was painted in Italy. The larger painting is not dated, but it was evidently sold in 1874 and may have been painted in that year (Ireland 564 dates it c. 1872, without explanation). The two paintings, in other words, could well have been painted at about the same time, not as a pair or pendants (they are too different in size) but perhaps as two deliberately different considerations of the formal and expressive possibilities of the same motif. —*N.C.*

[1]Inness to Mr. J. C. Dodge, 9 June 1874, National Gallery of Art. Ireland 564 transcribes Castello as "Costello."

Fig. 29a. George Inness. *Lake Albano, Sunset,* c. 1872. Oil on canvas. 30 ⅛ x 45 in. (76.5 x 114.3 cm). Ireland 564. National Gallery of Art, Washington, D.C.

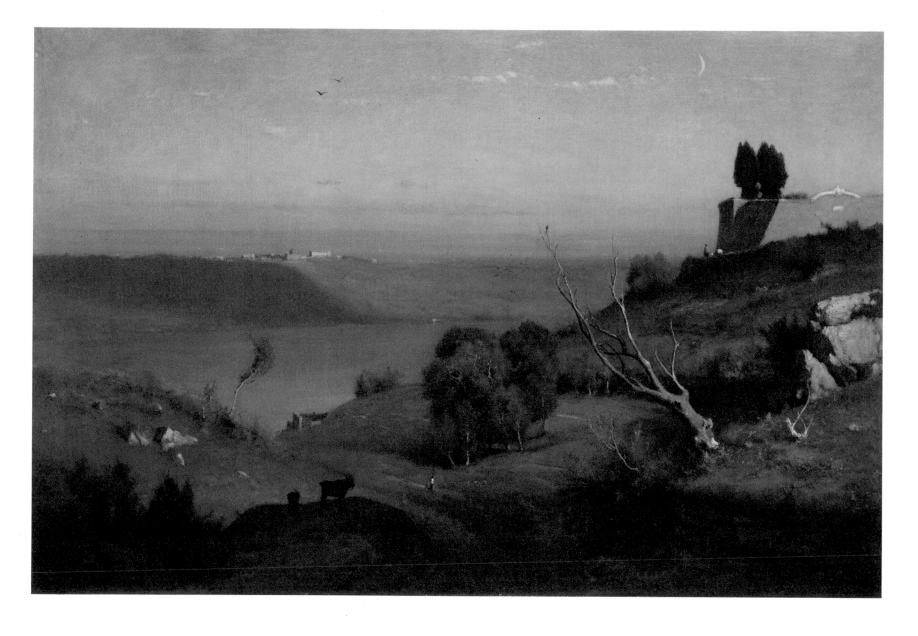

30 Autumn Oaks c. 1877

Oil on canvas
21 ⅛ x 30 ¼ in. (53.7 x 76.8 cm)
Ireland 729
The Metropolitan Museum of Art, New York
Gift of George I. Seney, 1887

136

Having received exceptional early prominence as a gift to the Metropolitan Museum of Art in 1887, *Autumn Oaks* has become one of Inness's most popular and widely known paintings. In spite of this wide attention, both its subject and its date are unknown. It has usually been dated about 1875, but that is probably too early. It seems more at home with paintings of a later date, like *Medfield* of 1877 (cat. no. 31). And their striking similarities of construction and effect, as well as their strong feeling for the same time of the year, suggest that they may depict the same region.

These similarities, however, although not as close as those between *Landscape near Perugia* and *The Olives* of 1873 (cat. nos. 21 and 22), are close enough to suggest also, despite their resemblance to seasons and places, that they comprise a substantial measure of invention.

Artistic invention was an important issue for Inness, a central premise of his artistic understanding. It was not merely a gift for making up pictures. It was, rather, what Inness called the "science" of art, a systematic means of organizing experience and perceiving its essence. "Landscape is a continual repetition of the same thing, in a different form and in a different feeling," he explained. "When we go outdoors our minds are overloaded; we don't know where to go to work. You can only achieve something if you have an ambition so powerful as to forget yourself, or if you are up on the science of your art. If a man can be an eternal God when he is outside, then he is all right; if not, he must fall back on science."[1] Invention, as "science," consisted of artistic wisdom, accumulated knowledge, and experience. But it also consisted in an important way of feeling, the "artistic impulse." Inness told how, at the beginning of his career, he found that paintings made "under the impulse of a sympathetic feeling," though not "correct," had more charm and beauty than ones that were dutifully exact depictions of what he saw.[2] To paint what he saw, he came to realize, was to paint with the physical eye only. To follow the promptings of feeling, not the strict requirements of fact, was somehow to engage the spirit, the "true artistic impulse," which was divine.[3] Allowing himself the latitude of invention, the freedom to obey feelings guided by the science of art, he touched the divine essence of nature as no exact imitation of its appearance could. —N.C.

[1]*New York Herald,* 12 August 1894.
[2]Ibid.
[3]"A Painter on Painting," *Harper's New Monthly Magazine* 56 (February 1878): 461.

31 Medfield 1877

Oil on canvas
20 x 30 in. (50.8 x 76.2 cm)
Ireland 819
Private Collection

138

This painting appears twice in LeRoy Ireland's catalogue of Inness's work, the first time as number 400, with the date misread as 1867. Since the entry indicates that he judged what he called number 400 only from a photograph, the error of dating is perhaps understandable. The subject of the painting is Medfield, and the imagery is that of Inness's Medfield period of the early 1860s: pastoral peace, the untroubled sky, the palpable sense of stillness found in *Landscape* of about 1865 (cat. no. 12). While in some later paintings of Medfield, Inness endowed the scene with the drama of *Autumn Oaks* (cat. no. 30), in others he indulged what must have been fond recollections of the tranquility of the place.

In looking at the painting, rather than merely a photograph of it, it is clear that *Medfield* belongs among the work of the late 1870s. The obvious proof is the richness and strength of its color, as well as the greater breadth of its technique. One also notices that the season is autumn, rather than the eternal summer of the early 1860s, and the time is late afternoon, rather than the midday characteristic of the earlier period. All of these elements contribute to a poignant mood of nostalgia and gentle melancholy, reflecting a more mature and more resonant point of view. —M.Q.

Oil on canvas
35 ¼ x 53 ½ in. (89.5 x 135.9 cm)
Ireland 821
Haggin Collection, The Haggin Museum, Stockton, California

This painting, another Medfield subject, occupied the place of honor in the principal gallery in the 1877 exhibition of the National Academy of Design.[1] It was among Inness's contributions that year that prompted a critic to say, "The landscapes of no painter in the exhibition, young or old, are so luminous, so full of vitality. The artist has lost none of the force, and what is still more remarkable, none of the curiosity of youth."[2] It was also much admired as an example of Inness's successful application of French style to American subjects, an admiration symptomatic of the enlarged regard and understanding of European art that overcame Americans in the late 1870s. The critic of the *New York Tribune* said Inness "fulfilled all the requirements of French landscape art without imitating it. He has given us, most admirably, the facts of Nature, and so much of her poetry as reaches the optic nerve."[3] The critic of the *New York Sun* was more expansive: "Our painters err chiefly in their bald and prosaic transcripts of natural scenery, and whether the tendency can be corrected by practice in European schools may be doubted. One of our best workers in this department has, however, applied foreign methods to the delineation of domestic scenery with undeniable success. Inness, whose style may be said to have been formed on that of Rousseau and of Corot, disdains finish, and in imitation of his distinguished masters, by a broad, free, and often coarse handling, infuses a simple bit of landscape with rich color and luminous atmosphere. His works, if unlike those of most American artists, are quite as true to nature, and exhibit often an individuality which renders them particularly attractive."[4]

If the painting's style was formed on French examples, there is in its subject—in its aged trees and old house—a feeling of settled permanence and measured historical time that may be a deliberate appeal to the nostalgia for their own past that Americans sensed with special keenness as a result of the centennial celebration of 1876. One recalls the early homesteads that figure so prominently in Worthington Whittredge's Newport landscapes of the same period. —N.C.

[1] *New York Evening Post,* 30 March 1878.

[2] *The Century* 14 (June 1877): 264.

[3] *New York Tribune,* 21 April 1877.

[4] *New York Sun,* 15 April 1877.

33 Gray, Lowery Day c. 1877

Oil on canvas
16 x 24 in. (40.6 x 61 cm)
Ireland 828
Collection of The Wellesley College Museum, Massachusetts

This painting was once owned by Thomas B. Clarke, the pioneering collector of American art. At a time when most American collectors were buying fashionable European artists, Clarke bought Americans. He bought their works liberally, not with mere acquisitive avidity, but with the avowed purpose of encouraging American artists and with taste and discernment that led him to obtain some of the greatest paintings of such major American artists as Inness, Winslow Homer (he owned thirty-one Homers), and Albert Pinkham Ryder. Inness was Clarke's favorite artist. He is reported to have said, "In my collection there was a God (meaning George Inness) and a Giant (meaning Winslow Homer). They stood alone."[1]

Clarke was Inness's major patron. Inness was one of the first artists whose work he acquired when he began collecting in earnest in the late 1870s, and this painting was one of his first acquisitions. Clarke eventually owned thirty-nine Innesses, more than by any other artist (cat. nos. 40, 41, and 52 were also once owned by Clarke). He also served as Inness's agent during the last fifteen years or so of the artist's life, and his shrewd management was to a great extent responsible for Inness's contemporary reputation. Clarke was responsible in certain cases for Inness's posthumous reputation as well, for it was Clarke's ownership of some of his paintings that established their subsequent value and fame. That is particularly true of *Gray, Lowery Day*. Only occasionally exhibited and discussed during Inness's lifetime, it brought the highest price of any painting (over $10,000) when Clarke sold his American collection in 1899 and thereby entered the canon of Inness's most esteemed paintings. The veracity of its closely tuned greens astonished early commentators. Now that it has entered a public collection, a new generation of viewers will likewise be astonished by the power of this almost legendary painting. —N.C. & M.Q.

[1]*The Bookman* 47 (July 1918): 487.

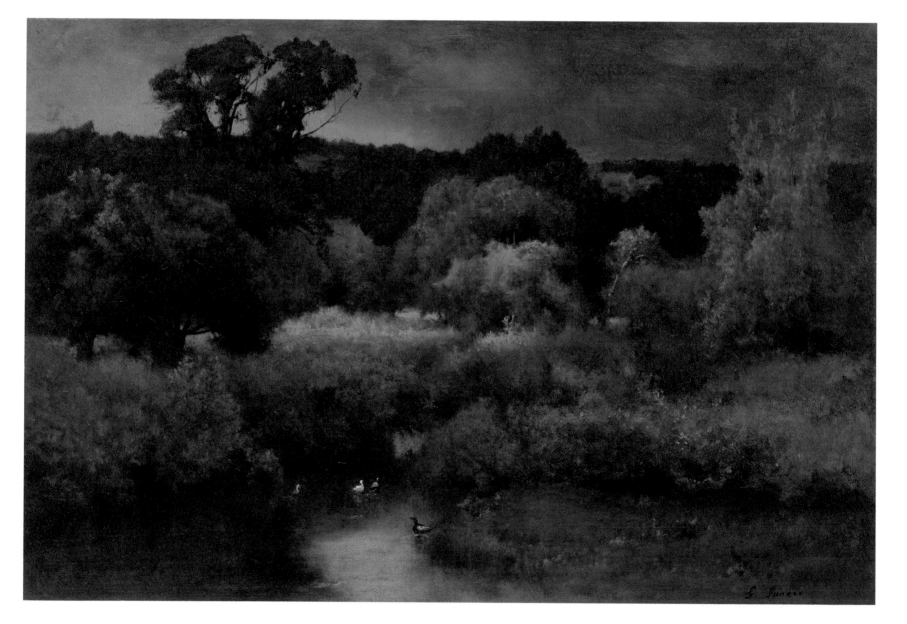

34 The Coming Storm 1878

Oil on canvas
26 x 38 ½ in. (66 x 97.8 cm)
Ireland 875
Albright-Knox Art Gallery, Buffalo
Albert H. Tracy Fund, 1900

144

This painting represents the climax of the expressive trend in Inness's work of the late 1870s. A change of style had accompanied his shift to storm subjects during those years; the big skies and stretches of distance in the storm paintings are opposed to an overall preference in Inness's work for intimacy, enclosed spaces, and undramatic presentation. The stronger contrasts in the dramatic skies were painted with increasingly free and forceful brushwork. The paintings were more violent in subject matter and in execution.

In this painting the new style reached a pitch of frenzied energy almost chaotic in its intensity. The bold and summary brushwork blurs the particular while sweeping everything up in its surging rhythms. Its universal turbulence blends earth and sky as on the day of creation. This vision of nature molded by titanic forces belongs to the Romantic period, during which Inness began his career. *The Coming Storm* of 1878 repeats the violence of some of Inness's storm paintings of the 1840s, but with an authority of technique and unity of means that lifts it to quite another level of achievement. Where the earlier paintings were dark, this was painted in rich and clear colors. —M.Q.

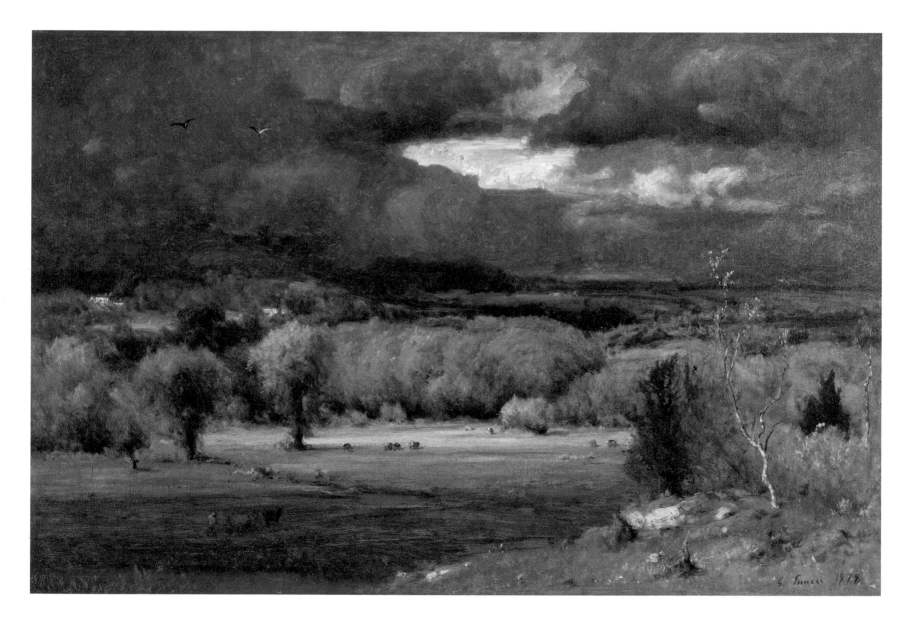

35 The Coming Storm c. 1879

Oil on canvas
27 ½ x 42 in. (69.9 x 106.7 cm)
Ireland 934
Addison Gallery of American Art, Phillips Academy, Andover,
Massachusetts

146 This painting is not dated. But it was given by Inness to his daughter as a wedding present, when she married in 1879. Therefore, the painting must have been made that year or the year before. Inness had a particular fondness for passing or impending storms in the late 1870s. In 1879, for example, he exhibited paintings with titles such as *After the Shower, After the Storm, A Passing Thunderstorm,* and *Storm Effect—Valley of the Saco.* Inness painted the subject so often that one critic was driven to remark, "as for thunderstorms, and driving rains, and 'great-coat' weather in general, commend us to Mr. Inness for a steady supply."[1] The critic found their intensity hard to tolerate— "Fancy being obliged to live in a room with one of these explosive, tempestuous pictures!" he exclaimed—but he obviously sensed Inness's expressive intentions. As another critic wrote of Inness's paintings a year later, "art here concerns itself not with the imitation of things, but with the reproduction of emotion."[2] —N.C.

[1]*New York Tribune,* 12 April 1879.
[2]*New York Evening Post,* 17 February 1880.

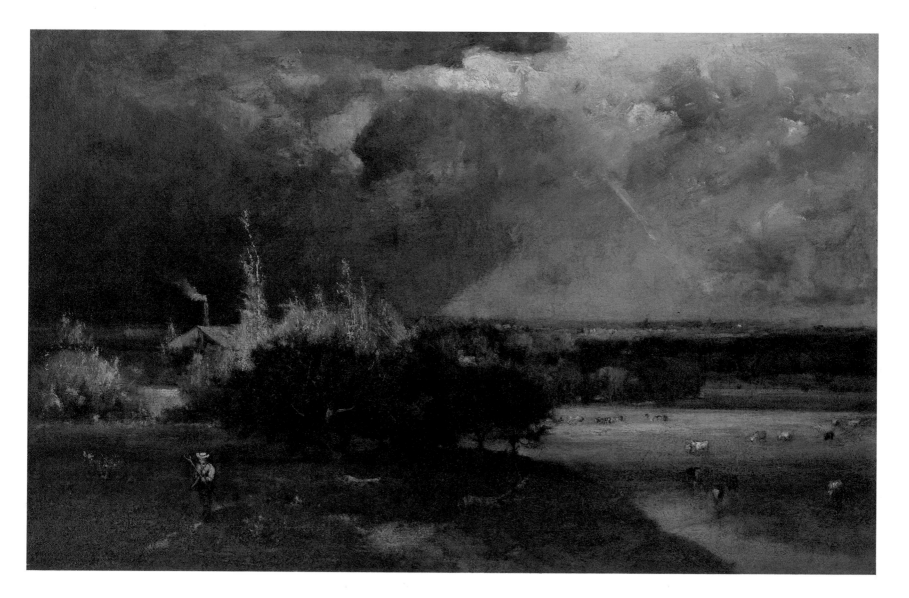

36 The Rainbow c. 1878–79

Oil on canvas
30 ¼ x 45 ¼ in. (76.8 x 114.9 cm)
Ireland 497
Indianapolis Museum of Art
Gift of George E. Hume

148

As with other important Inness paintings of the late 1870s, both the exact title and date of this work are unknown.

Its present title derives, of course, from the rainbow arc in its right half. This painting is a particularly fine and striking example of the stirring episodes of weather, particularly of sudden dramatic contrasts of light and dark, that Inness painted so often in the late 1870s. Indeed, it is very close in conception and effect to *The Coming Storm* of about 1879 (cat. no. 35). This resemblance, coupled with the fact that *The Rainbow* was illustrated in *Harper's New Monthly Magazine* in March 1879, strongly suggests a date in or about that year.

Rainbows had been important elements of Inness's earlier paintings. A rainbow was the subject and chief symbolic instrument of *The Sign of Promise* of 1863 (repainted, without its rainbow, as *Peace and Plenty* in 1865). When he painted this work, Inness regarded the rainbow differently. In 1878, comparing the French artists Corot and Meissonier, the one suggestive, the other precisely imitative, Inness said: "Let Corot paint a rainbow, and his work reminds you of the poet's description, 'The rainbow is the spirit of the flowers.' Let Meissonier paint a rainbow, and his work reminds you of a definition in chemistry. The one is poetic truth, the other is scientific truth; the former is aesthetic, the latter is analytic."[1] The rainbow, for Inness, was not now a symbol of specific traditional meaning but a poetic truth, a distillation of nature's spiritual essence. —*N.C.*

[1]"A Painter on Painting," *Harper's New Monthly Magazine* 56 (February 1878): 458.

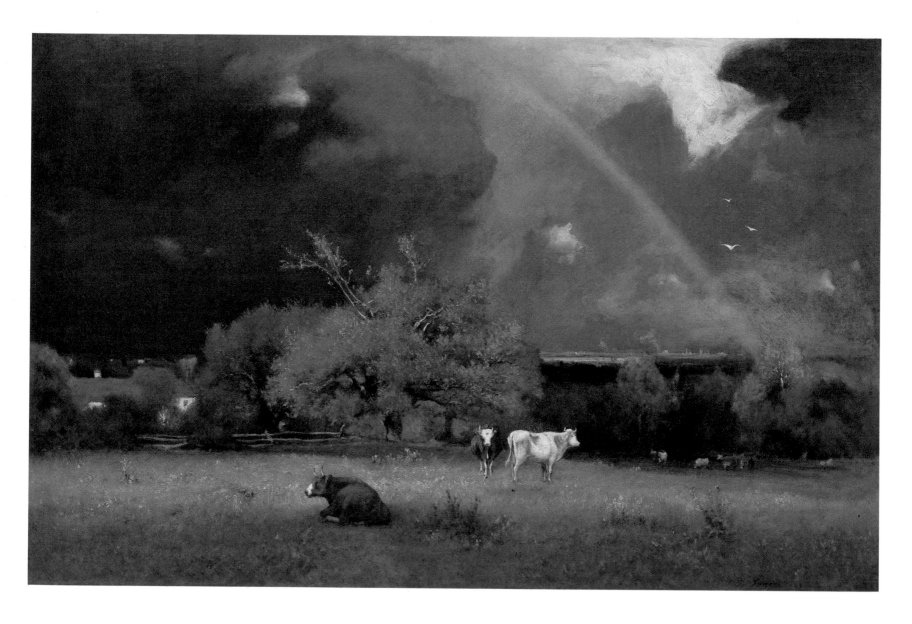

Oil on canvas
41 ¼ x 33 ½ in. (104.8 x 85.1 cm)
Not in Ireland
Private Collection

150

Near Perugia in Spring is a version of an earlier painting (Ireland 619), a 6-by-4½-foot canvas of 1872, now unlocated, that was one of the largest paintings Inness made in Italy. It depicts a particular place— the same place, fitted to a vertical format and seen from a different position, depicted in *The Tiber below Perugia* of 1871 (cat. no. 18). But this carefully executed painting seems to be a distillation and summary evocation of Italy rather than a specific piece of Italian scenery. It includes figures in Italian costume, Italian olive trees, Italian architecture, and Italian landscape. But it was the warm light and soft atmosphere of Italy that affected Inness the most, as they had his artistic predecessors like Claude Lorrain. Light and atmosphere received his greatest attention and were most lovingly painted. They redeem for us, as they may have done for Inness himself, an otherwise highly formal, overly elaborate painting. —N.C.

38 Homeward 1881

Oil on canvas
20 ¼ x 30 ¼ in. (51.4 x 76.8 cm)
Ireland 969
The Brooklyn Museum, New York
Gift of the Executors of the Estate of Colonel Michael Friedsam

152

Beginning in the 1870s, artistic finish was a sometimes bitterly debated issue. It figured centrally in both the criticism of French Impressionism and the Whistler-Ruskin trial in England. American artists, like Winslow Homer, who violated normal standards of finish were repeatedly upbraided for doing so. And finish was very much an issue in Inness's art and thought in the 1870s. His paintings became broader and more summary than ever, and he talked of finish almost as a question of theory in "A Painter on Painting," an interview published in 1878.

Inness believed that finish was incompatible with high artistic quality and ambition. Only mercantile work was finished. "Who ever thinks about Michael Angelo's work being finished?," he asked. "No great artist ever finished a picture or a statue."[1] Painstaking finish was also incompatible with true artistic inspiration and expression. Inness believed, doubtlessly on the basis of personal experience, that "men of strong artistic genius, which enables them to dash off an impression coming, as they suppose, from what is outwardly seen, may produce a work, however incomplete or imperfect in details, of greater vitality, having more of that peculiar quality called 'freshness,' either as to color or spontaneity of artistic impulse, than can other men after laborious efforts."[2] Inness's disdain for conventionally precise finish was notorious by 1880. That year a Chicago critic called him "the high priest of the indefinite."[3] He was also known to paint quickly. A work in the 1881 Society of American Artists exhibition was said to have been painted in three or four hours.[4]

By our standards, *Homeward* is an acceptably finished painting, in many ways more appealing than ones carried further. Despite his scorn for conventional finish and regard for expressive breadth, however, Inness would not have considered this to be a finished painting. He clearly liked it, or it would not have survived. But he would never have exhibited it in its present state.

Homeward is particularly appealing because it provides unusually fresh access to Inness's painting process. That process, as it was described in 1879, had four basic stages: First, Inness would stain the fresh canvas with a transparent pigment (often Venetian red). Next, with charcoal "confirmed" by pencil, he would draw the main forms in outline. Then, beginning anywhere on the canvas, he would paint in large areas and forms and work toward greater and greater detail. Finally, the painting would be glazed and scumbled, and details added.[5]

Inness's "keenest pleasure is usually at the beginning of his task; as the picture gets under way, the labor becomes harder and harder, and he often lays the canvas aside for another one."[6] *Homeward* seems to be one of those cases when Inness stopped after doing the most pleasurable preliminary work of drawing (still visible in the trees) and massing but not returning, as he usually did, to carry the painting through to the final stages of work. It probably remained in his studio in this state and was signed and dated, after his death, by his son.

—N.C.

[1] "A Painter on Painting," *Harper's New Monthly Magazine* 56 (February 1878): 461.

[2] Ibid.

[3] *New York Times,* 4 April 1880.

[4] *New York Evening Post,* 2 April 1881.

[5] Inness's painting method was described by George William Sheldon, *American Painters* (New York, 1879), 31.

[6] Ibid.

39 Summer Pastoral, Sarco Valley,
 Leeds, N.Y. 1882–85

Oil on canvas
40 x 30 in. (101.6 x 76.2 cm)
Ireland 1027
Jordan-Volpe Gallery, Inc., New York

154 There is no Sarco Valley. There is a Saco Valley in the White Moun-
tains of New Hampshire (cat. no. 28) but not in the Catskill Moun-
tains of New York, where Leeds is located. How and when this title
became so jumbled is not known. But its confusion is telling. It sug-
gests that during the 1880s Inness's landscapes became so generalized,
so abstract, that their resemblance to particular places either became
unclear or ceased to matter, and place names became mere conven-
tions, one quite as good as another.

That is not really so. Inness's paintings of the 1880s and after contin-
ued to depict, or at least to suggest, specific places and to have de-
notative titles. But they also became increasingly formal. As in this
painting, internal relationships of form became more explicit and
more visually significant than specific configurations of nature. As a
result, it became less and less clear what a painting depicted, other
than itself. The hopeless confusion of this title is not common, but it
reflects at least one person's confused perception of that condition.

—N.C.

40 Winter Morning, Montclair 1882

Oil on canvas
30 x 45 in. (76.2 x 114.3 cm)
Ireland 1034
From the collection of the Montclair Art Museum, New Jersey
Gift of Mrs. Arthur D. Whiteside

156

Inness settled in Montclair, New Jersey, in the late 1870s. After years of restlessly moving from place to place in America and Europe, Montclair would be Inness's home for the rest of his life. It was also frequently the subject of his art.

Winter Morning, Montclair is one of Inness's most admired paintings. It was acclaimed "the most poetical and individual and at the same time most subtly truthful landscape in the exhibition" when shown at the National Academy of Design in 1882.[1] Admiration for it has been unabated ever since.

Its reputation is deserved. Few of Inness's paintings are at once as subtle and as rich, as disarmingly simple and pictorially complex. It is bleak and cold, without inherent charm or conventional interest as a subject ("hardly more than the ghost of a landscape," one critic felt).[2] Yet, almost as a demonstration of Inness's belief that "subject is nothing, treatment makes the picture,"[3] it is redeemed by the fragile beauty of its mood, its sensitively restrained harmonies of color, and by the varied pattern and visual rhythm of the vertical trees in the upper half, their delicacy contrasted with the heavy, brutally broken, powerfully sculptural forms of the tree trunks lying in the foreground below. Their formal contrast is also the contrast between nature upright with life and immovably recumbent in death. The simultaneous presence of nature's life and death is the essence and concise expression of the seasonal moment that the painting depicts. —N.C.

[1]*New York World,* 10 April 1882.

[2]*Boston Advertiser,* 31 March 1882.

[3]Frederic Edwin Church to Erastus Dow Palmer, 18 March 1890, Albany Institute of History and Art.

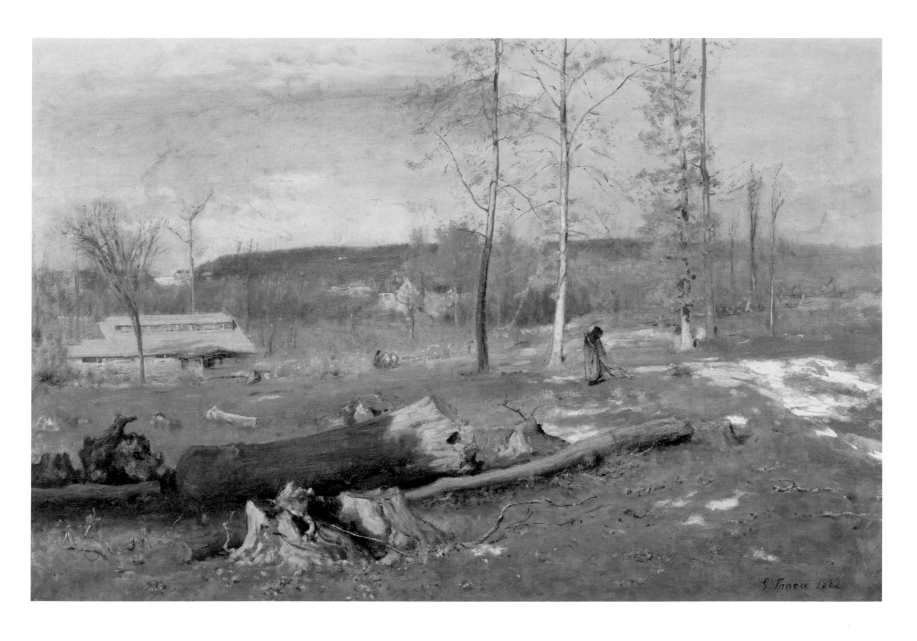

41 Summer Foliage 1883

Oil on canvas
30 x 45 in. (76.2 x 114.3 cm)
Ireland 1062
Dallas Museum of Art
Bequest of Joel T. Howard

In this painting, one must search out the structural elements that are so insistent in other Inness works of the period. The short stretch of wall to the right of the firmly upright central tree is the only clear horizontal element. The central tree, the scattered short, thin trunks that echo it, and the piece of wall are the little that suggests order and proportion in the painting. The rest is an amorphous array of lush, overlapping textures of foliage. The diagonal of the foreground wall is another uncharacteristic motif in this painting, likewise an element that works to undermine the orderly planar arrangement characteristic of Inness's compositions beginning in the early 1880s. Like the prominent foreground diagonals of *Winter Morning, Montclair* (cat. no. 40), the bulky wall contributes most to *Summer Foliage's* sense of being an impromptu painting that lacks a premeditated composition. In terms of the expectations of the public during that period, and as echoed in critical comments, both paintings had the quality of fresh studies: they were informal, direct, and disarmingly intimate.

Art lovers of the period were charmed by the novelty and immediacy of these paintings, placing a very high estimation on them and the likewise celebrated *Gray, Lowery Day* (cat. no. 33). They thought it remarkable that Inness would paint *just* vegetation or *just* the random barrenness of winter. The emphasis in the paintings, then, is on the artist's powers of observation, his clarity of vision, and his ability to set down a score or more of close variations on the color green. *Gray, Lowery Day* records the foliage of early summer under a heavy sky, *Summer Foliage,* the lushness of full summer in the warm light of the season's strong sun.

The random quality of this painting appropriately reflects its subject, which is the overgrown corner of a field. Weeds have grown up tall enough to nearly hide the stone wall that had once been the means and symbol of man's order, dividing field from field, purpose from purpose, perhaps owner from owner. The irrepressible energy of nature has reclaimed what man has left behind. The geometric order of man gives way to nature's randomness. Inness recorded this process in a nearly structureless painting. —*M.Q.*

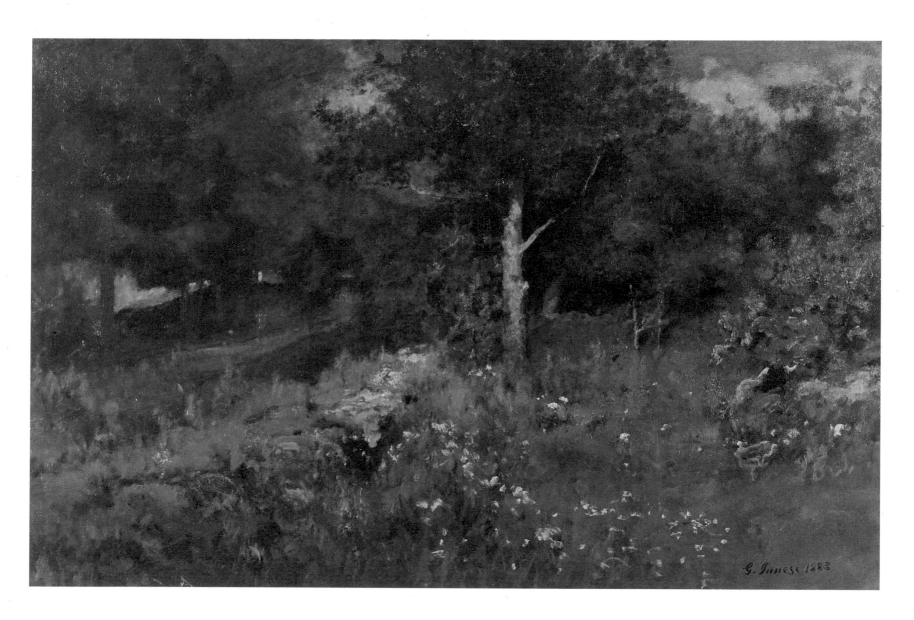

42 Sunshine and Clouds 1883

Oil on canvas
27 ½ x 41 ½ in. (69.9 x 105.4 cm)
Ireland 1085
Private Collection

160 Originally known by the prosaic title *Scene on the Pennsylvania Railroad,* the painting was rechristened with its present title by William T. Evans, the prominent collector of American art and of Inness. The original title would have more quickly drawn the eye to the puff of white smoke, near the right edge of the painting, that signifies a locomotive that is running in a hollow. The smoking locomotive appears in several paintings of just this period, including *Winter Morning, Montclair* (cat. no. 40). The flat and marshy quality of the land suggests that the view may have been taken near where Inness lived, looking across the New Jersey marshes toward where the line of the Pennsylvania Railroad ran, and still runs, near Newark.

Compositionally, the painting belongs to a type often used by American artists in the 1880s, in which most of the interest and detail appear, in light and silhouette, in a thin band along the horizon of the painting. It also belongs to the tradition of the classic Dutch landscape paintings of the seventeenth century, with their straight horizon and large, cloud-filled sky. The sky is the chief focus here. The land, in shadow, is subordinated to the study of changing weather in the sky, the piling up and opening of the great cloud masses. The painting's predominately cool palette also makes the warmth of sunshine felt and welcomed as it falls upon clouds and distant land. —*M.Q.*

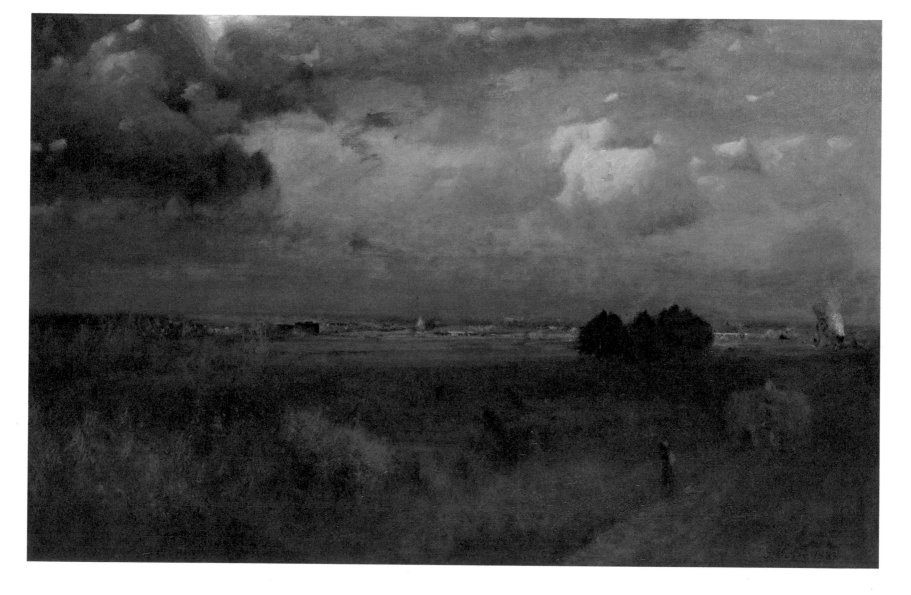

43 Winter at Montclair, New Jersey 1884

Oil on canvas
22 x 36 in. (55.9 x 91.4 cm)
Ireland 1108
Private Collection

162 Inness's landscapes had always included human and animal figures and signs of human use and occupancy. But during the early 1880s, Inness felt the disturbing pressure of a new taste for figure subjects. It developed about 1875 and in a very short time produced a dramatic change in the complexion of American art, seriously eroding the virtually absolute position landscape had held for half a century. Figure paintings and their painters attracted increasing critical attention and patronage. And figure paintings commanded greater space in exhibitions, so that they were no longer, as a critic said earlier Academy exhibitions had been, like "wildernesses where the human form was unknown."[1]

Inness viewed these changes with evident alarm. During the early 1880s, whether it was because he saw his livelihood as a landscape painter threatened or whether, as he told a Montclair acquaintance, he was tired of painting landscapes,[2] Inness tried to remake himself into a figure painter. The attempt was serious, but it was never wholehearted. Its results were seldom happy, and the episode was fortunately a brief one. Except for somewhat larger and more prominent figures, it left no significant mark on Inness's subsequent art.

This painting is the best of Inness's figure paintings of the 1880s, perhaps because its figural subject, so simple and unprepossessing, lends itself—by the pattern made by the clothesline, poles, and drying wash—to inventive pictorial design and is so fully integrated into one of Inness's handsomest and most evocative effects of nature. —N.C.

[1] *The Nation* 20 (1875): 352.
[2] S. C. G. Watkins, *Reminiscences of Montclair* (New York, 1929), 115.

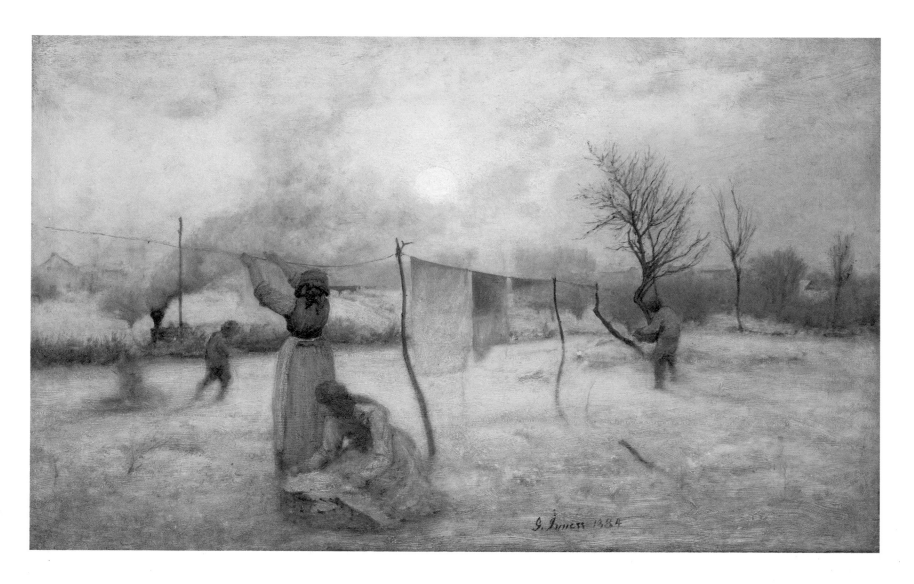

44 Sunset at Montclair 1885

Oil on canvas
30 x 40 in. (76.2 x 101.6 cm)
Ireland 1147
On extended loan to the Columbus Museum of Art, Ohio
from the collection of Mr. and Mrs. Walter Knight Sturges

164 Nothing immediately seems to distinguish this painting of the middle 1880s from earlier ones. Yet it is, in a quite literal sense, fundamentally different. The critic Charles De Kay detected that difference in 1882.[1] In the first comprehensive discussion of the character and development of Inness's art as a whole, De Kay described Inness's early art as analytical and his more recent work as synthetic. De Kay noticed that Inness's early paintings were assembled of parts and pieces and reflected particular sites and effects of nature, while his more recent ones had an initial wholeness, fundamental order, and conceptual generality. This painting is a case in point. Compared to paintings of only a few years earlier (e.g., cat. nos. 30–32), it has a denser, more compact and easily discernible unity. A few simple parts—earth, sky, trees—are held in a clear rectilinear system, its order made more explicitly apparent by large contrasts of light and dark and by a low point of sight and high horizon line that flatten the design and bring it visibly to the picture surface.

What is synthetic about *Sunset at Montclair,* and what separates it most essentially from Inness's earlier paintings, is not only its greater unity. It is, rather, that unity has not been extracted analytically from specific natural appearances but instead precedes appearance as a concept of form from which appearance is artificially derived. Art, in other words, is no longer induced from nature, but convincingly natural appearances are deduced, synthesized, from the forms of art. It was by that synthetic process, beginning in the 1880s, that Inness made his late paintings. —N.C.

[1]Charles De Kay (Henry Eckford, pseud.), "George Inness," *The Century* 24 (May 1882): 57–64.

45 The Storm 1885

Oil on canvas
20 x 30 in. (50.8 x 76.2 cm)
Ireland 1179
Reynolda House Museum of American Art, Winston-Salem,
North Carolina

166 This is the last of Inness's great storm paintings—the last, at any rate, in which he would paint what had been one of his favorite subjects with such ominous, expectant power and electric excitement. In the 1880s his feelings changed. He came to prefer gentler, more serene subjects and was less stirred by nature's extravagances than he had once been. As he matured, he could read nature's meanings in more subtle terms and in more subdued moods, and he could express those meanings through pictorial organization as much as through specially articulate natural effects.

This painting owes its impressiveness not only to its solemn colors and dramatic lighting but also to its trees. Inness had often been attracted to single trees of unusual expressive power and formal complexity (e.g., cat. nos. 15 and 18), but he seldom painted a group of trees as effective as this one. Arranged like parts of a friezelike composition, they embody the scale of reactions to the imminently impending storm, some bending passively before its surging wind, others resisting it, defiantly gesturing with the broken limbs that signify past defiance. In a repertory of poses and gesticulating movements, they make this drama of nature legible in terms of human action and feeling.

—*N.C.*

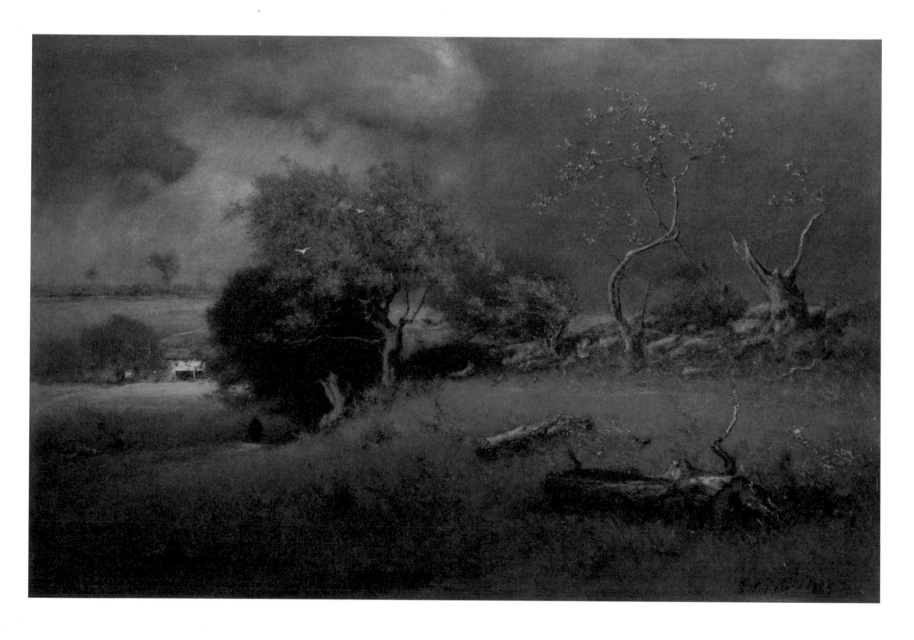

Oil on panel
20 x 30 in. (50.8 x 76.2 cm)
Ireland 1228
Los Angeles County Museum of Art
Paul Rodman Mabury Collection

168

In earlier paintings, Inness depicted different times of the day and different effects of weather, but the season he was fondest of was summer. In the 1880s other seasons began to attract him: he painted winter more frequently and spring, but it was autumn that appealed to him most strongly. It is not clear why. Perhaps by living in Montclair, he was more observant of all the seasons than he had been before, when, following the landscape painter's usual routine, he worked from nature in summer campaigns and painted in his studio in the winter. Or perhaps as he aged (he was sixty in 1885) he found nature's sadder and sterner times temperamentally more attractive and the poignancy of autumn particularly compatible to his feelings. Or perhaps he was inspired by, or took artistic advantage of, autumnal coloration. Inness had never felt constrained to follow nature's colors closely, but autumn gave him a special license to experiment with unusual colors and color relationships.

Like all of Inness's paintings beginning in the 1880s, this painting shows traits of his synthetic style in the explicitness of its ordering principle—the painting is divided almost exactly in half vertically and horizontally—and its consequences of decisive formal clarity. It also has expressive consequences. It gives to the depicted natural effects—ranging from the tranquil softness of this painting to the agitated movement in other works—an eloquent largeness of feeling and a monumental authority that raises them from the transient to the timeless. —N.C.

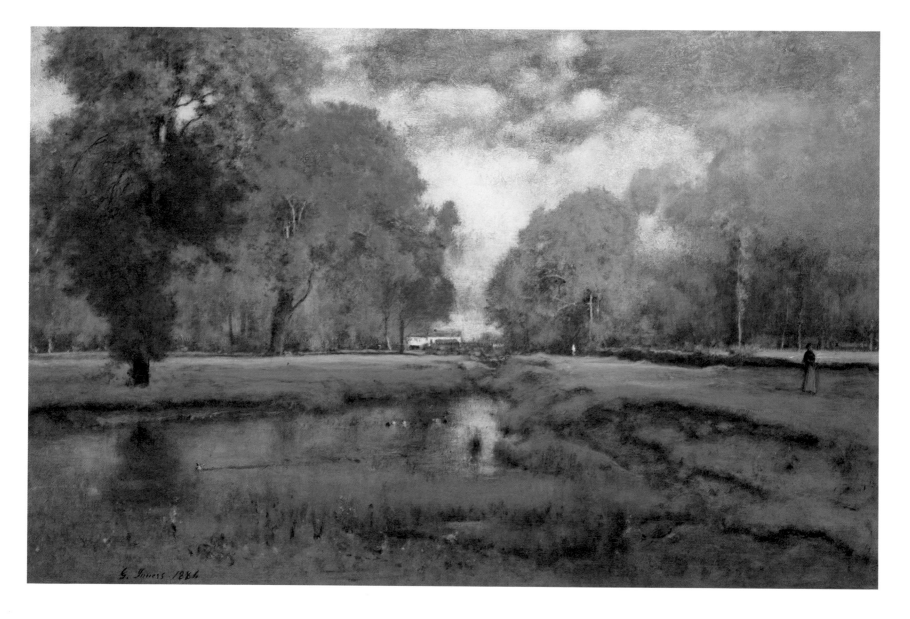

47 Off the Coast of Cornwall, England 1887

Oil on canvas
25 ¼ x 30 in. (64.1 x 76.2 cm)
Ireland 1244
Paine Art Center and Arboretum, Oshkosh, Wisconsin

Inness made a trip to England in 1887.[1] The evidence for it is mainly pictorial: the *Royal Beech, Lyndhurst Forest*, dated 1887 and painted on a canvas prepared in London, and several paintings done in Cornwall, of which *Off the Coast of Cornwall* is the finest.[2]

Coast scenes and seascapes occur infrequently and sporadically in Inness's work and were not, on the whole, his happiest subjects. This painting, one of his most powerful and spirited paintings, is the chief exception. It is not likely that Inness went to the Cornish coast expressly to paint this subject: he never traveled widely in search of subject matter. There is reason to think also that it was not just an experience of nature that moved him to paint it. Many other artists, French, English, and American, painted the same subject at nearly the same time. It was, for instance, precisely this heroic encounter of men and women with the sea that Winslow Homer made the subject of a series of monumental (or monumentally conceived) paintings beginning in the 1880s (fig. 47a). —N.C.

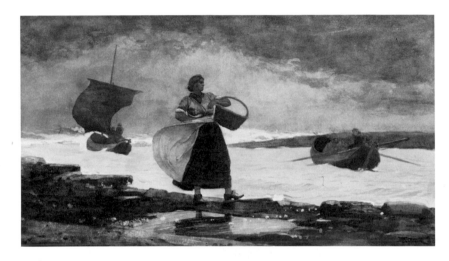

Fig. 47a. Winslow Homer (United States, 1836–1910). *Inside the Bar, Tynemouth,* 1883. Watercolor on paper. 15 ⅜ x 28 ½ in. (39.1 x 72.4 cm). The Metropolitan Museum of Art, New York. Gift of Louise Ryals Arkell, 1954, in memory of her husband Bartlett Arkell.

[1]He was reported to have crossed on the *Arizona* in 1887 (John C. Van Dyck, *American Painting and Its Tradition* [New York, 1919], 39). This trip has never been recorded in the Inness literature (including the author's contributions to it).

[2]Ireland 1245, 1255, and perhaps 1243 are also Cornwall paintings. This painting or the version now in The Art Institute of Chicago (Ireland 1245) was in Inness's possession at the time of his death ("His Art His Religion," *New York Herald,* 12 August 1894).

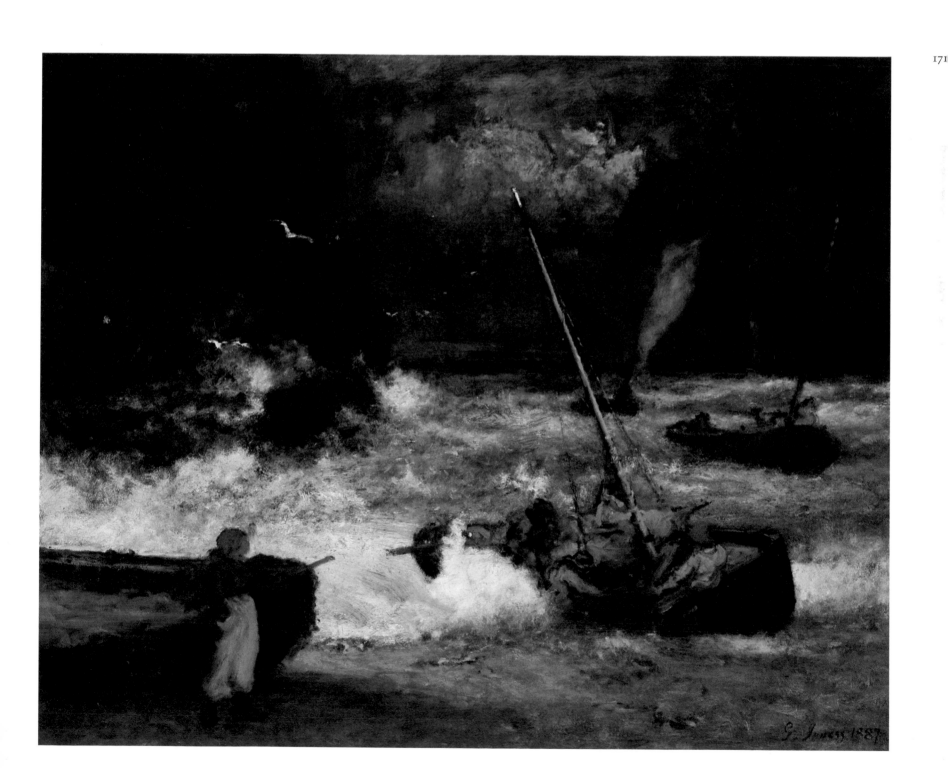

Oil on canvas
30 x 50 in. (76.2 x 127 cm)
Ireland 1257
Private Collection

172 Perhaps even more than other artists, Inness favored certain standard canvas sizes, among the most common being canvases of twenty by thirty inches and thirty by forty-five inches. Their proportion is two parts to three parts, the so-called golden section, for centuries thought to be a balanced and stable ratio for canvases. As an artist with a strong sense of classical structure, Inness returned again and again to this reposeful format. It is notable, therefore, that in setting out to paint the picture that became *A Breezy Autumn,* Inness must have specially ordered or himself stretched a canvas thirty by fifty inches. Even at a first glance, the painting looks stretched and decidedly unstable. Other elements enhance this general impression: the agitated contours of the central tree and the clouds, the high contrast of the numerous silhouettes in the middle distance, and the abrupt jumps from the plane of the foreground trees into the far distance. Viewing the painting closer, one can add to this list the sheer energy of the agitated brushwork of the sky and clouds. All elements of the painting work together to convey a sense of motion and exuberant freedom. —M.Q.

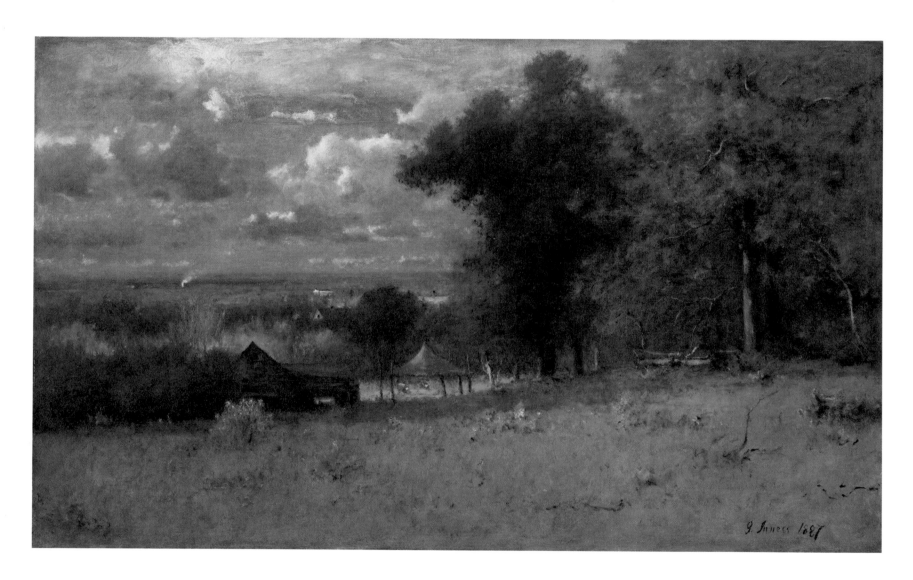
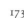

49 The Old Barn c. 1888

Oil on canvas
30 x 45 in. (76.2 x 114.3 cm)
Ireland 1279
Mr. Thomas Colville

174

When Inness settled in Montclair in 1878, he acquired a farmhouse and large property, with an orchard, in a part of the town just then beginning to be subdivided. Over the years he built, moved, and added to structures there, ending up with a large studio and connected houses, which he shared with his daughter and son-in-law, the sculptor Jonathan Scott Hartley. This painting, which Inness presented to his daughter, represents an old, red-brick barn on the rear of the property. Apparently some amount of farming continued to be done, to judge by the figure of the woman feeding chickens, the man with the wheelbarrow, and the wagon or wheeled implement next to the barn.

Far from the relaxed and informal treatment such a modest rural scene might receive, the painting is one of the artist's most rigidly formal compositions. A tree trunk is placed precisely to balance the figure of the woman, and the man with the wheelbarrow is placed to balance the mass of the barn. A line of orange and dark green connects, at right angles, the aligned tree and wall of the barn. Beyond the tall tree trunk, another rectangle is squared off in the distance. These and other aligned horizontals and verticals relate to one another in the sense of a surface pattern that flattens and confuses the spatial recession. It takes some effort to read the planes of the painting and determine how the parts are arranged in space. The bulky foreground figure supports, almost alone, the illusion of depth.

The painting's rich color is likewise disciplined: the orange and blue chord, struck in the figure standing in front of the barn, pervades and shapes the large areas of green, the orange suggesting sunlight and the blue, cool shadow. At the same time, the vigorous application of these colors animates the stately composition. The orange in the foliage is dabbed on, and the blue is worked into the green in the same calligraphic fashion in which the wheelbarrow and wagon are dashed off. Austere in its thoroughgoing abstraction, *The Old Barn* is nevertheless tender in its soft handling and sumptuous in its interlaced color. —M.Q.

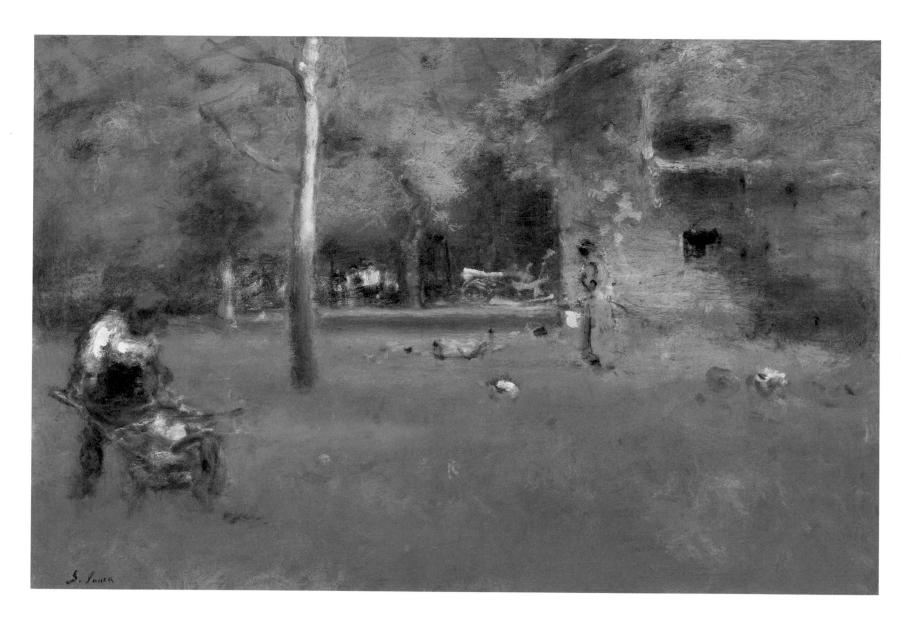

Oil on canvas
30 ½ x 45 in. (77.5 x 114.3 cm)
Ireland 1269
Meredith Long & Co., Houston

176 After his period of intensive figure painting during the early 1880s, Inness apparently felt more confident with the use of the figure as a more prominent element in what are basically landscape compositions. His landscapes had always been settled ones, of course, generally with figures as a point of reference and scale, what is known as staffage. In the late 1880s, however, the sentiment of several important works is keyed to the presence and activity of figures. For instance, in *Sunset at Montclair* of 1885 (cat. no. 44), the figures, although relatively small, seem to sum up the meaning of the painting. They certainly dominate the composition with their ambiguous activity.

The activity of the figures in *The Bathers* can be explained. Three women are about to undress to bathe in the water that is indicated in the lower right corner of the painting. Before doing so, they look, from the edge of the field, toward the men finishing their day's work of loading the haywagon, silhouetted against the glow of the setting sun. The workers' late summer activity explains the urge for a refreshing swim. Nevertheless, there is much about the painting that defies or circumvents rational explanation: the vagueness of the figures, the way the near ones seem to glow in the darkness, as opposed to the way the far ones are dissolved by excessively strong and colorful light, and the tension of the interaction at a great distance. Inness had long made almost a specialty of poetic, mysterious twilights; in a painting like *The Bathers,* the insubstantial figures seem to embody the charged quality of those hushed moments. These figures and many other, more ghostly, ones—figures that glide, unheeding, through Inness's late paintings—partake of qualities of the contemporary Symbolist movement, whether or not Inness would have recognized the affinity. —M.Q.

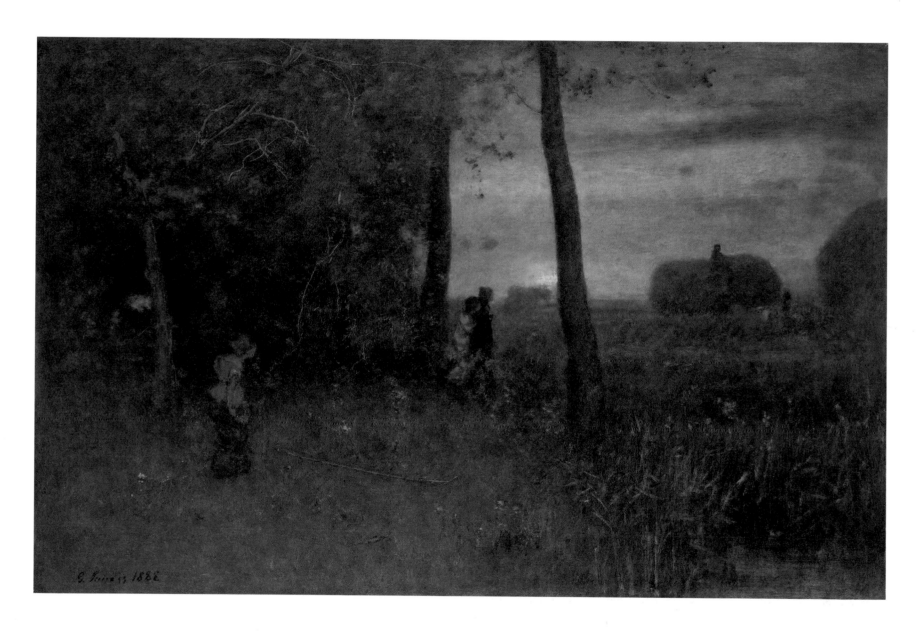

Early Autumn, Montclair 1888

Oil on canvas
30 x 45 in. (76.2 x 114.3 cm)
Ireland 1286
Montclair Art Museum, New Jersey

The familiar elements of Inness's civilized landscape are here. One looks from the edge of an orchard, across a field, toward a farm building and perhaps a town in the far distance. One is in nature, but a nature shaped by man. In the painting's apparent subject, there is nothing to generate the energy and exhilaration that *Early Autumn, Montclair* conveys. Even enjoyment of strong autumn colors and the clear light of an Indian summer day do not provoke such exuberance. Everything in the painting seems to quake with emotion: the sky boiling, the foliage rolling in the wind. The surface of the painting records the force with which the paint was applied, for instance, in the scrubbed shapes of the clouds in the upper left. In the apple tree on the left side, Inness used the end of his brush to scratch jagged lines suggesting the branches. The artist used strong color, extreme contrasts, and jumps into distant space to enhance this impression of dramatic power.

What, then, is the artist expressing in this painting? He is certainly not reproducing the appearance of his orchard on a given fall day. One feels, instead, the artist's exultation in living, or some such triumphant shout. It is an intense feeling of great power that he translates into contrasting images of light and dark, color, movement and fixity. Through the elements of this rich composition, the artist brings us toward a feeling we may not have felt before but to which we may now return, again and again, to our inestimable enrichment.

According to Elliott Daingerfield, Inness considered this one of his finest paintings. It is the only painting of which he had an etching made (by Robert Eichelberger). —*M.Q.*

52 The Clouded Sun 1891

Oil on canvas
30 x 45 in. (76.2 x 114.3 cm)
Ireland 1365
Museum of Art, Carnegie Institute, Pittsburgh
Purchase from T. B. Clarke Sale through
M. Knoedler & Co., New York City, 1899

Suggestiveness and indefiniteness of form are as old in Inness's art as his attraction to Barbizon style in the 1850s. But by about 1890 and in all of his late work, they were carried beyond anything found in Barbizon painting itself or beyond anything found in Inness's own art before then. What had been originally a way of capturing breadth and movement in the physical world became transformed into a mode of metaphysical description. It was his way of casting "an atmosphere about the bald detail of facts," of expressing the "subtle essence which exists in all things of the material world," of conveying "the great spiritual principle of unity," and of depicting the true reality that, Inness believed, could only be suggested, never shown.[1]

The suggestiveness of Inness's late paintings, such as this one, coupled with their rich and unusual coloration, prompted comparisons with French Impressionism. But Inness objected strongly to being called an Impressionist. That comparison fundamentally misconstrued and misrepresented his purpose. Impressionists, he said, "pretend to study from nature and paint it as it is," and thus they "ignore the reality of the unseen."[2] Nothing could be farther from the intentions of Inness's late style than Impressionist transcriptions of transient optical sensations.

By what means, or with what precision, Inness expressed the unseen cannot be determined. As a Swedenborgian, he believed in correspondences, the expression of spirit in matter, of the divine by the physical. There is no evidence that he developed or consistently employed a symbolic language of correspondences in his paintings. He regarded that kind of precision as literary and intellectual. "The intellect," he said, "naturally desires to define everything," but it must "submit to the fact of the indefinable—that which hides itself that we may see it."[3] In certain of his late paintings, however, Inness seems to have attempted narrative or symbolic expression. That is what the figures drifting noiselessly through some of his canvases, or meeting in strange, silent encounters, intimate (cat. no. 44). So, too, does the construction of this picture: the white-clad human figure at the left contemplating (but separated from by the stone wall) the right-hand part of the painting, which contains animals (including ominously dark crows) and in which the light of the sun is beclouded. The construction is so emphatic, so fraught with states of consciousness and divine enlightenment, it is impossible not to feel that Inness intended it to represent a definite condition of meaning. —*N.C.*

[1]"Mr. Inness on Art-Matters," *The Art Journal* 5 (1879): 376–77.

[2]*New York Herald,* 12 August 1894.

[3]"Mr. Inness on Art-Matters," 377.

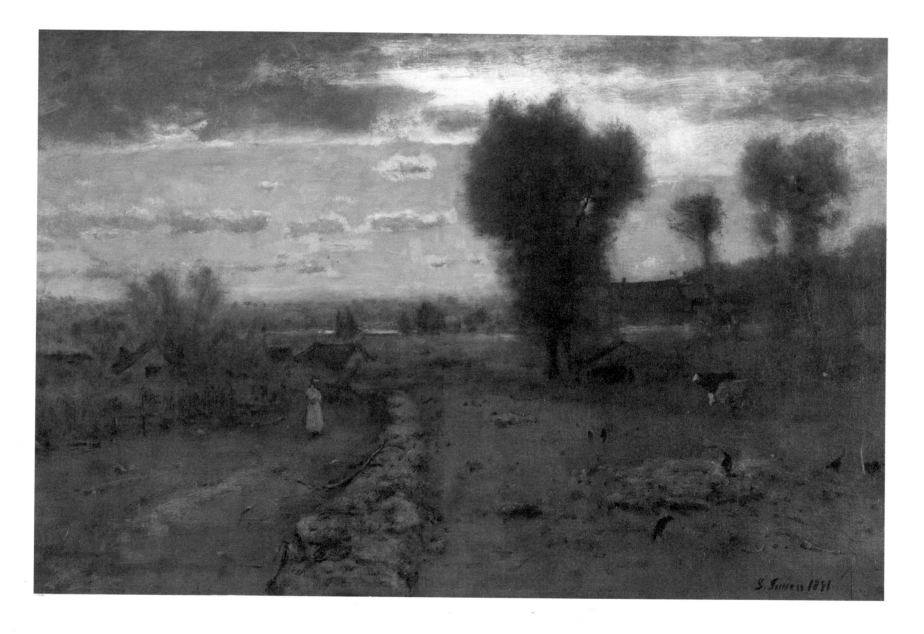
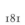

53 Early Autumn, Montclair 1891

Oil on canvas
30 x 45 in. (76.2 x 114.3 cm)
Ireland 1369
Delaware Art Museum, Wilmington
Special Purchase Fund and the Friends of Art

The late nineteenth century found obscurity, allusiveness, and softly shaded meanings irresistibly attractive. So did Inness. Much late nineteenth-century art was only suggestive, suggestive for the sake of suggestiveness itself. Inness's was not. He was deeply wary of the emptiness of undisciplined allusion.

Suggestive paintings were usually called poetic, and the term was often used to describe Inness's late paintings. He did not object to it, except when it implied or excused, as it too often did, an absence of plausibility and coherence. "What is often called poetry is a mere jingle of rhyme—intellectual dish-water," he said emphatically. "The poetic quality is not obtained by eschewing any truths of fact or of Nature...The lack of objective form...[is] a detraction from its power forcibly to represent emotional vision, and therefore a lack in the full presentation of the poetic principle. Poetry is the vision of reality." An experience of truly poetic painting would be like St. John's apocalyptic vision: "When John saw the vision of the Apocalypse, he *saw* it. He did not see emasculation, or weakness, or gaseous representation. He saw *things,* and those things represented an idea."[1]

That is why Inness was so attentive to the structure of his paintings. Talking on "structural forms, dimensions, distances, spaces, masses and lines," he seemed to a pupil like "an architect laying out a large structure."[2]

Early Autumn, Montclair and, for that matter, all of his finest paintings of the 1890s are pictorial poetry as Inness believed it should be expressed, not as incoherent "gaseous representation" but as lucid, palpably convincing sensations of masses and spaces ordered with the structural soundness of architecture, imbuing visionary suggestiveness with the full authority of reality. —N.C.

[1]George W. Sheldon, *American Painters* (New York, 1879), 34.

[2]Arthur Turnbull Hill, "Early Recollections of George Inness and George Waldo Hill," *New Salmagundi Papers,* series of 1922 (New York, 1922), 114.

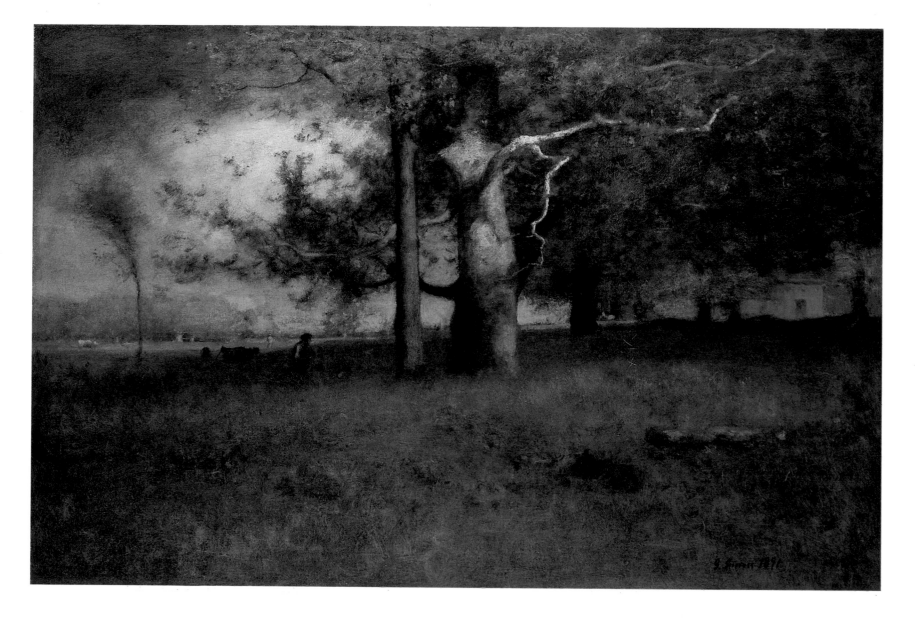
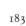

54 Sunset in the Woods 1891

Oil on canvas
48 x 70 in. (121.9 x 177.8 cm)
Ireland 1372
In the collection of The Corcoran Gallery of Art,
Washington, D.C.
Museum Purchase

84 Inness said a great deal about art in general but very little about particular paintings. That is not surprising. A painting, he believed, should disclose its meaning unaided by titles and explanations. One that told its story properly in pictorial terms, as any worthwhile painting must, could have no equivalent in words.

But he did say something about this painting. He wrote about it the year it was finished:

> The motive for the picture was taken from a sketch made near Hastings, Westchester Co. [New York,] over twenty years ago. I commenced this picture several years since but until last winter I had not obtained any idea commensurate with the impression received on the spot. The rocks and general formation are like the place but the trees, especially the beech, are increased in size. The idea is to represent an effect of light in the woods toward sundown but to allow the imagination to predominate.[1]

Inness wrote of the long distillation process this painting underwent, perhaps not because it was a process unique to it but, far from being singular, was a process that most of his late paintings underwent. But he may have written of it, too, because it embodied a lesson on the relationship—indirect and essentially distant—between art and nature, of how a sensation of nature was transformed, by time, protracted thought, and arbitrary artistic reformation into a subjective, imaginative experience of art. —N.C.

[1]Inness to Thomas B. Clarke, 23 July 1891, Massachusetts Historical Society.

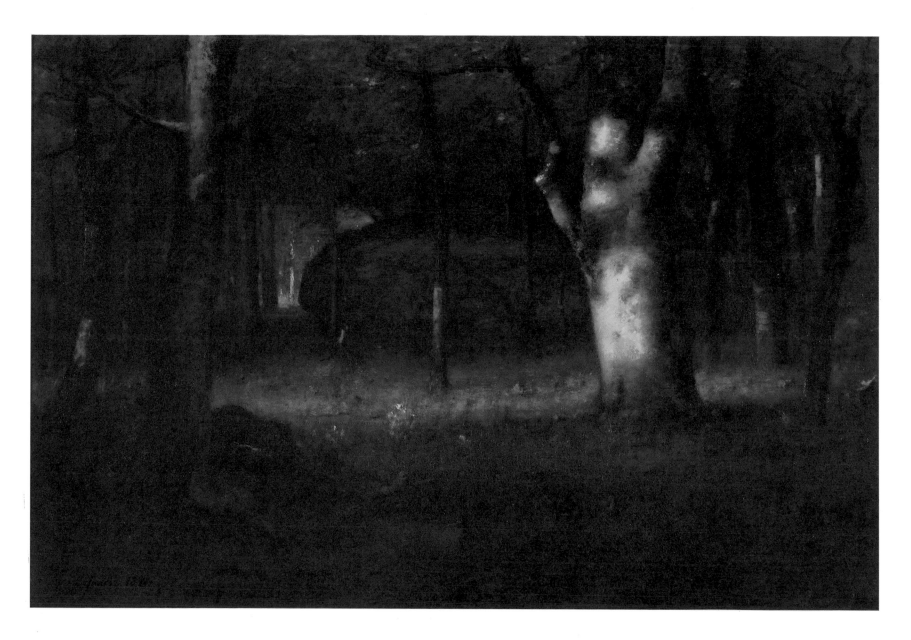

Spirit of Autumn 1891

Oil on canvas
30 x 45 in. (76.2 x 114.3 cm)
Ireland 1377
Private Collection

The synthetic order and wholeness of Inness's late style did not preclude visual complexity. Synthesis was not an aesthetic policy for reductive simplicity of design and color. Instead, in paintings like *Spirit of Autumn,* the synthetic command of underlying pictorial architecture is so complete that it allows an uninhibited, almost lavish play of pictorial elements. Color has a fuller range and sumptuousness, brushwork is richer and more gesturally varied, the repertory of shape is larger, and the pattern, repetition, and tension of design is carried nearly to maximum complexity. In this painting, the result is almost pure painting frankly sensuous in its appeal.

It is sensuousness with a purpose, however. Inness regarded sensuousness as an instrument of meaning, not as a vehicle of empty pleasure. "Christ never said anything that need lead an artist to be ashamed of, or sorry for, creating or enjoying sensuous form," he said. "The lily of the valley is sensuous form; Christ bids us consider it." It is with the sensuous form of his art, "with the pathos of his color, with the delicacy of his *chiaro-oscuro,* with the suggestions of his form," that "the painter tells his story." It is "that which inspires with a human sympathy what is told, making it appeal from man to man, . . . which addresses eloquently, through the senses, the human consciousness." It is through "sensuous apprehension" that art speaks "of that which is unseen."[1] —N.C.

[1]"Mr. Inness on Art-Matters," *The Art Journal* 5 (1879): 376.

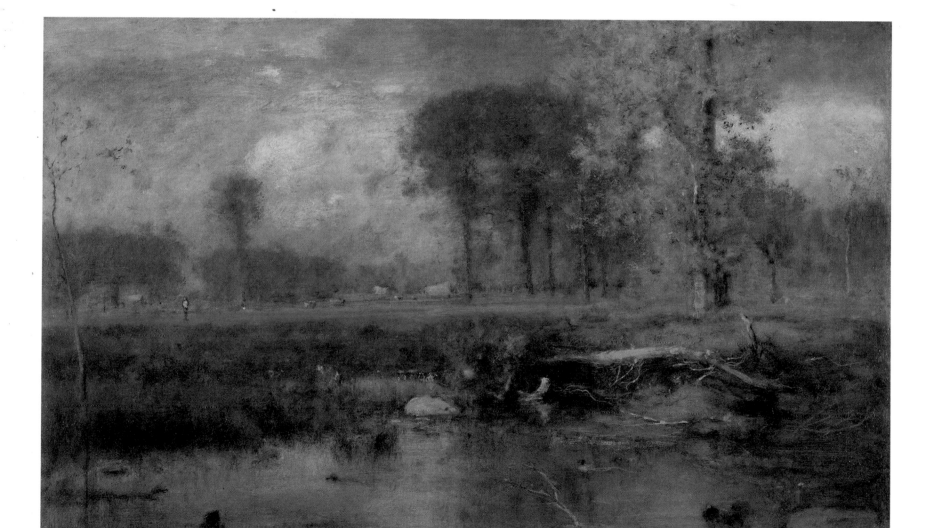

Oil on canvas
30 x 45 in. (76.2 x 114.3 cm)
Ireland 1402
Courtesy of The Art Institute of Chicago
Edward B. Butler Collection

188

Inness's increasing prosperity during his last decade enabled him to travel to such distant places as England and California. Although the record of his whereabouts is unclear, it appears that he wintered in the South during several of his last years and summered in Nantucket, Massachusetts, and New Brunswick, Canada. This painting once bore the title *The Lonely Farm, Nantucket.*

Inness clearly responded to the new tree types and light effects he encountered on his travels. He adopted an uncharacteristic vertical format, to record the high, floating foliage of trees in *Early Morning, Tarpon Springs* of 1892 (cat. no. 58). Numerous paintings capture his delight in the tropical sunsets he experienced in Florida. In *The Lone Farm,* Inness may have sought to express the unusual openness of the areas of flat, partially marshy ground that appear nearly treeless in nineteenth-century photographs of Nantucket. Space is his subject here, space energetically expanding toward the flat line of the horizon. In few of his paintings is the upper part of the painting so empty, the thrust into distance so dramatic.

This spatial tension was generated with the most minimal of means. Compositionally, it is established simply by the line of recession of the two haystacks. Technically, it is enhanced by the horizontal direction of the long brushstrokes in both the bold streak of distant light and in the land near the horizon, as well as by the contrast between the relative sharpness and definiteness of the barn and the general amorphousness of the large areas of earth and sky that are merely blocked out. Simply with his brushing and rubbing of these often thin amounts of paint, Inness was content to suggest and keep at the level of suggestion various shapes and types of moving clouds in the sky, as well as areas on the land that appear high and low, solid and marshy. *The Lone Farm* epitomizes Inness's concept of the unified work of art, in which all elements contribute to generating a single strong effect and resulting emotion in the viewer. In terms of attaining such a goal, an unfinished Inness painting like this one is essentially complete and perhaps even more moving. —M.Q.

57 Near the Village, October 1892

Oil on canvas
30 x 45 in. (76.2 x 114.3 cm)
Ireland 1432
Cincinnati Art Museum
Gift of Emilie L. Heine in memory of Mr. and Mrs. John Hauk

190

In 1892 Inness painted a disproportionate number of his very finest works. Generally speaking, the beauty of the works from his remaining years is more delicate than paintings like this one that still seem solidly real. But like all the late paintings, the very perfection of this painting could only have resulted from the distillation and refinement of Inness's experience.

The mood of the painting is conjured from the same elements that went into *Early Autumn, Montclair* and *Spirit of Autumn,* both of 1891, (cat. nos. 53 and 55) and other classic works: autumn foliage, the warm, flat light of late afternoon, and the familiar elegiac terrain of the civilized landscape. The rich color, lyrical beauty, and nobility of composition in late paintings such as these set them apart within the field of American landscape. —M.Q.

58 Early Morning, Tarpon Springs 1892

Oil on canvas
42 x 32 ¼ in. (106.7 x 81.9 cm)
Ireland 1445
Courtesy of The Art Institute of Chicago
Edward B. Butler Collection

192

Inness appears to have first visited Florida in 1890. His advancing age, which made wintering there attractive, colored his interpretations of what he saw with the reverie of his late style. He responded to the special motifs and conditions of the state in a quite varied group of paintings, which all shared in the romance of the exotic. The artist left behind his beloved meadows and exchanged his majestic, gnarled oaks and autumn tones for the strange, subtropical vegetation of Florida. The land was flat, with short vistas and thin, young forests. Inness found few of his favorite motifs there.

This painting partakes of the feeling of novelty that characterizes many of the Florida paintings. Its vertical format is dictated by the high, floating foliage of the pine trees. Inness focuses on their slightly bizarre natural form and makes the experience of recession into space, both along the ground and the plane of the foliage overhead, one of the subjects of the painting. An equal subject is the lush coloration of the interwoven pink and blue of the morning light. The artist was enthralled by the delicate sunset and dawn effects in Florida. Inness has transformed an already exotic scene into a paradise.

—M.Q.

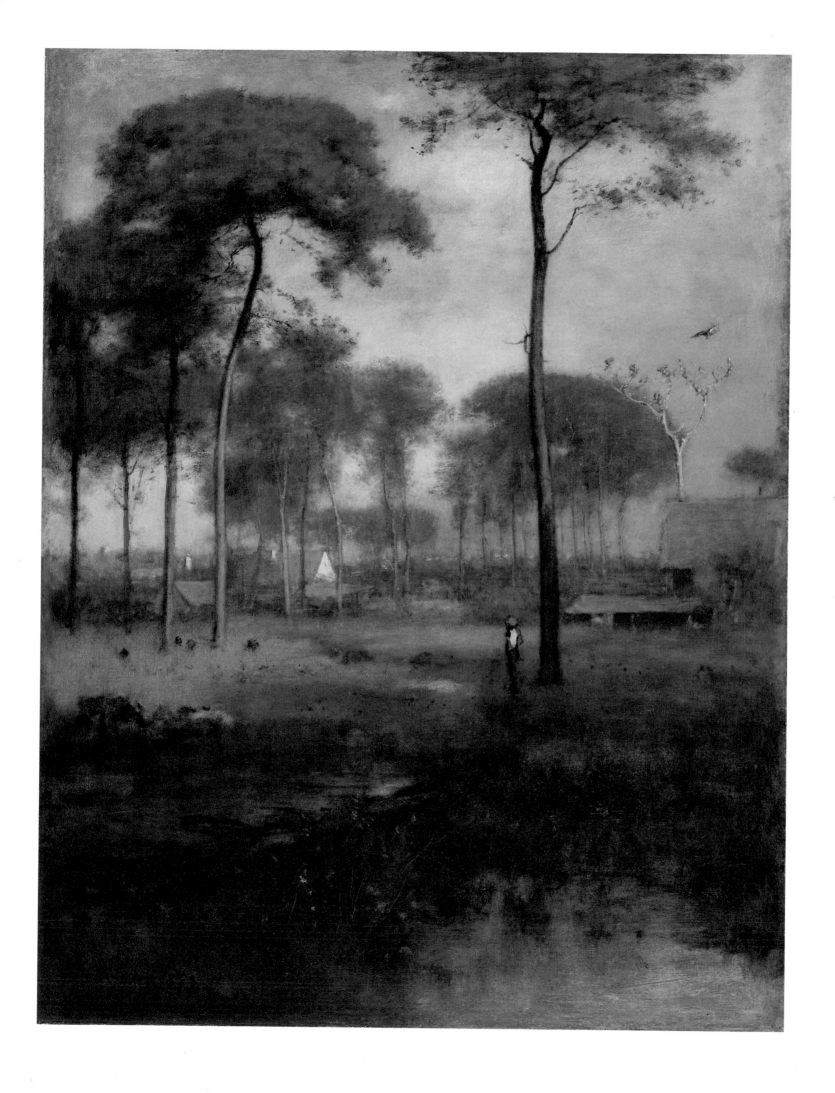

Oil on canvas
30 x 45 in. (76.2 x 114.3 cm)
Ireland 1455
Courtesy of The Art Institute of Chicago
Edward B. Butler Collection

94

Inness apparently had many theories of pictorial construction, ones used to determine the size of the sun in relation to the total picture space, for instance, or to fix the distance of the nearest foreground point. It is not likely that he followed such theories closely or with any regularity. He was too impulsive and valued the operations of instinct too highly. Nevertheless, in paintings like this, proportion and measure, size and interval, seem carefully determined and exactly plotted. They are so crucial to the effect—indeed, to a very large degree *are* the effect—that some theory or system must have guided them, but perhaps not as mathematical formulas. Although we know that Inness was interested in mathematics and numerology, this was mathematics internalized as an instinctive, almost musical sense of rhythmic relationship, cadenced order, and melodic line. In this painting, the tree trunks, which in other paintings are so plastic and by their placement make space plastic as well, are more like musical markings, the notations of a harmonic, not a plastic order. —N.C.

60 The Old Farm, Montclair 1893

Oil on canvas
30 x 50 in. (76.2 x 127 cm)
Ireland 1457
The Nelson-Atkins Museum of Art, Kansas City, Missouri
(Nelson Fund)

96

It often seems that Inness's late paintings neither depict discretely separate things nor closely observe the distinction between substance and void, matter and space. Instead, what by actual experience and the conventions of representation should appear hard and solid does not, and what should be without substance has it. That is not because of soft colors and blurred edges; it is not merely a function of style. It is, rather, as though the world of Inness's late paintings had been transposed to a different state of being. Everything in that world is familiar. Things have the familiar form of figures, animals, trees, and buildings, and they have their familiar colors; they are located in familiar relationships of space and place. Yet they do not quite follow the laws of earthly time and space. Time is slowed, movement stilled, weight suspended, and it is as though everything was of the same essential medium or material but in different, variable densities and shapes.

As a Swedenborgian, Inness knew that Swedenborg claimed to have been admitted bodily, many times, into the spiritual world. He would have known, too, that what Swedenborg reported seeing was a world in all respects familiar to the natural world, except that matter had the quality of substance and space the quality of appearance and that nothing was hard, fixed, or settled in form or position. Inness's late paintings are not simply landscapes of the Swedenborgian spiritual world, based on Swedenborg's descriptions. They are spiritualized landscapes, however, and the ways and means by which they are spiritualized yield effects so close to those Swedenborg claimed to have experienced that his images can only have been a potent influence on Inness. —N.C.

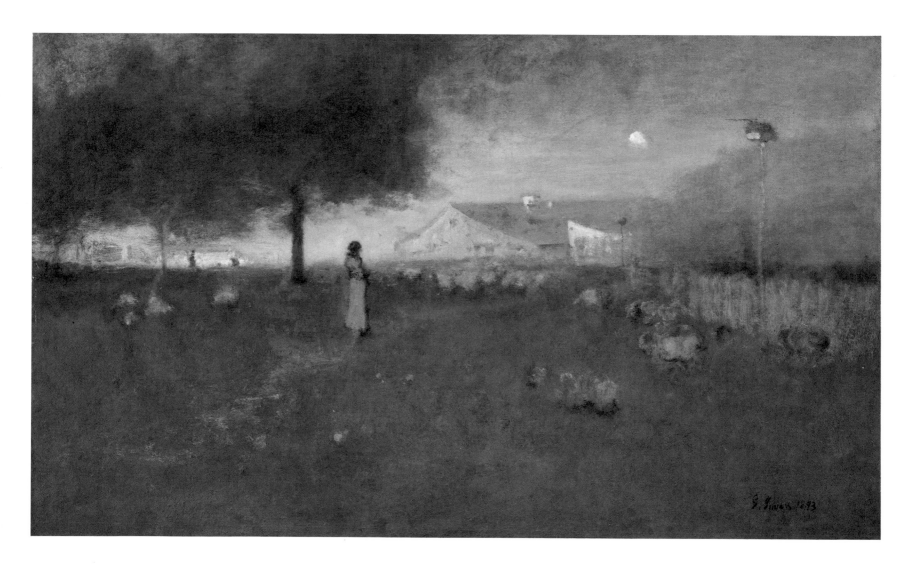

61 Misty Morning, Montclair 1893

Oil on canvas
30 x 50 in. (76.2 x 127 cm)
Ireland 1467
The Butler Institute of American Art, Youngstown, Ohio

98

In spite of the characteristic softness of his handling in his late paintings, most of Inness's finished paintings convey a sense of clarity in their atmosphere. There are enough sharp lines and enough areas of textures to indicate that, except in the distance, it is not haze that slightly blurs the forms. In fact, the strongest of his paintings are generally characterized by a strikingly crisp, clear element.

An infinitely varied artist, Inness did occasionally paint misty subjects, just as he also painted a group of nocturnes and even marines. This painting is the most ambitious and successful of his fog subjects. A silvery tone pervades the scene, robbing objects of color to the same extent that it obscures their form. It seems to erode contours and flatten masses. Placed precisely in the center of the composition, the tree mediates between the worlds of mist and of reality. Its dissolving volume alone establishes the illusion of space within the painting.

Fog effects were prominent in the work of many American landscape artists of the late 1890s and beginning years of this century. They admired the effects of rounded, softened contours and the unified tonality imparted by the thick atmosphere. But their paintings often have a dreamy, delicate quality quite different than the elegant simplicity and strength that make *Misty Morning, Montclair* so distinctly the work of Inness. —M.Q.

62 Morning, Catskill Valley
 (The Red Oaks) 1894

Oil on canvas
35 ³/₈ x 53 ³/₄ in. (89.9 x 136.5 cm)
Ireland 1504
Collection of The Santa Barbara Museum of Art, California
Gift of Mrs. Sterling Morton to the Preston Morton Collection

200 This is the last painting Inness exhibited at the National Academy of
Design in New York a few months before his death at the age of sixty-
nine. It shows no signs of decline, betrays no premonitions of mortal-
ity. It is, on the contrary, one of Inness's most masterful paintings and
one of his most serene. Without intending to be, this beautiful, sen-
sitive, and serious painting is a splendid summary of all that Inness
was and achieved as an artist.

The skill, refinement, taste, intuition, emotion, knowledge, thought,
and conviction of a lifetime of the most earnest artistic endeavor lie
modestly within this painting and quietly give it form. The sheer phys-
ical delight in pigment, thick and thin, glazed and scumbled, moved
with virtually every kind of gesture; the daring hues and subtle, inven-
tive harmonies of color; the nearly abstract design and architecturally
constructed space; the charged intensity of feeling and energy of im-
pulse, ballasted by keen intelligence and artistic science; the poetic
allusiveness and suggestive stillness; and the religious belief that
suffuses the sensuously beautiful and plausibly real form that clothes
it—all are here to represent Inness's final achievement in its fullest
form. —N.C.

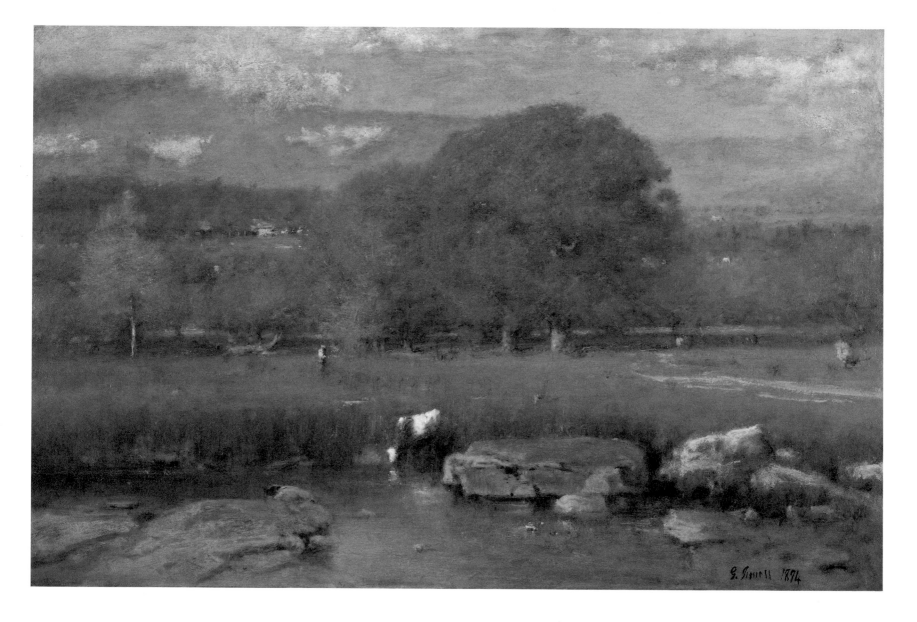
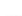

63 Sundown 1894

Oil on canvas
43 ¼ x 68 ½ in. (109.9 x 174 cm)
Ireland 1514
National Museum of American Art, Smithsonian Institution,
Washington, D.C.

202

Few of Inness's paintings followed a direct, uninterrupted course from beginning to end, or emerged at the end as they began. Some were never finished at all (cat. no. 38); others were ruined with over-working. Inness preferred to use old canvases or, in a seizure of inspi-ration, he would paint on anything readily at hand. In any painting, seasons, weather, times of day, or places could change completely. Fig-ures and animals, trees and buildings could be added, removed, or shifted about freely, and schemes of color wholly altered, often with an impetuously irresponsible disregard for proper materials and correct technique.

Inness could be moved by effects of nature or by his own feelings. But he was driven most of all, it seems, by the creative life and inner for-mal logic of the paintings themselves as he interpreted them, not always correctly. Although nothing about its serene stillness and per-fectly resolved formal arrangement betrays struggle and indecision, this painting bears in its physical condition the traces, in places the scars, of a rich, active, and perhaps at times tormented life.

It can only have been its pictorial life and formal logic, only a process of painting rather than anything external or extraneous to that pro-cess, that generated such a remarkable composition. It could not have been seen in nature nor foreseen in artistic imagination. Only formal logic, operating by a process of trial and error, could have produced such a pictorial arrangement, and only that logic and the experience of that process could validate it. —N.C.

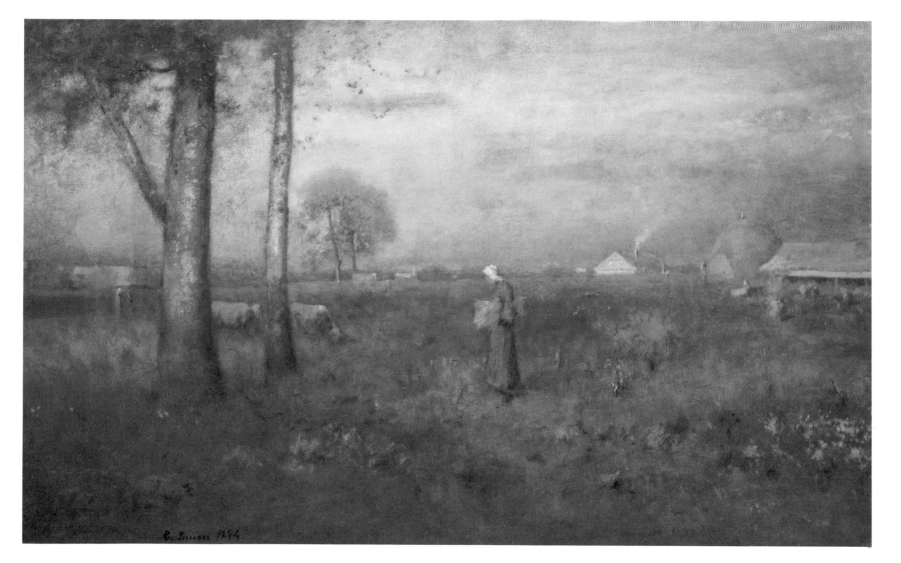

"A Painter on Painting."
Reprinted from Harper's New Monthly Magazine
56 (February 1878): 458–61.

"Some artists," said Mr. George Inness, as he leaned over to relight his cigar (I was conversing with the landscape painter)—"some artists like a short brush to paint with, and others a long brush; some want a smooth canvas, and others a rough canvas; some a canvas with a hard surface, and others a canvas with an absorbent surface; some a white canvas, and others a stained canvas. Deschamps, you know, bought old pictures and painted over them; his canvas was a painting before he touched it; and I should say that if a man wished to paint as Delacroix painted, an old picture would suit him as well as a new canvas to put his scene on. On the other hand, Couture painted only over a fresh, clean canvas, slightly stained, while Troyon evidently preferred a plain white surface, because he and Couture used transparent washes of color, through which the original surface of their canvases could often be seen. But Delacroix painted solid all through, and his quality, unlike that of Troyon, Couture, Ziem, and other artists, does not depend upon the transparency of the color. Some artists use quick-drying oils for varnishing, and others slow-drying oils. Most artists prefer to paint in a north room, because there the light is more equable—the sun does not come in. But Mr. Page likes a south room, although I don't know why. You see, there are no absolute rules about methods of painting."

"Principles, I suppose, are the things that should be looked after."

"Yes, principles—a few of them, that's all. Pupils can't be taught much by an artist. I have found that explanations usually hinder them, or else make their work stereotyped. If I had a pupil in my studio, I should say to him as Troyon once said in similar circumstances, 'Sit down and paint.' Still, now and then, I should tell him a principle of light and shade, of color, or of *chiar-oscuro*, and criticise his work, showing him where he was right and where he was wrong, as if I were walking with him through a gallery of pictures, and pointing out their faults and their merits. The best way to teach art is the Paris way. There the pupils—two, three, or more—hire a room, hire their models, and set up their easels. Once or twice a week the master comes in, looks at their work, and makes suggestions and remarks, advising the use of no particular method, but leaving each pupil's individuality free. If a young man paints regularly in the studio of his teacher, he is apt to lose spontaneity and vitality, and to become a dead reproduction of his teacher. Van Marcke suffered, I think, from this cause. He painted within arms-length of Troyon, and he has become a sort of inanimate Troyon."

"What is it that the painter tries to do?"

"Simply to reproduce in other minds the impression which a scene has made upon him. A work of art does not appeal to the intellect. It does not appeal to the moral sense. Its aim is not to instruct, not to edify, but to awaken an emotion. This emotion may be one of love, of pity, of veneration, of hate, of pleasure, or of pain; but it must be a single emotion, if the work has unity, as every such work should have, and the true beauty of the work consists in the beauty of the sentiment or emotion which it inspires. Its real greatness consists in the quality and the force of this emotion. Details in the picture must be elaborated only enough fully to reproduce the impression that the artist wishes to reproduce. When more than this is done, the impression is weakened or lost, and we see simply an array of external things which may be very cleverly painted, and may look very real, but which do not make an artistic painting. The effort and the difficulty of an artist is to combine the two, namely, to make the thought clear and to preserve the unity of impression. Meissonier always makes his thought clear; he is most painstaking with details, but he sometimes loses in sentiment. Corot, on the contrary, is, to some minds, lacking in objective force. He is most appreciated by the highly educated artistic taste, and he is least appreciated by the crude taste. He tried for years to get more objective force, but he found that what he gained in that respect he lost in sentiment. If a painter could unite Meissonier's careful reproduction of details with Corot's inspirational power, he would be the very god of art. But Corot's art is higher than Meissonier's. Let Corot paint a rainbow, and his work reminds you of the poet's description, 'The rainbow is the spirit of the flowers.' Let Meissonier paint a rainbow, and his work reminds you of a definition in chemistry. The one is poetic truth, the other is scientific truth; the former is aesthetic, the latter is analytic."

"You do not, then, think highly of Meissonier?"

"I do, and I do not. Meissonier is a very wonderful

painter, but his aim seems to be a material rather than a spiritual one. The imitative has too strong a hold upon his mind; hence, even in his simplest and best things, we find the presence of individualities which should have been absent. That idea which came fresh into his mind from the scene that he saw had in it nothing of self. Why should he not have conveyed it in its original freshness and purity, unalloyed by the mixture of those individualities? Even in his greatest efforts there is not that power to awaken our emotion which the simplest works of a painter like Deschamps possess. There every detail of the picture is a part of the vision which impressed the artist, and which he purposed to reproduce to the end that it might impress others; and every detail has been subordinated to the expression of the artist's impression. Take one of his pictures, 'The Suicide'—a representation of a dead man lying on a bed in a garret, partly in the sunlight. All is given up to the expression of the idea of *desolation*. The scene is painted as though the artist had seen it in a dream. Nothing is done to gratify curiosity, or to withdraw the mind from the great central point—the dead man; yet all is felt to be complete and truly finished. The spectator carries away from it a strong impression, but his memory is not taxed with a multitude of facts. The simple story is impressed upon his mind, and remains there forever.

"Contrast such a work with a Meissonier. Here the tendency seems to me to be toward the gratification of lower desires, and you see long-winded processions and reviews; great historical composi-

tions; you see horses painted with nails in their shoes, and men upon them with buttons on their coats—nails and buttons at distances from the spectator where they could not be seen by any eye, however sharp or disciplined. Meissonier's *forte* lies in his power of representing one, two, or three figures under circumstances where they can be controlled by a single vision; and his best works are small pieces, like his 'Chess-Players,' for instance. But this very power of his, when used in representations like his great historic subjects, is a fault. Indeed, all historic subjects have in them necessarily more or less of what belongs to the literary mind. Their successful treatment depends upon a general ability to represent, and not so much upon great ability to imitate. By the greater intensity of mind, which removes him from external things to the thorough representation of an idea, Deschamps surpasses Meissonier. Gérôme is worse than Meissonier, and in the same way. So is Detaille; so are the multitudes of their school. It is the same story all through. Deschamps's mind is more perfectly governed by an original impulse, and it obeys more perfectly the laws of vision."

"Who are the best landscape painters?"

"As landscape painters, I consider Rousseau, Daubigny, and Corot among the very best. Daubigny, particularly, and Corot, have mastered the relation of things in nature one to the other, and have attained in their greatest works representations more or less nearly perfect. But in their day the science underlying impressions was not fully

known. The advances already made in that science, united to the knowledge of the principles underlying the attempts made by those artists, will, we may hope, soon bring the art of landscape painting to perfection. Rousseau was perhaps the greatest French landscape painter; but I have seen in this country some of the smaller things of Corot which appeared to me to be truly and thoroughly spontaneous representations of nature, although weak in their key of color, as Corot always is. But his idea was a pure one, and he had long been a hard student. Daubigny also had a pure idea, and so had Rousseau. There was no affectation in these men: there were no tricks of color."

"Is Turner as great a painter as Mr. Ruskin pronounces him?"

"Parts of Turner's pictures are splendid specimens of realization, but their effect is destroyed by other parts which are full of falsity and clap-trap. Very rarely, if ever, does Turner give the impression of the real that nature gives. For example, in that well-known work in the London National Gallery which presents a group of fishing boats between the spectator and the sun (the sun in a fog) we find that half of the picture, if cut out by itself, would be most admirable. Into the other half, however, he has introduced a dock, some fishermen, some fishes: an accumulation of small things impossible under the circumstances to unity of vision. Frequently, as in this case—in fact, almost continually—the sun is represented as before us, and objects are introduced for the

purpose of conveying Turner's ideal of effects in all sorts of false lights, as though there were half a dozen different suns shining from various positions in the heavens. Of course all this may appeal—as probably he intended it should—to foolish fancies, which are only sensuous weaknesses, and not the offspring of profound feeling. His 'Slave-Ship' is the most infernal piece of clap-trap ever painted. There is nothing in it. It has as much to do with human affections and thought as a ghost. It is not even a fine bouquet of color. The color is harsh, disagreeable, and discordant. Turner was a man of very great genius, but of perverted powers—perverted by love of money, of the world, or of something or other. His best things are his marines, in which appear great dramatic power. Constable was the first English painter of the modern landscape idea; and the French school to which Troyon, Corot, Daubigny, and others I have mentioned belong was founded upon him. These Frenchmen learned from Constable, and improved upon him. But in Turner the dramatic predominated—the desire to tell a story. His 'Wreck,' for example, contains little figures in boats, and other details which are incompatible with the distance, and which prevent that impression which comes to the spectator from the vision of nature. The greater of the French artists would have given to that boat and those figures only a general appearance of more or less complex forms suitable to convey the sense of weight and the sense of distance. While looking at the Claude which hangs next to one of the Turners in the National Gallery—and which knocks the Turner

all to pieces—I seemed to be in the presence of a great, earnest mind. The picture, to be sure, manifests some childishness that resulted from a certain lack of artistic knowledge; but the general impression is of something out-doors. The canvas is as fresh as if painted yesterday, and all seems air and light, while the Turner, on the contrary, is a mere make-up of fancies. I think the general estimate that any true artist must form before the works of Turner is that he was a very subtle scene-painter. He stands alone, it is true, and I do him all reverence; but his genius was not of the highest order."

"You prefer French art?"

"Among the French artists, undoubtedly, have been found the best works of art. Delacroix, for example, was one of the greatest of them. His 'Triumph of Apollo,' on a ceiling of the Louvre, is a most sublime story. It really signifies, I think, the regeneration of the human soul. An enormous serpent represents the sensual principle; the smoke from its mouth, forming the whole base of the picture, represents all ideas of darkness and gloom, and, as it spreads and rises, assumes monstrous forms, which are the evil consequences of natural lusts. Above is Apollo, the sun-god, standing in the brilliant light, his chariot drawn by horses which are intelligences, and surrounded by various divinities which drive down the monstrous forms that are rising. It is a splendid allegory, painted with immense power, but, of course, with no attempt to realize nature, to represent what we

see. Yet is is a true story, both ideal and descriptive. Nevertheless, many of Delacroix's pictures are bad—broken, confused, and presenting the appearance of efforts to describe what can not be described, to realize what he never saw, and could not have seen, but what he only heard. Hence arises the confusion, though the realization in parts is wonderful. Firmin-Girard (to take a more modern instance) seems to have gone from a higher to a lower degree of description. His description was first of heaven; it is now of the world. The 'Flower Market' is painted in a thoroughly worldly spirit—a 'Market' for a market—and dollars were apparently demanded according to the number of people and things described. Such a picture is not a description of any thing significant, of any thing worth describing. Here is an example of a man who, apparently from the lack of success in a higher sphere, has given himself up to pander to wealth and popularity; for in a sale last winter of pictures in the Kurtz Gallery there was an earlier work of his—a small pastoral description, which belonged to another world. I noticed it among all the paintings in the room. Its singular beauty and tenderness arrested my attention. It seemed to carry the spirit of conjugal love almost into the reality of nature. No appreciative mind could look at it without being possessed by the gentlest emotions, and without being excited to the purest desires. Every thing around it, in comparison, seemed to be animated by the spirit of lust and of the world. Yet the picture was not generally appreciated. Scarcely any body stopped before it, and at the sale it went for a song. It is a

great misfortune for Firmin-Girard that he should not have held his own."

"Was Washington Allston a great painter?"

"Washington Allston's 'Vision of the Bloody Hand' was, excepting Deschamps's 'Suicide,' the most significant picture, in my opinion, in the Johnston collection. In the *technique* of color and form it is inferior, and the spectator received, in consequence, a disagreeable impression of woodenness. But the story is given with the simple earnestness of the 'I saw' of inspiration. Allston's misfortune was that the literary had too strong a hold upon his mind, creating in him ideas which were grandiose. By the literary I mean the influence upon us of what we have heard or read of things we have not seen. In 'Belshazzar's Feast,' by the same artist, we perceive a powerful feeling overwhelmed in a mass of literary rubbish. Who cares for Belshazzar or his feast, unless we can meet him on 'Change, and he asks us to dinner? The story of *Mene, Mene, Tekel, Upharsin* is a story of today, and if Allston had freed his head from the clouds of literary fancy, and taken notice of the facts before his eyes, he would not have struggled (his picture bears most evident marks of a struggle) with the impossible. The powerful emotion which the vision of Belshazzar, really seen, would have evoked, forcing the spectator to overlook or disregard impertinent vessels of gold and of silver and all the paraphernalia of external circumstance, should and might have found in Allston an admirable translator, for when not trammelled by the ghosts of other men's fancies he worked well and nobly. We see this in his portrait of Benjamin West, in the Boston Athenæum, in the knock-down argument of an individual character. How real seems that portrait alongside of Stuart's pink fancy of Washington! and what a piece of bosh, by contrast, is the 'Portrait of Benjamin West, Esquire' (I believe he wasn't 'Sir'd'), 'President of the Royal Academy,' by Sir Thomas Lawrence! Things that were can be properly represented only in things that are."

"What is the tendency of modern art buyers?"

"Our country is flooded with the mercantile imbecilities of Verboeckhoven and hundreds of other European artists whose very names are a detestation to any lover of truth. The skin-deep beauties of Bouguereau and others of whom he is a type are a loathing to those who hate the idolatry which worships waxen images. The true artist loves only that work in which the evident intention has been to attain the truth, and such work is not easily brought to a fine polish. What he hates is that which has evidently been painted for a market. The sleekness of which we see so much in pictures is a result of spiritual inertia, and is his detestation. It is simply a mercantile finish. Who ever thinks about Michael Angelo's work being finished? No great artist ever finished a picture or a statue. It is mercantile work that is finished, and finish is what the picture-dealers cry for. Instead of covering the walls of his mansion with works of character, or, what is better, with those works of inspiration which allure the mind to the regions of the unknown, he is apt to cover them with the sleek polish of lackadaisical sentiment, or the puerilities of impossible conditions. Consequently the picture-dealer, although he may have, or may have had, something of the artistic instinct, is overwhelmed by commercial necessity. The genuine artist sometimes supposes that he suffers because his love is not of the world. But let him beware of such a fancy. It is a ghost. It has no reality. Our unhappinesses arise from disobedience to the monitions within us. Let every endeavor be honest, and although the results of our labors may often seem abortive, there will here and there flash out from them a spark of truth which shall gain us the sympathy of a noble spirit."

"What is the true use of art?"

"The true use of art is, first, to cultivate the artist's own spiritual nature, and secondly, to enter as a factor in general civilization. And the increase of these effects depends upon the purity of the artist's motive in the pursuit of art. Every artist who, without reference to external circumstances, aims truly to represent the ideas and emotions which come to him when he is in the presence of nature, is in process of his own spiritual development, and is a benefactor of his race. No man can attempt the reproduction of any idea within him, from a pure motive or love of the idea itself, without being in the course of his own regeneration. The difficulties necessary to be overcome in communicating the substance of his idea (which in this case

is feeling, or emotion), to the end that the idea may be more and more perfectly conveyed to others, involve the exercise of his intellectual faculties; and soon the discovery is made that the moral element underlies all, that unless the moral also is brought into play, the intellectual faculties are not in condition for conveying the artistic impulse or inspiration. The mind may, indeed, be convinced of the means of operation, but only when the moral powers have been cultivated do the conditions exist necessary to the transmission of the artistic inspiration which is from truth and goodness itself. Of course no man's motive can be absolutely pure and single. His environment affects him. But the true artistic impulse is divine. The reality of every artistic vision lies in the thought animating the artist's mind. This is proven by the fact that every artist who attempts only to imitate what he sees fails to represent that something which comes home to him as a satisfaction—fails to make a representation corresponding in the satisfaction which it produces to the satisfaction felt in his first perception. Consequently we find that men of strong artistic genius, which enables them to dash off an impression coming, as they suppose, from what is outwardly seen, may produce a work, however incomplete or imperfect in details, of greater vitality, having more of that peculiar quality called "freshness," either as to color or spontaneity of artistic impulse, than can other men after laborious efforts—a work which appeals to the cultivated mind as something more or less perfect of nature. Now this spontaneous movement by which he produces a picture is gov-

erned by the law of homogeneity or unity, and accordingly we find that in proportion to the perfection of his genius is the unity of his picture. The highest art is where has been most perfectly breathed the sentiment of humanity. Rivers, streams, the rippling brook, the hill-side, the sky, clouds—all things that we see—can convey that sentiment if we are in the love of God and the desire of truth. Some persons suppose that landscape has no power of communicating human sentiment. But this is a great mistake. The civilized landscape peculiarly can; and therefore I love it more and think it more worthy of reproduction than that which is savage and untamed. It is more significant. Every act of man, every thing of labor, effort, suffering, want, anxiety, necessity, love, marks itself wherever it has been. In Italy I remember frequently noticing the peculiar ideas that came to me from seeing odd-looking trees that had been used, or tortured, or twisted—all telling something about humanity. American landscape, perhaps, is not so significant; but still every thing in nature has something to say to us. No artist need fear that his work will not find sympathy if only he works earnestly and lovingly."

Selected Bibliography

This selection includes only works published from 1970 to 1984. For a listing of earlier publications, see the bibliography in Nicolai Cikovsky's 1971 monograph on the artist.

Arkelian, Marjorie Dakin, and George W. Neubert. *George Inness Landscapes: His Signature Years, 1884–1894*, exh. cat. Oakland: Oakland Museum, 1978–79.

Bermingham, Peter. *American Art in the Barbizon Mood*, exh. cat. Washington, D.C.: National Collection of Fine Arts, 1975.

Cikovsky, Jr., Nicolai. "George Inness and the Hudson River School: *The Lackawanna Valley*." *The American Art Journal* 2 (Fall 1970): 36–57.

————. *George Inness*. American Art & Artists Series. New York: Praeger Publishers, 1971.

————. *The Life and Work of George Inness*. New York: Garland Publishing, Inc., 1977. (Published version of 1965 Ph.D. dissertation, Harvard University.)

Corn, Wanda M. *The Color of Mood: American Tonalism, 1880–1910*, exh. cat. San Francisco: California Palace of the Legion of Honor, 1972.

Gerdts, William H., Diana Dimodica Sweet, and Robert R. Preato. *Tonalism: An American Experience*, exh. cat. New York: Grand Central Art Galleries Art Education Association, 1982.

Mattison, Robert S. *George Inness: Watercolors and Drawings*, exh. cat. New York: Davis and Long Co., 1978.

Schlageter, Robert W. *George Inness in Florida, 1890–1894, and the South, 1884–1894*, exh. cat. Jacksonville, Florida: The Cummer Gallery of Art, 1980.

Weinberg, H. Barbara, "Thomas B. Clarke: Foremost Patron of American Art from 1872 to 1899," *The American Art Journal* 8 (May 1976): 52–83.

County of Los Angeles Los Angeles County Museum of Art

21

Board of Supervisors, 1985

Edmund D. Edelman
Chairman

Michael D. Antonovich
Deane Dana
Kenneth Hahn
Peter F. Schabarum

Earl A. Powell III
Director

Board of Trustees, Fiscal 1984–85

Mrs. F. Daniel Frost
Chairman

Julian Ganz, Jr.
President

Norman Barker, Jr.
Vice President

Eric Lidow
Vice President

Charles E. Ducommun
Treasurer

Mrs. Harry Wetzel
Secretary

Mrs. Howard Ahmanson
William H. Ahmanson
Howard P. Allen
Robert O. Anderson
Mrs. Anna Bing Arnold
R. Stanton Avery
Daniel N. Belin
Mrs. Lionel Bell
B. Gerald Cantor
Edward W. Carter
Hans Cohn
Joseph P. Downer
Richard J. Flamson III
Arthur Gilbert
Stanley Grinstein
Dr. Armand Hammer
Felix Juda
Mrs. Howard B. Keck
Mrs. Dwight M. Kendall
Robert F. Maguire III
Steve Martin
Dr. Franklin D. Murphy
Mrs. Edwin W. Pauley
Sidney R. Petersen
Henry C. Rogers
Richard E. Sherwood
Nathan Smooke
Ray Stark
Mrs. John Van de Kamp
Hal B. Wallis
Frederick R. Weisman
Dr. Charles Z. Wilson, Jr.
Robert Wilson
David L. Wolper

Honorary Life Trustees

Mrs. Freeman Gates
Mrs. Nasli Heeramaneck
Joseph P. Koepfli
Mrs. Rudolph Liebig
Mrs. Lucille Ellis Simon
John Walker
Mrs. Herman Weiner

Edited by Edward Weisberger
Designed by Lilli Cristin

Text set in Simoncini Garamond typefaces by
Continental Typographics Inc., Chatsworth,
California.
Printed in an edition of 27,000 softcover and
2,500 hardcover copies by Balding & Mansell,
Great Britain.

Photo Credits. All photographs reproduced
courtesy of the works' owners with the
following photographers credited: E. Irving
Blomstrann (cat. no. 5); Joseph Szaszfai (cat.
no. 25); David Wharton (cat. no. 41);
Lawrence S. Reynolds, head photographer,
Peter Brenner and Jeffrey Conley,
photographers, Los Angeles County Museum
of Art (cover; figs. 23, 27, 30, 40, and 50;
cat. nos. 21, 27, 31, and 46).

www.smpl.org